HOLLYWOOD MAKEUP LAB

INDUSTRY SECRETS AND TECHNIQUES

by Bruna Nogueira and Diane Namm

Photographs by Travis Smith-Evans

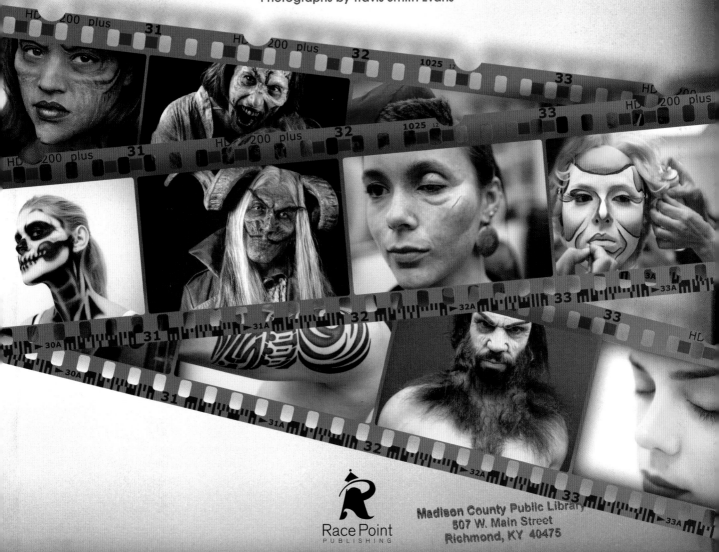

Race Point
PUBLISHING

An imprint of Quarto Publishing Group USA Inc.
276 Fifth Avenue, Suite 206
New York, New York 10001

DESIGNER Tim Palin Creative

PHOTO CREDITS: Travis Smith-Evans—cover and interiors, except where otherwise indicated; courtesy of Joel Harlow—13; courtesy of Rayce Bird—36-39; Ben Bornstein—42 (left); Robert Kazandjian—42 (right); courtesy of Rod Maxwell—43; courtesy of Edward French—54-55; Livia Wippich—256 (top); Albane Navizet—256(bottom)

ISBN-13: 978-1-937994-56-3

Printed in China

2 4 6 8 10 9 7 5 3 1

www.racepointpub.com

TABLE OF CONTENTS

PREFACE

What are the origins of the terms *Makeup Artist* and *Special-Effects Makeup*?

Decades ago, an artist who did makeup in beauty, facial hair, cuts and bruises, bald caps, and appliances was called a *makeup artist*; and some artists were better at these skills than others. An excellent makeup artist was able to do *all* of these makeups. In the film and television industries, somewhere around the mid-1970s, the demand for makeup artists exploded. To satisfy the demand, studios and unions brought in a large number of newly credentialed makeup artists and other crafts people. Some of these individuals were very accomplished, others were only knowledgeable in beauty makeup and not much else.

During a film shoot, if a director would ask a typical on-set makeup artist to apply a moustache to an actor, the newer makeup artists would reply, "I don't do moustaches. That's a special effect." Ironically, the "not my job" attitude was the impetus for the creation of a skilled craftsperson whom we now identify as the *Special-Effects Makeup Artist*.

Today, the term Special-Effects Makeup covers everything from the creation and application of prosthetics to something as simple as generating a bruise. So how do we distinguish among a Beauty Makeup Artist, a Character Makeup Artist, and a Special-Effects Makeup Artist? Clearly, the most valuable artist is the one that is skilled in all three, and that artist is also the one most likely to be hired.

Makeup department heads, production managers, directors, producers, and actors always remember the artist who does "exceptional work," just as they also remember the artist who does not! It's the makeup artist's job to make everyone look good. When the makeup is right, the film or television project has that much greater of a chance to succeed. And a successful special-effects makeup artist is one who is consistently requested by directors, producers, and actors. In fact, an in-demand artist can even be a deal-breaking part of an actor's contract!

The most treasured special-effects makeup artist is someone who knows how to do everything—from designing a character to creating prosthetics, applying them, and painting an authentic makeup that will match or exceed the director's vision, and that will assist the actors in doing their jobs to the best of their abilities. Keeping abreast of the latest, best, and most efficient ways to generate a makeup is essential for the artist who works in an industry where the mantra is "time is money."

Unlike the early years, when makeup was a budding industry, now there are a variety of products, materials, and solvents available to give makeup artists a leg up in their never-ending quest to create the most authentic makeup possible. Decades ago, foam-rubber appliances were glued down to an actor's skin with spirit gum, edges were blended with Duo Adhesive, and the appliance was colored with very sticky castor oil rubber grease. It was an unpleasant, often painful, and much-dreaded process for the actor.

Today makeup artists have a plethora of actor-friendly, easier-to-use, and more authentic-looking material options for appliances: foam, gelatin, encapsulated silicone, Bondo transfers, and more. If an artist has no time to construct a mold and generate an appliance or prosthetic, now there are ready-made foam and silicone appliances available for purchase in specialty beauty supply stores. Premade, intricately designed facial-hair appliances, including beards, sideburns, mutton chops, and moustaches, first introduced by makeup artist John Blake, can be purchased as stock items for artists to keep in their kits.

Filmmakers want the viewer to be caught up in the world of the story, and the makeup effect must simply be a seamless part of the storytelling. So the question on every makeup artist's mind is, will Visual Effects (or computer-generated—also known as CG—effects) replace the special-effects makeup artist in the future?

In the years to come, I think we will see a blend of the special-effects makeup and visual effects industries, an effort to use the best of both crafts to make the most believable characters. In the meantime, there isn't a single director, producer, or actor who will deny how important makeup artists are to the success of their productions. *The Hollywood Makeup Lab* book gives readers a sneak peek into the world of those accomplished makeup artists, their processes, and their secret "bags of tricks," providing insights that I think every professional, amateur, or special-effects lover will enjoy.

Leonard Engelman

Leonard Engelman, a two-time Prime Time Emmy Award winner with three additional Emmy nominations, is on the Board of Governors and is VP of the Academy of Motion Picture Arts and Sciences. He's been the lead makeup artist on such classics as Rocky IV, Rambo, Ghostbusters, *and* Moonstruck.

INTRODUCTION

How did a small town girl from Curtiba, Brazil, become an internationally in-demand makeup artist on high-profile Hollywood projects like *Teen Wolf* and *The Hunger Games: Catching Fire*, in addition to being the founder and owner of the Hollywood Makeup Lab intensive workshop program?

When I was eleven years old, I saw my first movie on the big screen, Spielberg's *E.T.* That's when I knew that working in movies had to be my destiny! At nineteen, I moved away from home to the big city, Sao Paulo, to study cinematography at Escola Panamericana de Arte e Design. I graduated to making documentaries for the Museu da Imagem e do Som de São Paulo. Much as I loved the travel and the filmmaking, there was a part of my creative soul that wasn't being fulfilled. So, at the age of thirty-one, I embarked upon, what seemed to my family, a completely crazy adventure. I packed up everything, including my young son, Vitor, and moved to the USA—specifically to Hollywood, the heart of the filmmaking industry.

In 2005, we arrived in the United States—just my little boy and me. I had no connections, and I wasn't exactly sure where to begin. Early on I heard about the Joe Blasco School of Makeup and registered for class. From the first moment I entered that magical work of makeup, I knew I'd found my place in the world of cinema, the place where my imagination and movie monsters coincided. Because my English wasn't very good, I became a visual sponge, watching the work of Ve Neill, Edward French, Leonard Engelman, and more—learning from the best makeup artists working in Hollywood today. In just three years, I worked on thirty-two movies and gained enough credits to join the the Make-Up and Hair Stylists Guild Local 706—the first Brazilian to ever do so.

A couple of the US projects of which I'm most proud are my participation in a team of forty makeup artists on the *The Hunger Games: Catching Fire* film, and as the key makeup artist on the *Teen Wolf* series.

I love what I do, from designing characters and generating prosthetics to make the monsters or their bloody victims, to executing the visions of great writers and directors on a daily basis. And there's always more to learn. Makeup artistry, more than most, is a collaborative community. Makeup artists are problem solvers. But there's precious little time, when working round-the-clock, to learn and research all the newest and latest techniques in special-effects makeup.

That's why I created the Hollywood Makeup Lab ten-day intensive workshop program—so that all of us in the industry would get the chance to learn informally from each other, and as an opportunity for those who aspire to be a part of the makeup community to meet with and watch the work of the great artists of today.

This lavishly illustrated book represents the workshop intensive format at its best. With the assistance of my friend Mark Rappaport of Creature Effects Inc., I hosted (at Mark's workshop) a myriad of award-winning makeup artist greats, including Joel Harlow and Chris Nelson, who graciously shared how they make "magic in action" happen daily. Each chapter provides a behind-the-scenes look into the techniques and supplies that the different artists use; an explanation of their processes; and how they achieve the makeups for demon, zombie, werewolf, vampire, devil, and more, as well as do-it-yourself "looks" that you can create at home.

It's my honor and privilege to share these secrets of my industry with you.

I hope you enjoy your journey through the world of special effects makeup as much as I've enjoyed bringing it to you!

Bruna Nogueira

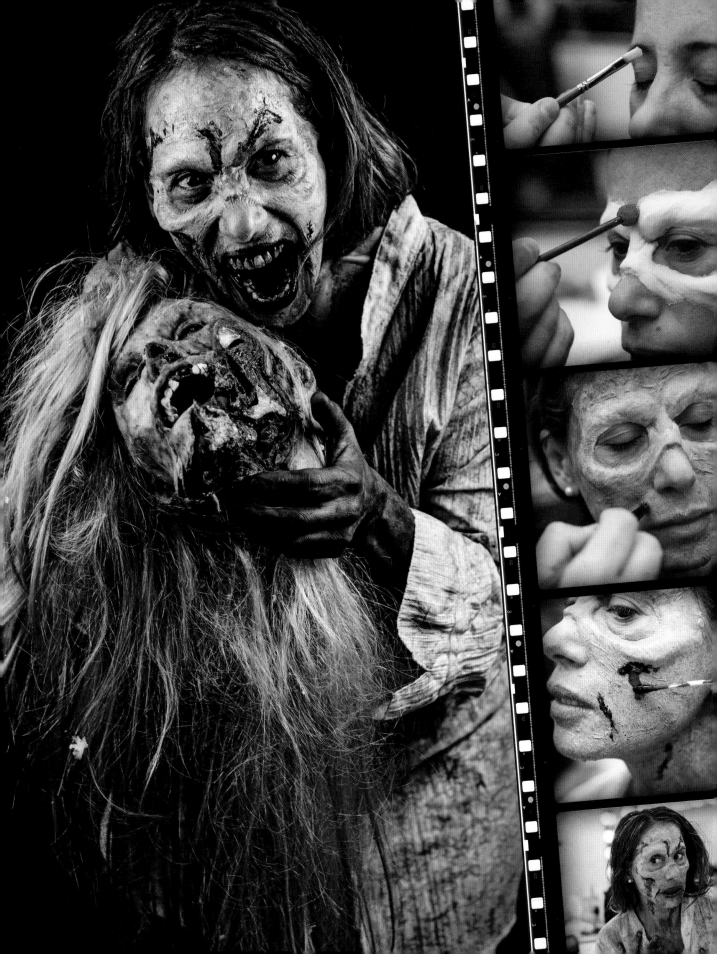

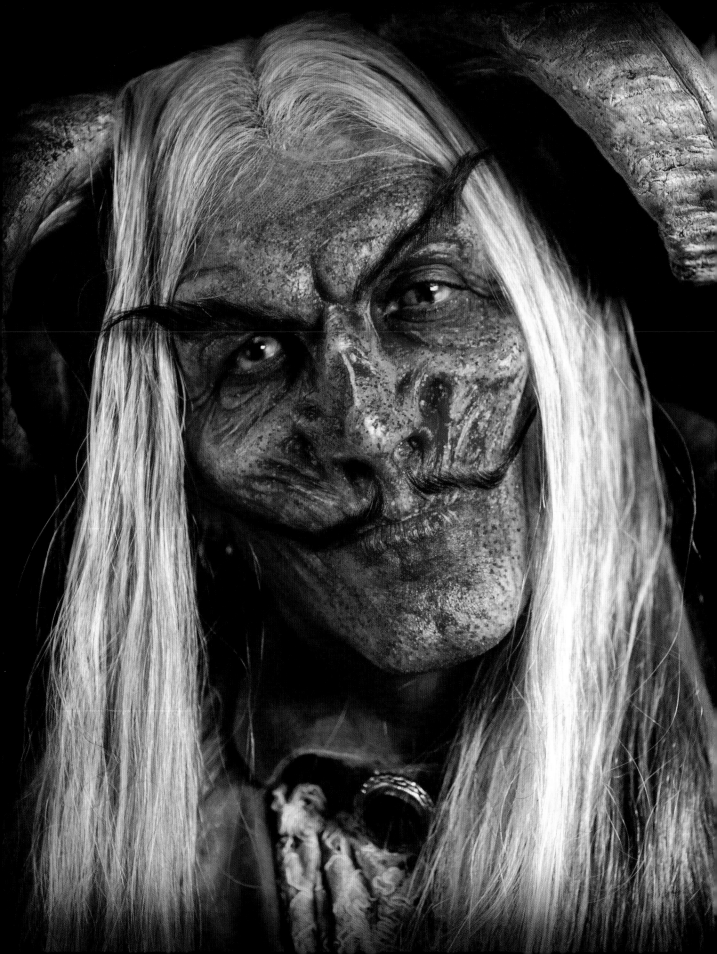

CHAPTER 1

DESIGNING CHARACTERS

"It's the golden age for special-effects makeup artists—it used to be an industry hidden in the shadows, but now it's a viable, attractive, and valued career choice. . . . I especially love the mixture and marriage between CG (computer-generated) and the practical makeup effect. When it works together, and not in competition, wonderful creations emerge."

—Joel Harlow

CLAY SCULPTURE
with Joel Harlow

For the workshops in the Hollywood Makeup Lab, we asked two-time Oscar-nominated and Oscar-winner Joel Harlow (www.harlowdesigns.com) to show us how he designs a character using the clay sculpture approach—with nothing more than a block of clay and his imagination as reference.

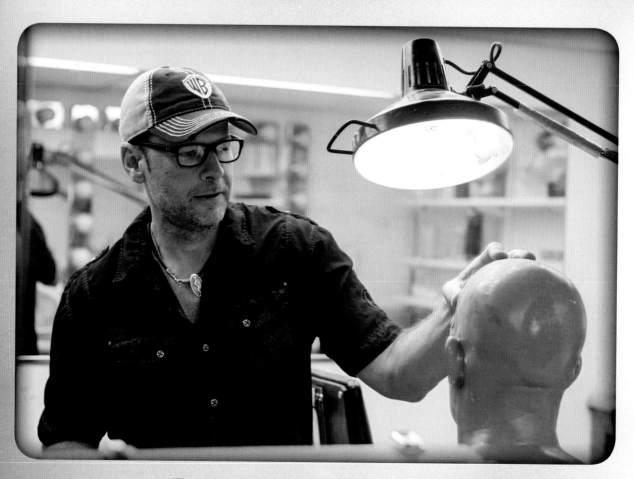

"There's nothing like the feeling of sculpting the likeness of someone . . . and nailing it. . . ."

—Joel Harlow

Joel has been creating his own characters ever since he was a kid in North Dakota.

Here are a couple of images from Joel's "Rogue's Gallery" of creatures from his imagination.

Normally, Joel works with a director's vision or suggestion of the character before him. Joel works a great deal with Johnny Depp, engaging in a creative collaboration to design the makeups for each of Johnny's characters (*Pirates of the Caribbean 2, 3,* and *4, Lone Ranger, Alice in Wonderland, Mortdecai, Transcendence,* and *Into the Woods*). In *The Lone Ranger,* it took three makeup artists eight hours to apply Johnny's "Old Tonto" makeup and two hours to remove it—every day for an entire week!

Upon winning the Oscar for his work on *Star Trek,* Joel gave the statue to his parents, whom he'd brought to the awards ceremony, to make up for all the destruction he'd caused in his childhood—for example, almost setting the garage on fire trying to make a film with a smoke effect, making homemade foam-latex appliances, baking clay sculptures in their home oven, and spilling cement all over his dad's library.

Joel's creative process almost always starts the same way. He begins with his sculpting tools, a warm lump of clay heated in a toaster oven (you see why he gave his mother his Oscar), and a life cast.

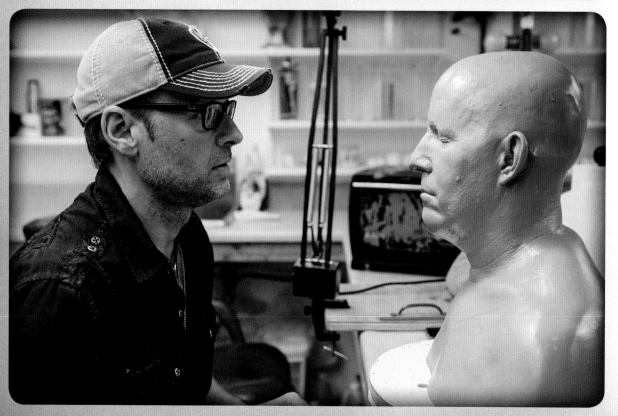

To provide a base for his clay sculpture, Joel brought with him the head cast of Scott Ian, guitar player in the band Anthrax, for whom he's done a number of different makeups in the recent past. To see how life casts are created, see pages 64–71 in the Bruises chapter.

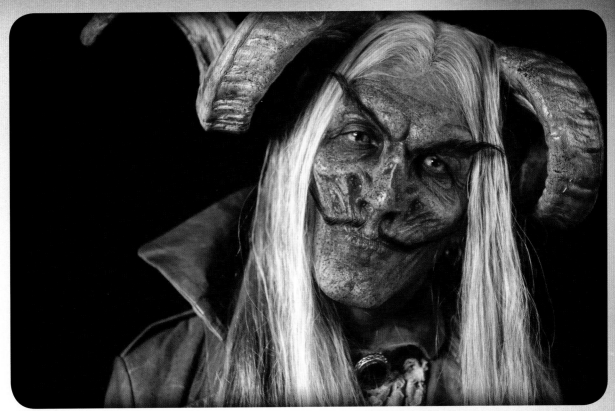

Joel shows us how he transforms that lump of warm clay into the makeup for Salvatore Devilé, the newest addition to Joel's "Rogue's Gallery."

Joel applies the clay to the life cast, accentuating the bone structure of this particular head cast, confident that one of the "many heads in his head" will make its way through his fingers into the sculpture.

Joel always allows for the possibility of "happy accidents," that his fingers will form something unexpected.

Note: Designing with a 3-D design concept software, the other and more typical way to create character designs, doesn't really allow for happy accidents. On the other hand, it's a great way to show different concepts without having to sculpt five heads, and an excellent tool with which to do pre-prep for the actual sculpture.

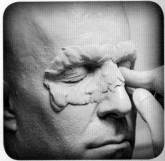

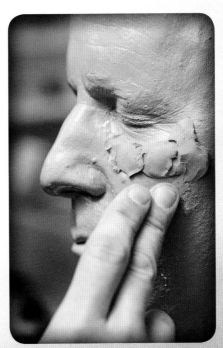

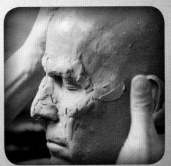

Often, Joel will modify his sculpting tool to accommodate the look he wants.

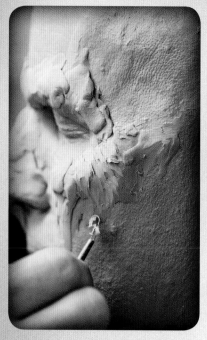 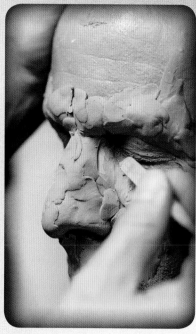 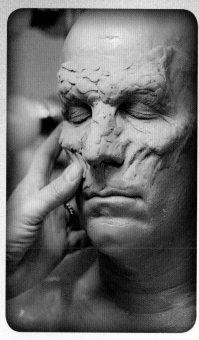

This type of sculpting over another character's life cast is an "additive" art form. Joel fakes the hollows, the shadows, and the gauntness of the character's face that he's creating by bringing out the high points of the base life cast. There's a certain stage where the creativity all comes together. Joel finds the character in the sculpture. From that point on, the sculpting becomes about fine-tuning the look with detail.

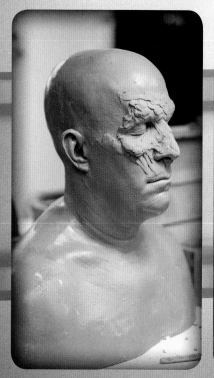 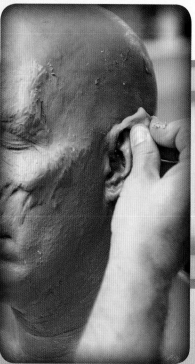 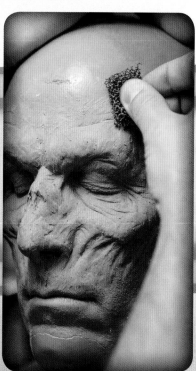

Joel changes the edge of the sculpting tool in order to draw the age-wrinkle lines,

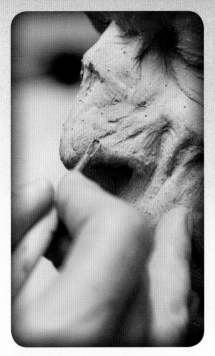
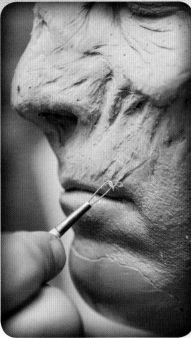
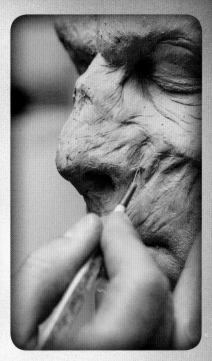

Since the sculpture will be used to create the facial prosthetic, Joel makes sure that the creation is symmetrical.

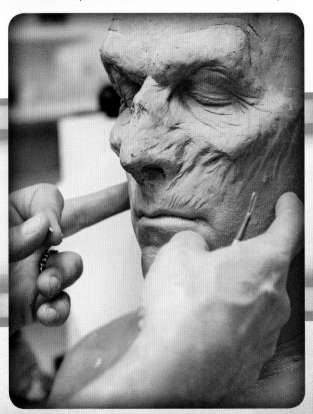
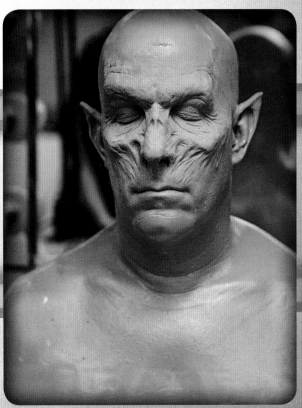

Joel wants every detail in place before he determines the character is complete.

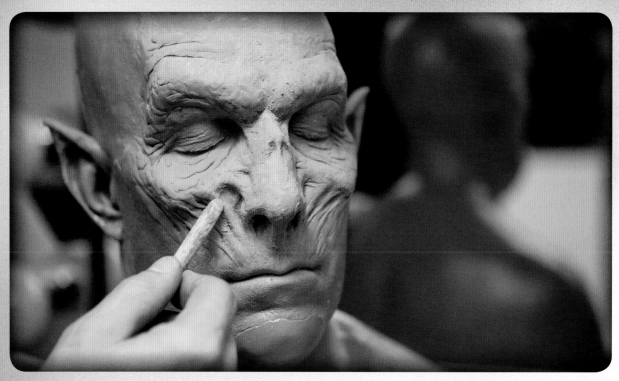

Joel shoots a picture of the final model for reference before the last step, just in case anything shifts during the finishing.

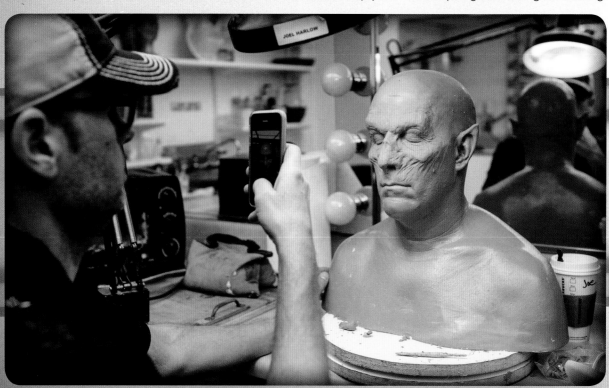

Then he carefully finishes off the sculpture by brushing it with 99 percent alcohol to smooth out the clay.

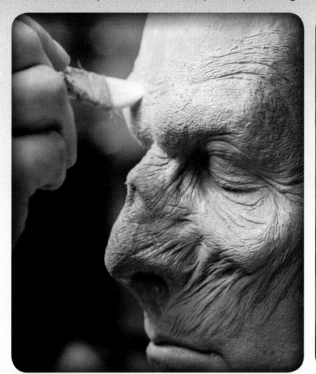

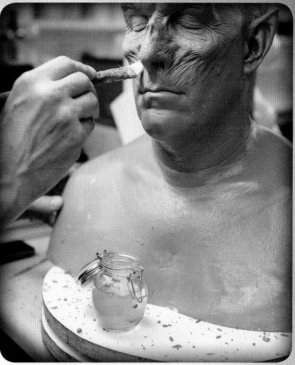

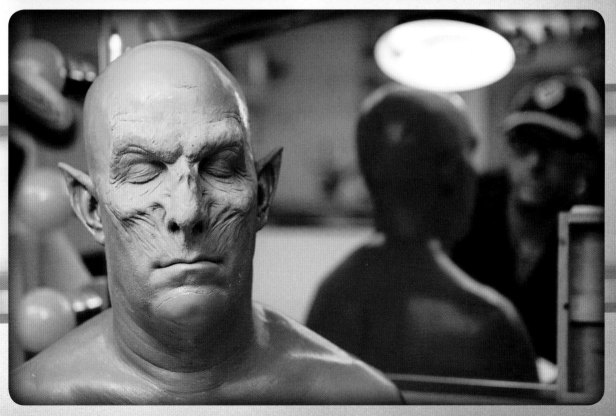

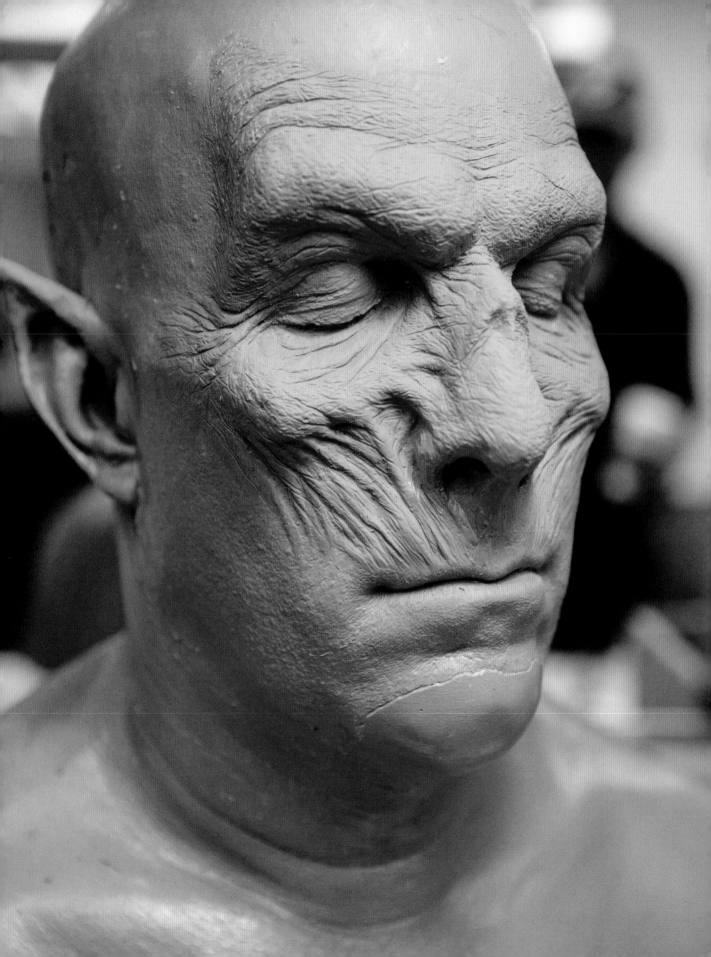

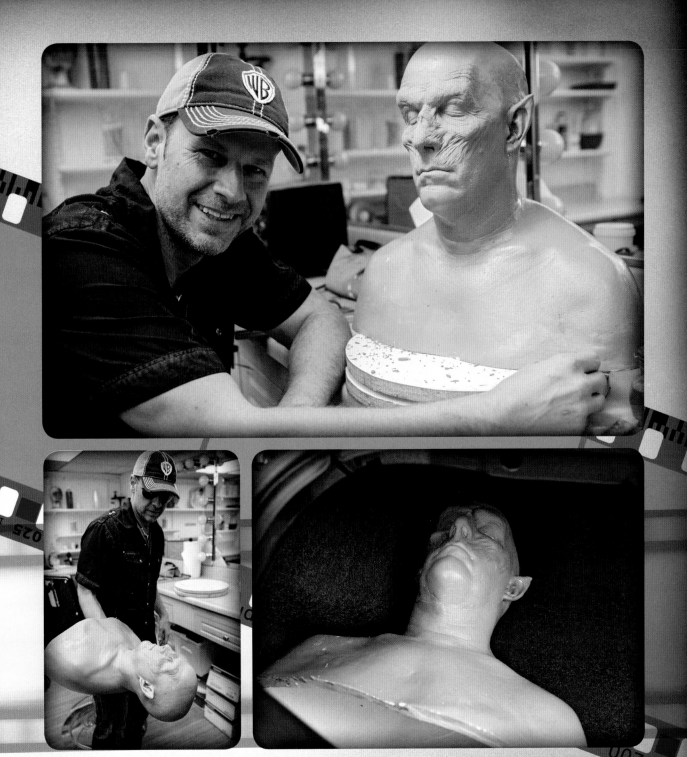

Joel takes the finished clay sculpture and unceremoniously brings it back to his shop in the trunk of his car.

(When Joel was working on a movie called *Twisted*, he had made a full-body version of Samuel Jackson's character, complete with a gunshot wound to the head. He placed Samuel's double in the passenger seat and drove to set, no doubt surprising unsuspecting passersby along the way!)

Then Joel entrusts his clay sculpture creation to Steve Buscaino, an integral member of Joel's design team, to execute phase 2: making the mold. Steve has been working with Joel since the *Pirates of the Caribbean* films *2* and *3*.

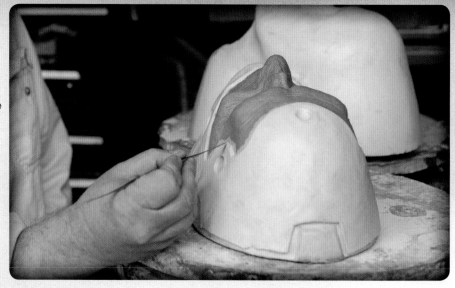

The first thing Steve does with the clay sculpture is "float" off the hardened red-clay pieces from the original life cast. He then lays them onto a corrected life cast so it becomes a positive part of the mold. (This is a true act of trust on Joel's part, and a tribute to Steve's abilities, since if the clay pieces are not removed correctly, Joel would have to start all over from scratch!)

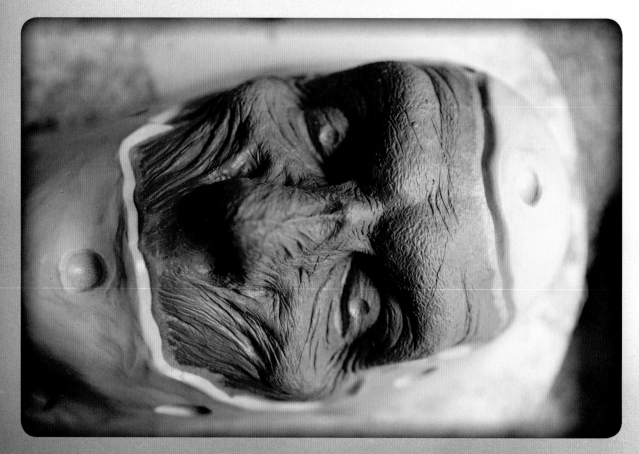

Steve adds gray clay around the red clay to create a gap in the red-clay positive mold. This way, when he adds the silicone to the final mold, there will be a place for the excess to go. This creates flashing, or excess edging, which helps the artist blend the prosthetic to the actor's face. (For an example of mold making with silicone, see pages 72-75 where Vincent Van Dyke demonstrates how molds are made in the Bruises chapter.)

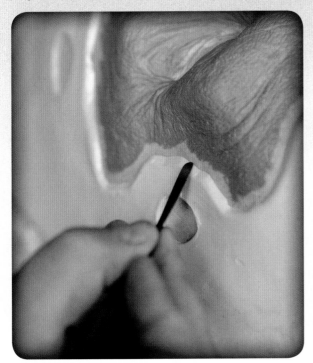 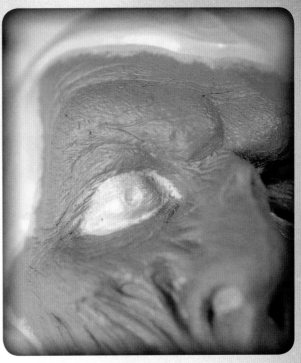

Next, Steve presses clean gray clay strips through a pasta machine and applies them around the red-clay positive mold.

Steve slices slabs of dark gray molding clay and presses them around the circumference of the mold to form a lip.

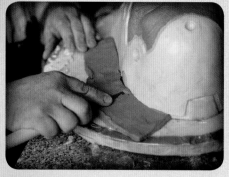

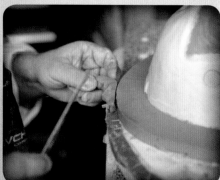

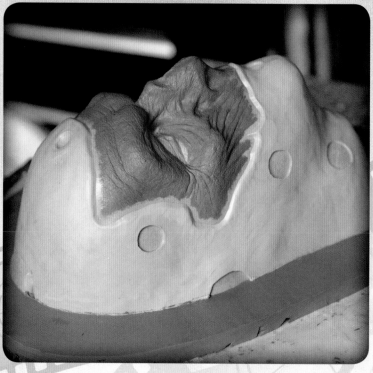

He then mixes up a batch of gypsum cement and brushes it onto the red-clay mold until it's completely covered, and the details of the red clay are barely visible. (At this point, the red clay has completely hardened, so brushing on the cement will not endanger the details Joel has sculpted.)

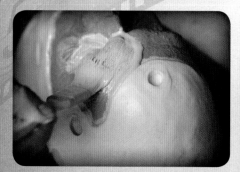

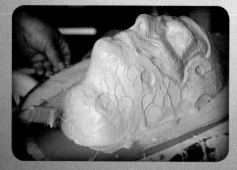

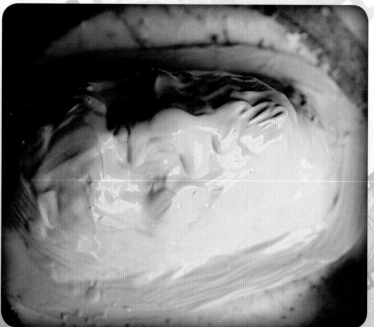

Steve waits for the cement to dry and harden.

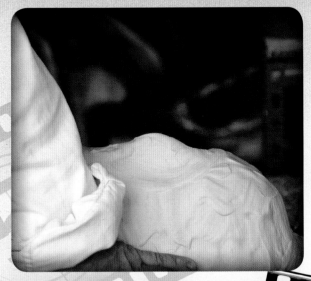

Next, Steve dips burlap strips into a bucket of plaster and layers them onto the cement-covered mold to form a casing.

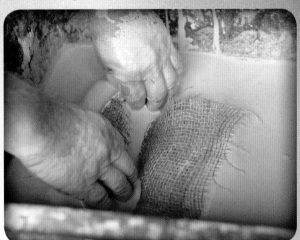

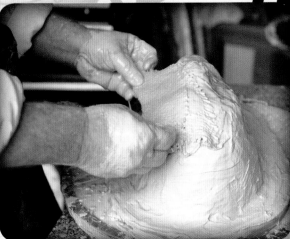

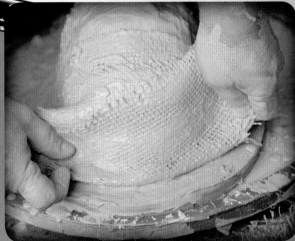

On top of the burlap strips, he ladles on even more plaster and smooths it over until the mold is completely buried. The red-clay sculpture is merely a faint memory at this point. It takes several hours to set, and the string texture of the burlap keeps the mold from breaking or warping.

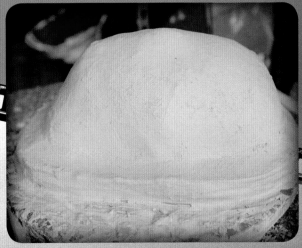

Once the mold is set, Steve turns it upside down so he can release the mold from the plaster casing to reveal a bust of the life cast and a negative mold for the character sculpture made from the red-clay mold.

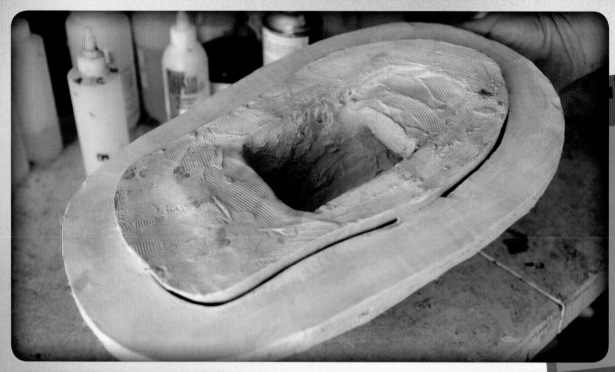

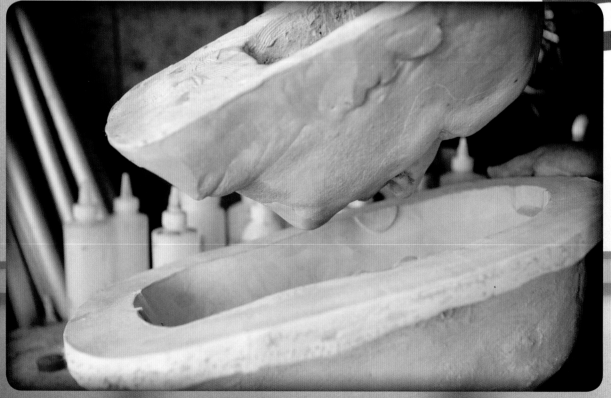

When Steve is done scraping out the remnants of the red-clay sculpture, all that's left of the red-clay model sculpture is a tiny ball of clay.

 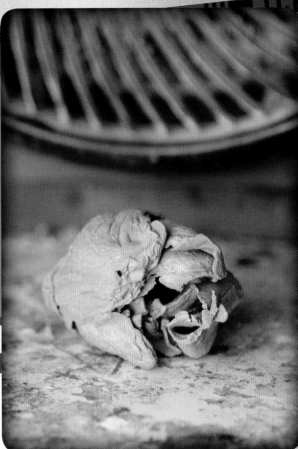

Steve coats the bust and the negative mold with three different types of releasing agent so that the silicone prosthetic will be easy to remove.

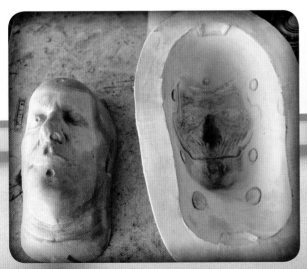 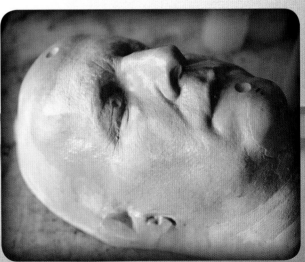

Steve pours the silicone mixture into the negative mold.

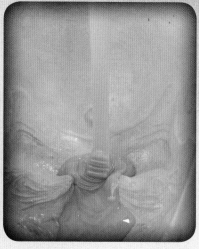

He tightly fits the bust into the negative mold. Then he applies pressure to let the excess silicone ooze out from the sides.

Steve tightens the mold with three ratchet straps and lets it cure for between one and two hours. (Steve checks the excess silicone to see if it's cured, and when it is, the mold is ready for release.)

The appliance is almost ready. Steve trims off the excess silicone flashing and removes the prosthetic from the bust.

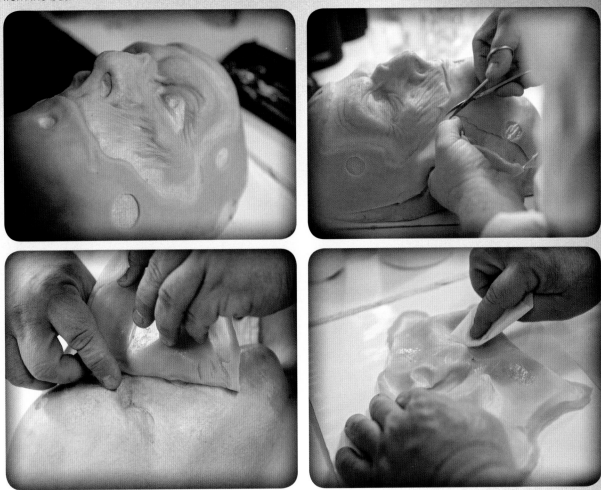

The facial appliance is now ready for Joel to work his magic on our model Gilbert Laberto.

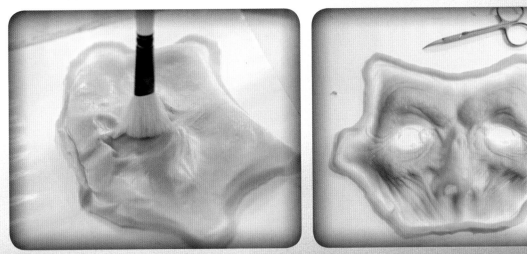

Joel blends the edges of the appliance into the model's skin with Pros-Aide cream adhesive and a cotton swab, dowel, or sponge wedge (depending upon the position of the appliance). He continues to glue down the prosthetic, removing the excess flashing along the way, sealing the edge of the prosthetic with Bondo (a combination of Pros-Aide adhesive and Cabosil).

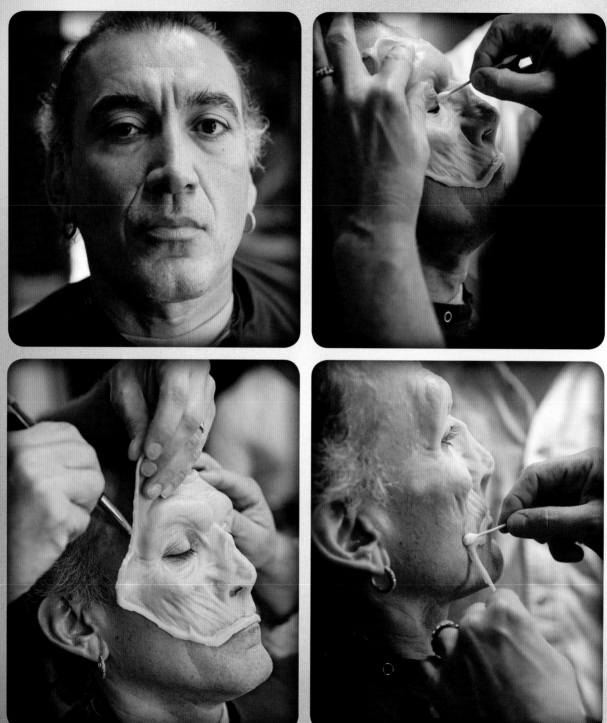

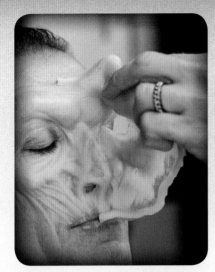

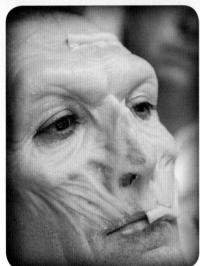

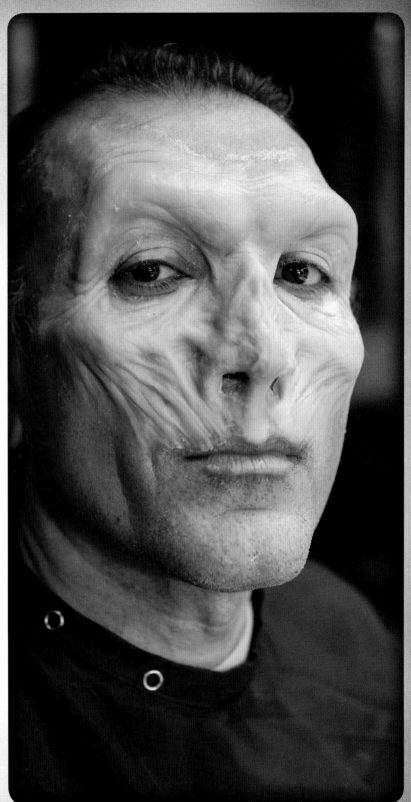

When the glue is dry, Joel applies alcohol-activated paints with fine brush strokes and airbrush spattering, using a variety of illustrator palettes.

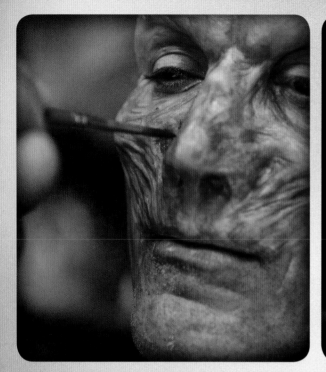
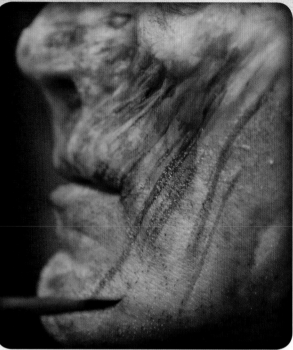
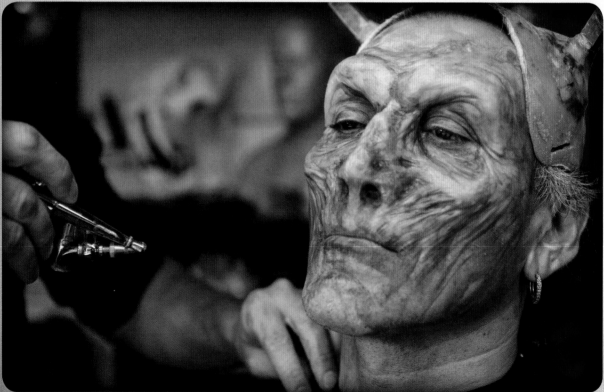

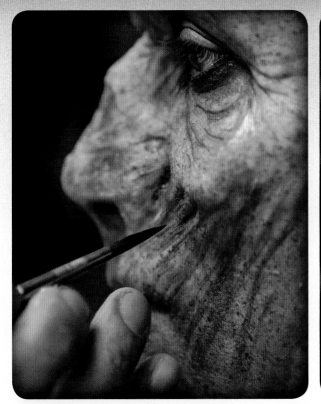
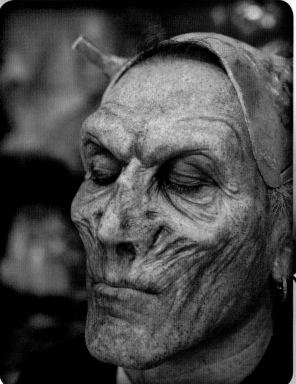
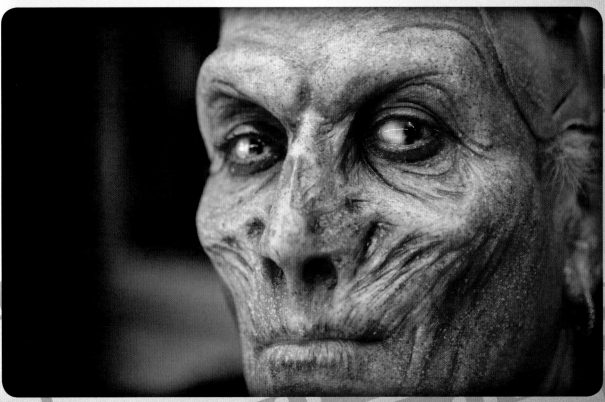

Once Joel is satisfied with the color of the makeup, it's time to add a bit of flair to round out the character's personality—mustache, eyebrows . . .

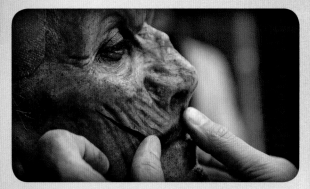

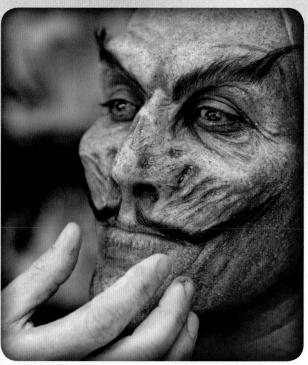

. . . costume, horns, and hair, which Joel sets with a spritz of seaweed spray.

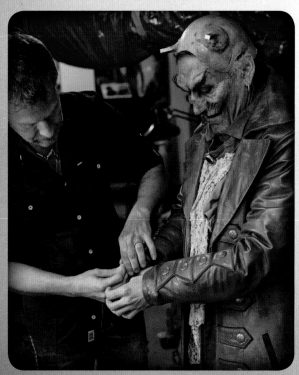

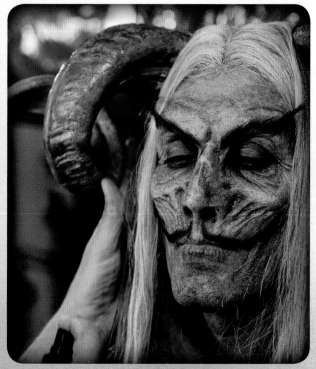

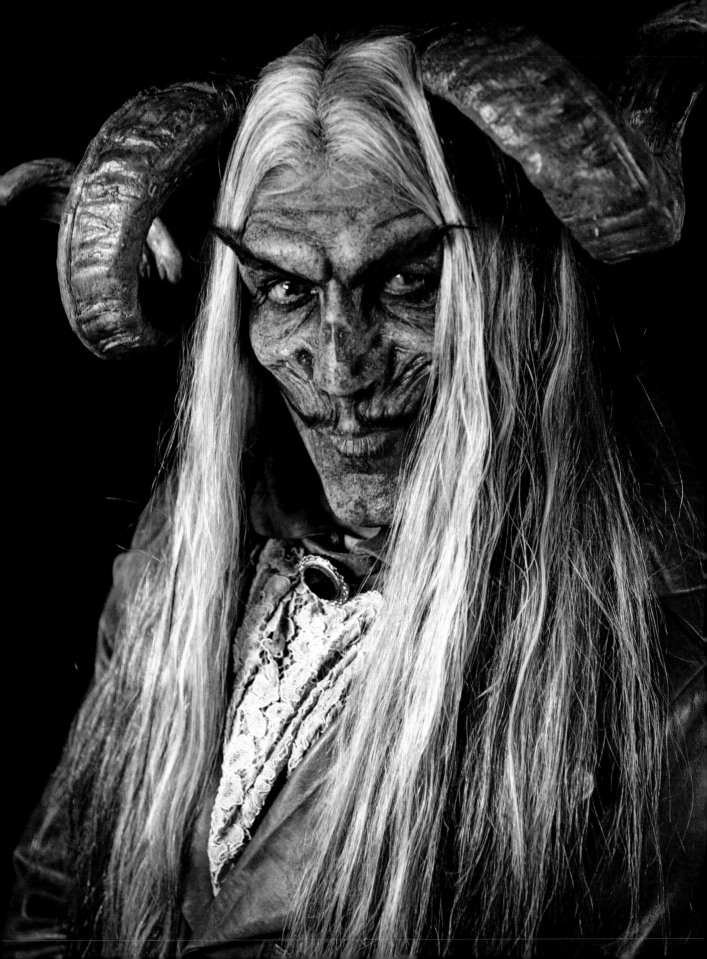

Workshop #2

DIGITAL DESIGN
with Rayce Bird

Like so many special-effects makeup artists, Rayce Bird, Season 2 winner of SyFy's hit television show *Face Off*, is an artist who wears many hats. He does character and creature concept design, special-effects makeup, tattoos, graphic design, website development, video game design and app building, and product design consulting, and he's an instructor for the University of Idaho's Virtual Technology and Design program. He's often asked to participate in the re-design of well-known characters. For example, when his friend Frank Ippolito (who has been documenting the Zoidberg project on www.tested.com) asked him to re-design Zoidberg, a character on the television show *Futurama*, Rayce was excited to be a part of it.

To Reimagine Zoidberg, Rayce maintained a line between goofy cartoon and really cool believable. Zoidberg could have been an evil-looking villain—but instead, the shapes that Rayce chose for him make Zoidberg the lovable, quirky personality that he is.

For Rayce, conceptualizing is an important part of good makeup design. With the use of Adobe Photoshop, he designs many different characters before he even touches a makeup palette or brick of clay.

"Being on Face Off *was a wonderful experience. . . . I feel like I received four years of schooling, learning and making progress from both my peers and the judges."*

—Rayce Bird

Just as a writer creates a character, or an actor prepares for a role, Rayce designs his characters to have depth and to be relateable to an audience.

Rayce likes to know a character's origins, its environment, its emotional perspective, and its personality, so he can create a memorable character who looks, feels, and moves with intention—a character that will stand the test of time.

To do this, Rayce tries lots of different "looks," and he uses digital technology as a time-saving tool.

Rayce's favorite challenge is to reinvent a character that everyone knows. For example, Adobe asked him to redesign Frankenstein for their classes and shows in order to demonstrate how digital design works.

Rayce's approach to Frankenstein was more vicious than the original. In one model, he added wire cables throughout the creature's face and details of electrical cabling inside the head with an infrared sensor, to make

it seem contemporary with today's technology. In another, Rayce exposed the character's skull, keeping the flatness at the top of the head, but infused a metal band element—a steampunk copper grunge band that goes around Frankenstein's head.

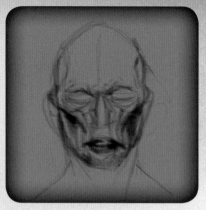

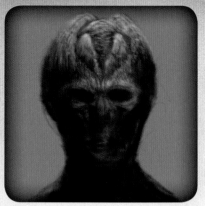

First thing Rayce does is sketch out a character and then fills in the background with a medium-gray color. This allows him to focus on the shadows and highlights—the most important part of making a character look realistic and believable. He knows that the actor is likely to have generic features, so he roughly sketches out a basic human head (which doesn't have to be perfect).

Next, Rayce draws a rough sketch, or template, in place so he can focus on shapes that will define his character. At this point, Rayce doesn't get too detailed with his line work, nor does he overthink the shapes.

Rayce continues to sculpt shadows and refine forms until he finds something he likes. He chooses to make the top of the head open to expose some softer tissue underneath. He also allows the shadows around the eyes to become very deep, similar to those of a gorilla's.

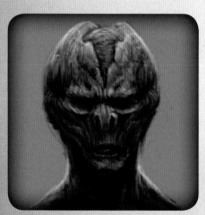

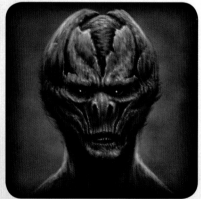

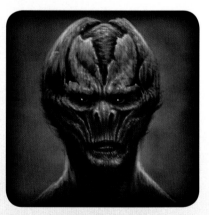

Notice that Rayce starts to overlay darker values to the overall design. He does not want to use color at this stage, since value, and not color, is the most important part of the beginning stages of form development.

Rayce adds a subtle reflection in the eyes, which makes the creature less menacing and slightly more relatable, almost as if it now has a soul. He feathers in some hair to link him even more to a primate character and adds texture and value to the background to make the character more believable in his space. This focuses the viewer's attention on the center of the face.

Now it's time to add color.

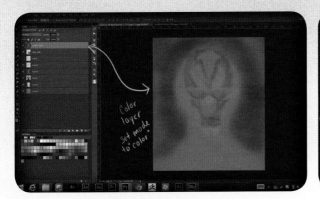

Look at how rough his color layer looks when he removes it from the other layers.

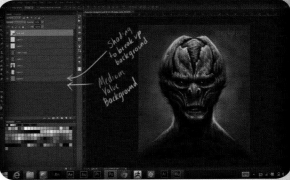

Rayce continues to add colors to the color layer; the subtle reds and blues start to give more dimensions to the character.

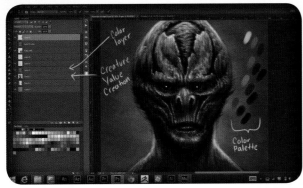

He selects the colors within his painting and enhances the details in his character. This is the only part of the process where Rayce actually paints with color. The colors work because he's created a substantial base value system underneath. At this point he selects and paints some larger swatches off to the side of his character; these will help maintain his palette throughout the finishing process.

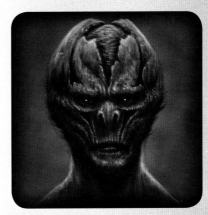

At last, the creature has Rayce's seal of approval. Then a sculpture or bust of the model is made, and the mold-making process to create the silicone prosthetics (described in pages 22–29 of this chapter) can begin!

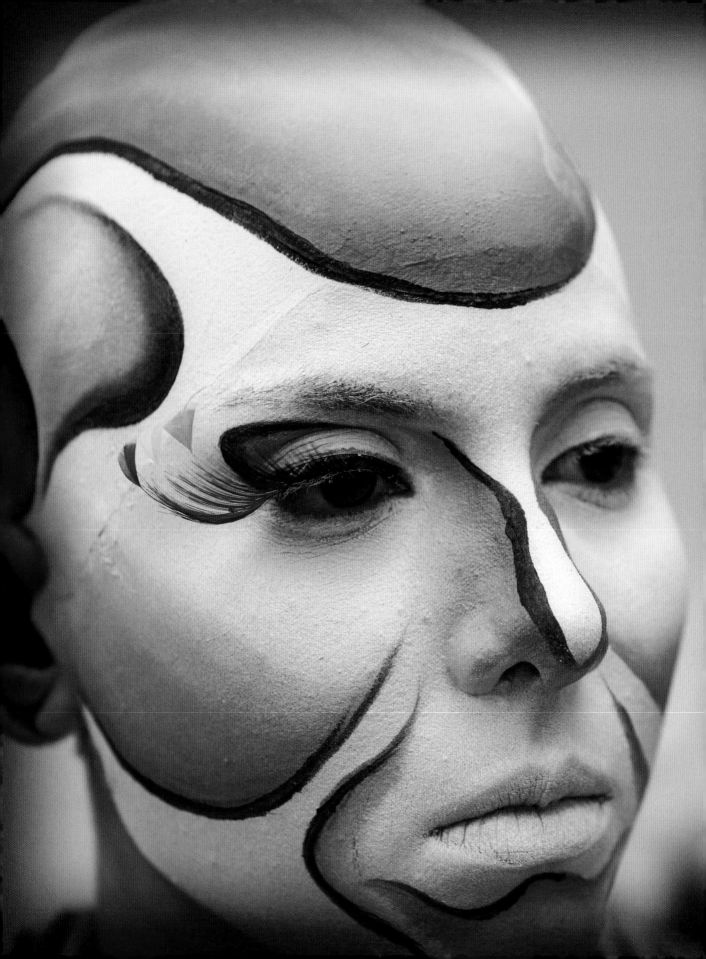

COLOR THEORY AND BALD CAP

"Mixing colors to taste is as personal as cooking—trial and error, with a knowledge of science required. Using a combination of yellow, red, green, and blue, with a sprinkling of umber, raw umber, burnt umber, or white, you can make just about anybody's skin color."

—Sue LaPrelle

Special-effects painter Sue LaPrelle explains the basics of traditional color theory, using a color wheel for reference.

Primary Colors are pure yellow, blue, and red

Secondary Colors are two primary colors mixed together.

Tertiary or Intermediate Colors are an equal mixture of a primary color with the secondary color closest to it in the color wheel.

Color Temperature

Warm colors are related to red.
Cool colors are related to blue.

Complementary Colors

Opposites on the color wheel, one cool, one warm. (When aligned they intensify each other. When mixed they neutralize each other.)

Tint

Mixing any color with white creates a lighter tint of the same color.

Shade

A hue or color mixed with black or otherwise darkened in value.

COLOR THEORY
with Rod Maxwell
(*FaceOff* and Flesh Master)

Matching flesh-tone colors is an essential key to having special-effects makeup—from bald caps to prosthetic applications—blend seamlessly into the skin. No one knows that better than Rod Maxwell, season three alumnus of SyFy's hit show *Face Off*, Instructor at Cinema Makeup School in Hollywood, and inventor of Flesh Master (www.fleshmasterpro.com), a ground-breaking color-theory app that literally reinvents the wheel—the color wheel, that is!

"I developed the Flesh Master Color System to help artists match flesh tones quickly with just a glance. The Flesh Master app trains your eyes to break down flesh tones into a simple mixture of yellow and red with the addition of blue. It's a thrill to see how Flesh Master has been helping artists mix and match colors so quickly!"

—Rod Maxwell

To demonstrate the versatility of his special-effects makeup skills, and as a graphic illustration of his Flesh Master system, Rod made a short film, *The Wishing Well* (www.thewishingwellmovie.com), in which he played twenty-six characters and did all of his own makeup. That's Rod beneath each of these makeup effects!

COLOR THEORY IN ACTION

with KC Mussman and
Actress Meagan Tandy of *Teen Wolf*

After consulting on color theory with both Rod Maxwell and Sue LaPrelle, we stopped by the Cinema Makeup School in Hollywood where KC Mussman showed us how she uses a combination of color theory and her own instincts to turn actress Meagan Tandy into a glamour witch.

KC glues down the "witchy" facial prosthetics (the pointy chin and bony eye sockets that make Meagan's face sharp and angular, in classic witch form).

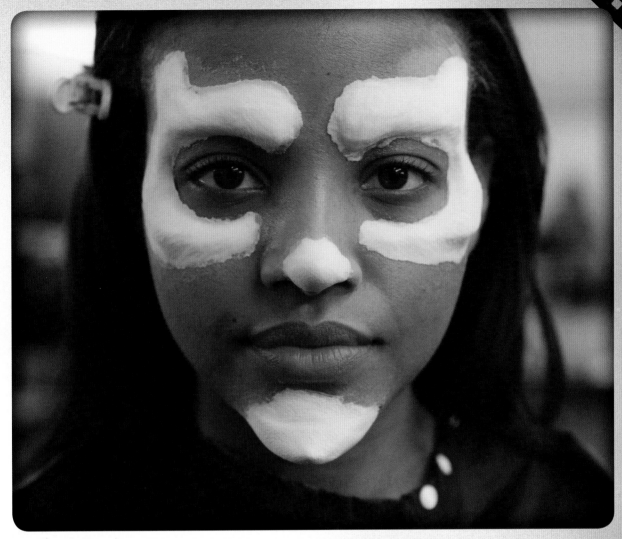

KC will mix orange/brown and brown flesh tones from warm-color paint palettes to match Meagan's skin color.

KC combines red, yellow, burnt umber, white, and black paints to create a flesh color to match Meagan's skin tones.

KC uses a sponge wedge to blend the hard, rough edges of the prosthetic into Meagan's skin.

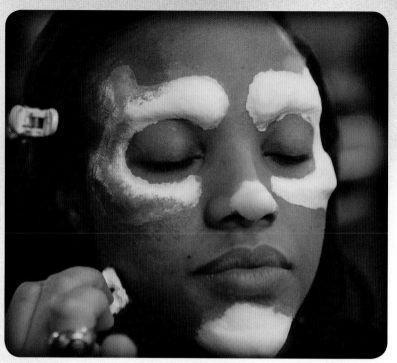

She adds clay and water to purple paint to create a thick paste, which she applies with a sponge wedge.

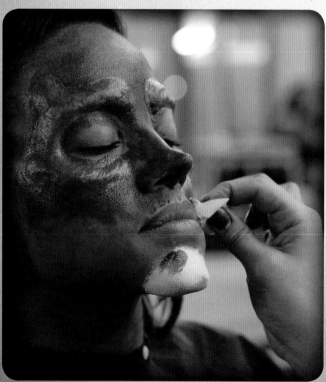

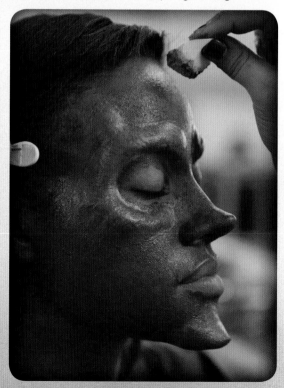

Once the hard edges of the prosthetic are fully blended, KC adds black lines to the ridges around Meagan's eyes.

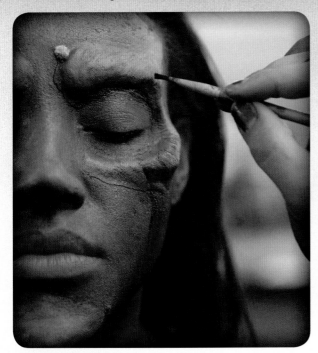
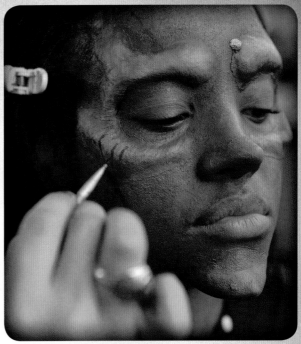

KC creates a mottled skin tone by spattering paint with her fingers to create a "voodoo" effect, which will mask and break up the hard edges of this prosthetic.

Since Meagan's costume will have a plunging neckline, KC makes sure that the skin tone color used on Meagan's face and prosthetic extends to cover all the exposed skin on her neck and chest.

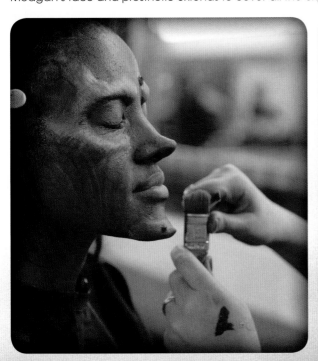
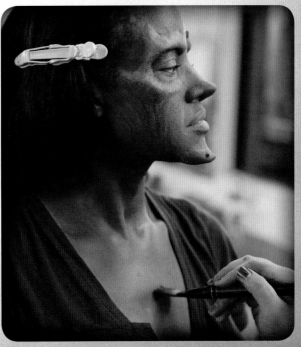

KC paints the lips a deep purple color. To give the lips a "bump," KC adds pink and turquoise cerulean lip colors.

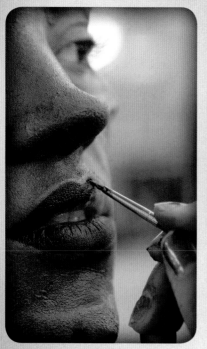 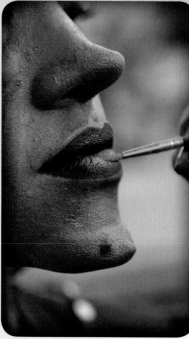 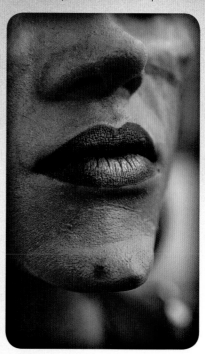

Then KC brushes on a purple mole and purple vein lines around Meagan's eyes.

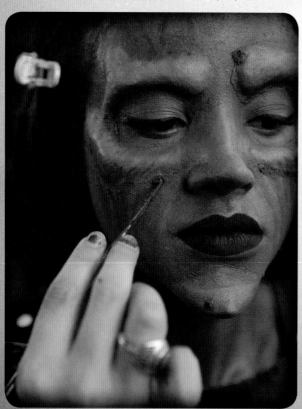 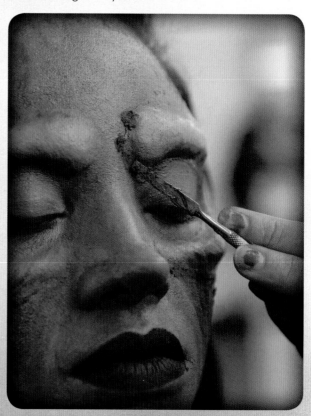

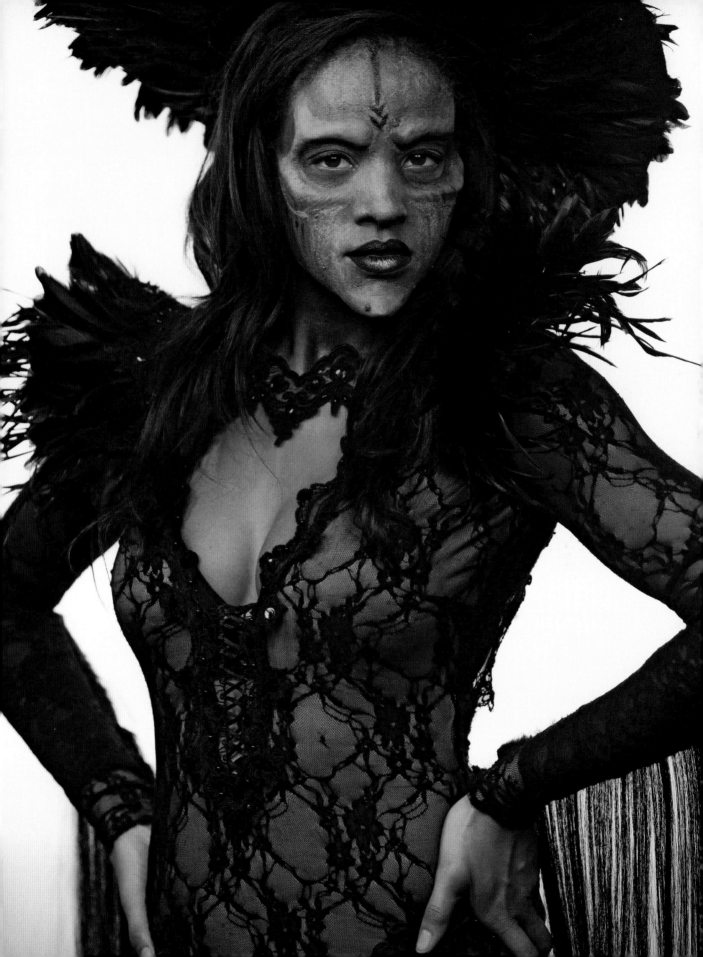

Workshop #4

BALD CAP
with Tony Carrillo

Tony Carrillo, a makeup artist at Mark Rappaport's Creature Effects, Inc., demonstrates how to apply and match flesh tone on a bald cap, turning model Vitor Nogueira from having a full head of hair to completely bald.

Tony uses a small amount of this soupy solution of Gafquat (it's very expensive, so a little goes a long way) and water to comb down Vitor's short hair. Tony stretches on a bald cap for a snug fit—the tighter the better.

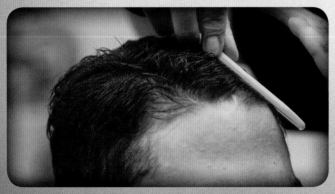

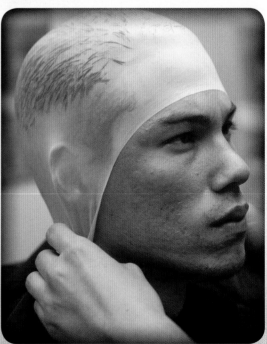

Next he glues down the bald cap with Telesis 5 glue and seals the edges with Bondo (an equal combination of Pros-Aide adhesive cream and Cabosil).

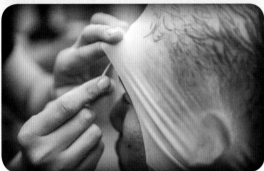

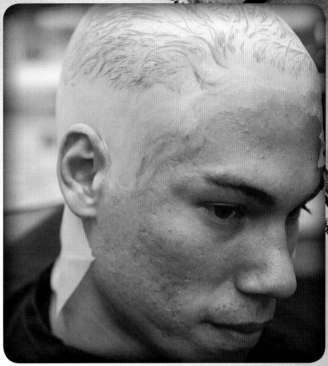

Tony sets the bald cap with translucent powder until it fits snugly all around.

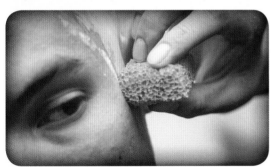

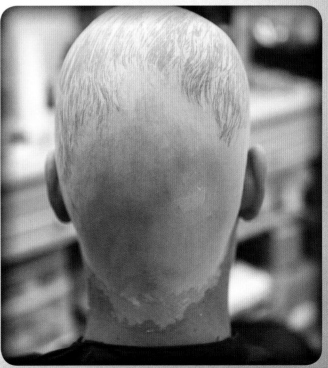

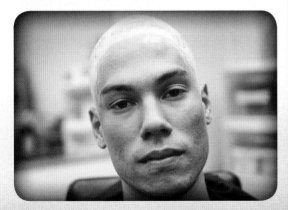

Now comes the challenge of coloring the bald cap to match skin tone. Tony mixes several shades of umber to achieve Vitor's Brazilian skin color. (Flesh color is not one simple color, but a combination of several shades. One flesh color alone would look flat and inauthentic.)

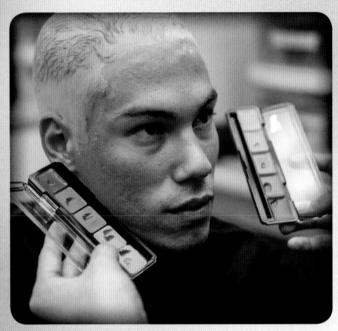

With a sponge wedge, Tony dabs, blends, and smooths the shades of flesh tones onto the bald cap. Tony prepares a mixture of 99 percent alcohol (isopropyl myristate) and alcohol-activated paints in complementary flesh-tone colors. Using a medium paintbrush and his finger, he spatters the paint onto the bald cap to add depth.

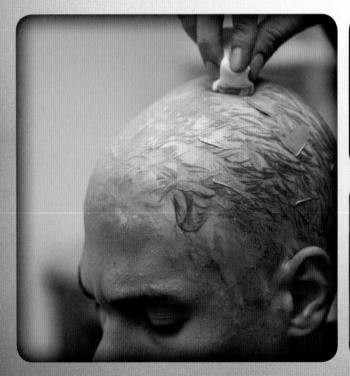

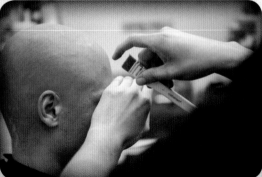

Once Tony's done, Vitor looks as though he's always been bald!

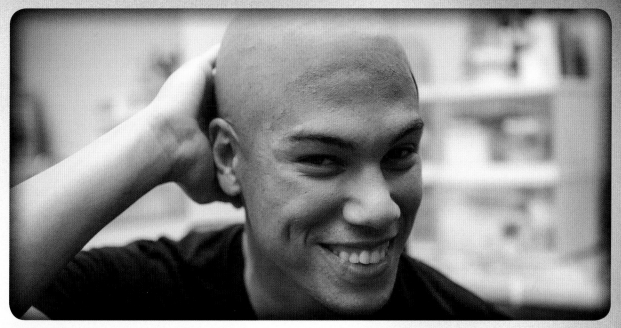

How do you remove a bald cap that looks like it's a second skin? With the end of a comb, Tony pokes a hole in the top of the bald cap and pulls through a tiny clump of hair. He then widens that hole, to split the bald cap apart. Thus, he returns Vitor to his natural state of full hair, albeit a little flatter than it was before.

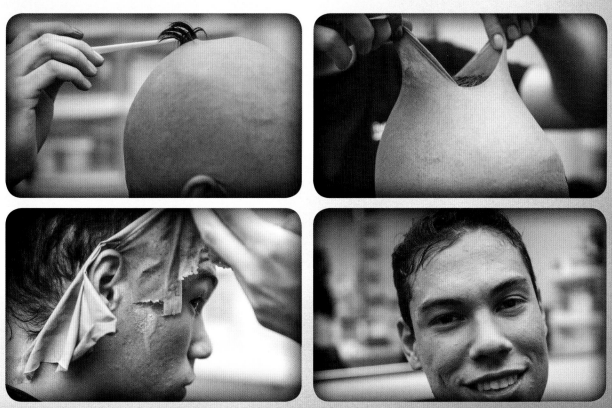

THE ULTIMATE BALD CAP
with Edward French and
Actress Kate Flannery of *The Office*

Edward French, an Oscar-nominated and Emmy-award-winning makeup artist (www.edfrenchmakeupfx.com), has worked on some of the most high-profile films and television programs, like *Terminator 2* and *3*, and *Valkyrie* with Tom Cruise. Ed was nominated for an Academy Award for *Star Trek VI* and in addition, has multiple Emmy nominations for his work on Grey's *Anatomy*, *Buffy the Vampire Slayer*, *MADtv*; and an Emmy win for his work on *House*.

Ed gave us a behind-the-scenes look at how he and Kim Ferry made Kate Flannery's lovely full head of hair disappear into a bald cap, in stages, for her part in the "Lice" episode of the television show *The Office*.

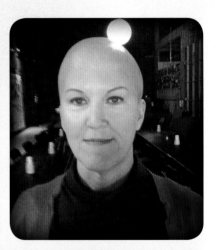

Gafquat (a gelatinized hair spray) is used to slicken Kate's hair. Ed's specially devised layer of polyester fiber is placed over Kate's hair to smooth out and prevent dents and stiff hair texture that could show through the bald cap and ruin the effect.

Ed recommends strengthening a bald cap, which is a hybrid of vinyl and plastic, before applying. (Turn the cap inside out and stipple with five coats of balloon rubber, and add powder to set.)

After the bald cap is glued down and blended into the skin, the next challenge is to match Kate's flesh tone perfectly, using a combination of PAX paints, tattoo-ink colors, over-the-counter makeup, rubber mask greasepaint, and translucent powder, to fool the unrelenting lens of an HD camera. And like magic, Kate looks authentically bald, with just a hint of stubble.

(See a detailed description of how to apply bald cap and match flesh tone on pages 50–53 of this chapter.)

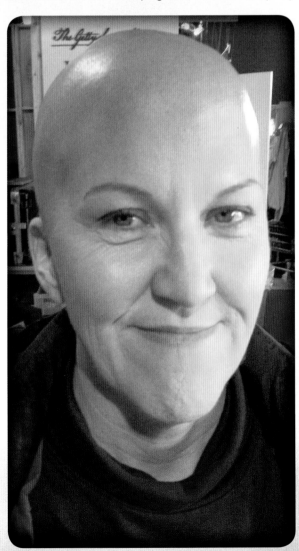

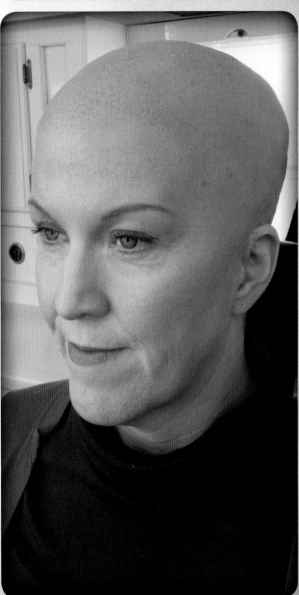

DO IT YOURSELF!
with Cleber de Oliveira

Cleber de Oliveira, a makeup artist from Brazil who is known for his unique color combinations, shows us how he turns model Gabriella Teixeira into a colorful Cirque du Soleil-like clown using a bald cap and just four paint colors. (Cleber went to circus school, worked in a circus, and did his own makeup, so he knows his clown makeup.)

HERE'S WHAT YOU NEED:

Medium-size plastic bald cap

Pros-Aide Cream Adhesive

Cotton swabs

Acetone (edger)

Bondo (mixture of Pros-Aide and Cabosil) aka Cabo-Patch*

Oil-based paints
(color palette: red, yellow, black, and orange)

Clown face design for reference

Gafquat and water

Sponges

Paintbrushes

White cream makeup

Powder puff

White talcum powder

NOTE: People with allergies and sensitive skin should check the ingredients before using.

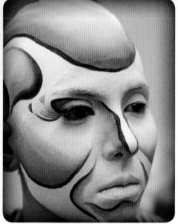

*This Bondo is not the industrial polyester resin product, also called "Bondo," which is used as an autobody repair filler. The adhesive blending paste listed above is the only type of Bondo that should be used on human skin.

Slick back (and braid, if necessary) hair with watered-down Gafquat (a soupy consistency). Fit the bald cap over the hair.

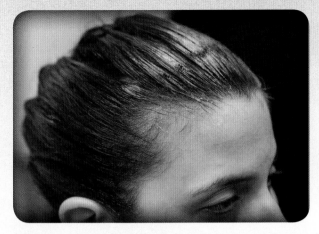 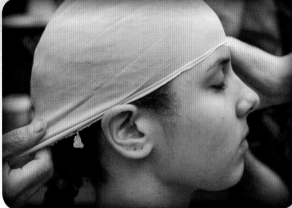

Glue down the bald cap with Pros-Aide on a cotton swab. Trim the bald cap around the ears.

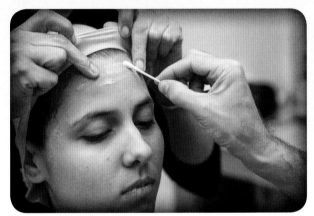 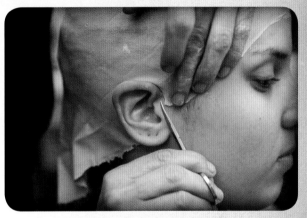

Seal the edges of the bald cap with Bondo. Use a powder puff and translucent powder to set the Bondo adhesive.

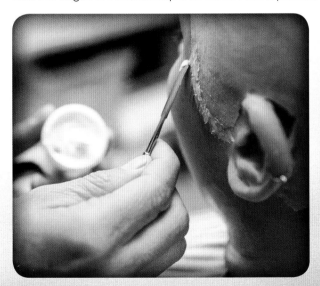 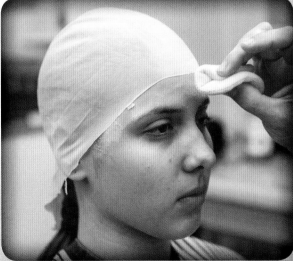

With a sponge, pat on the white cream base paint to cover the skin and the bald cap. Brush on the white paint to fill in the creases and missed spaces. Remember to cover the ears as well. Brush on the white talcum powder to smooth over the cream paint.

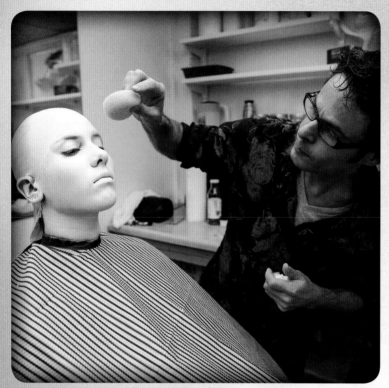

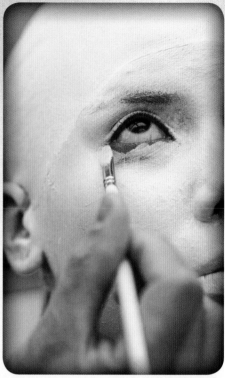

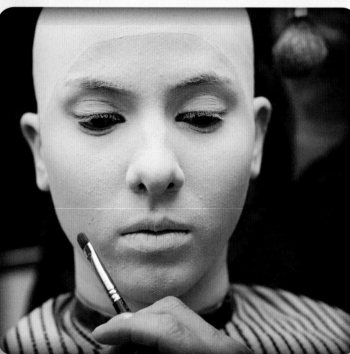

Mix two primary colors, red and yellow, to create bright orange. Paint red lines, yellow eyelids, and red- and yellow-shaded designs.

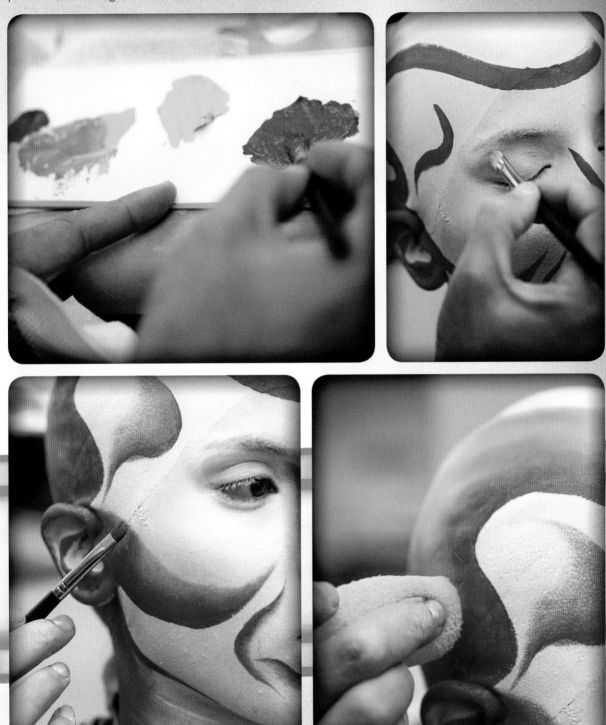

Brush on black inside ears and then add fake eyelashes.

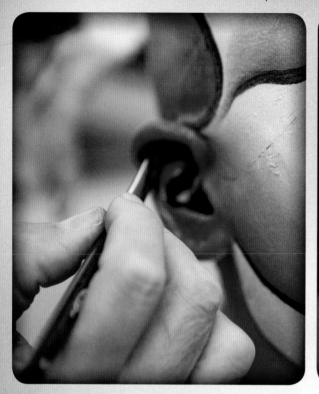 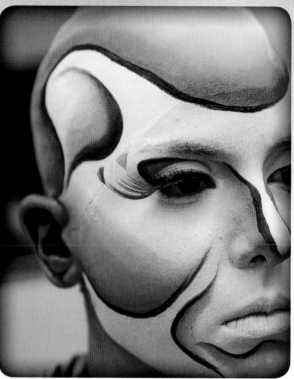

Use yellow and red on the lips. Add a blonde wig. Dab on red around the neck and chest.

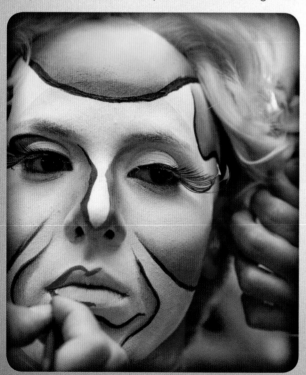 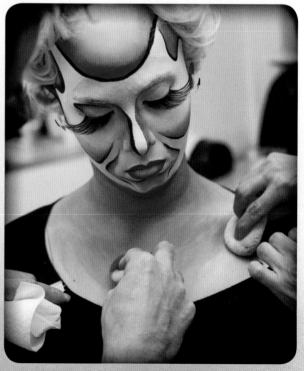

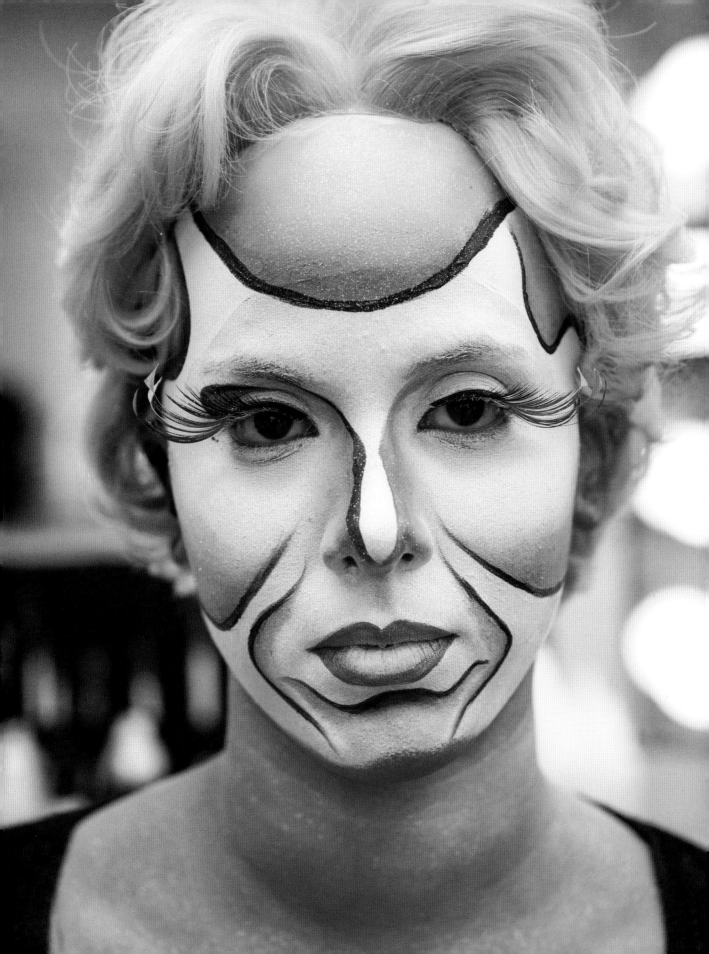

CHAPTER 3
BRUISES

"How much makeup does it take to make a bruise? Well, that depends upon how much battering the director wants. Black eyes, garden-variety cuts, and bruises can be accomplished with makeup alone. But if the bruise calls for someone beaten to a bloody pulp—with misshapen lumps, massive swelling, and serious wounds (think Rocky)— then that's a job for special-effects makeup artists."

—Diane Namm

LIFE CASTING
with Greg Solomon

Creating major bruising is a lengthy three-fold process that involves life casting, prosthetic construction, and prosthetic application.

Life casting is when the makeup artist takes a plaster mold of a live actor's head and face in order to create a negative mold and then a positive sculpture of the actor's features.

Life casting is not for the faint of heart. It's a claustrophobic experience, a lot like being locked in a hot, stuffy cabinet from the shoulders up. So next time you see a movie with special makeup effects, pity the poor actor who donned that makeup every day!

Special-effects makeup artist Greg Solomon demonstrates how to construct a life cast that will be used as the base sculpture to generate facial-bruise prosthetics.

Greg prepares actor Vitor Nogueira by covering his body with a large plastic smock or a split dry-cleaning plastic bag. He then tapes the plastic to the actor just below the shoulders, leaving the neck and shoulders bare. He then sizes the actor's head for a bald cap. (Medium is usually the right size, unless the actor has an unusually small or large head.) Greg glues down the bald cap at an anchor point on the forehead, removing excess material around the ears with a small safety scissors and then melting the bald cap into the skin with an edger liquid made of acetone.

 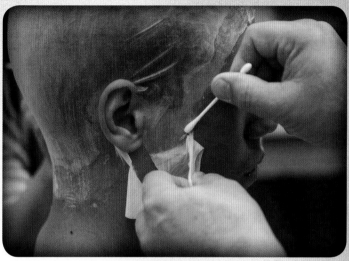

Greg coats the cap with a heavy-duty thick and creamy hair conditioner, so that when the life cast is dry it will release easily from the bald cap. He also uses the conditioner and a cotton swab to coat the actor's eyebrows, eyelashes, and any facial hair or stubble. No one wants the plaster to stick to any hairs, since removal will be that much more complicated and painful if it does.

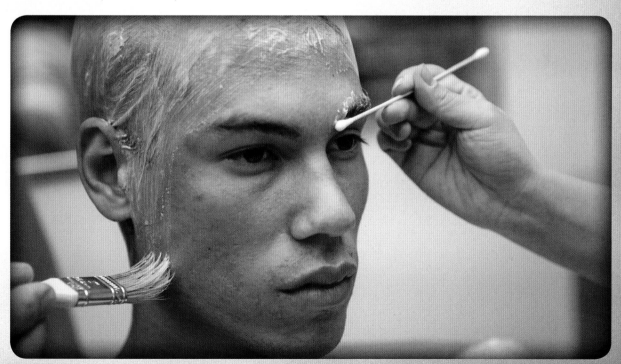

After Greg coats the actor's face with the conditioner, he mixes up the first batch of plaster, which is a dental molding plaster that's safe for use on skin. Greg uses this bubblegum-pink substance to fill in the spaces behind the actor's ears. This type of plaster dries really quickly, so Greg has to move fast! When the pink dental plaster turns white, it means it's dry. Greg then coats the dental plaster with petroleum jelly so it will be able to release the next coat of molding plaster that will create the life cast.

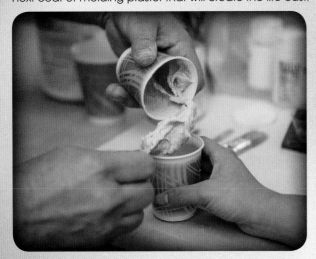

To cover the actor with the molding plaster, Greg must work very quickly again, since the medical grade plaster will dry fast—within five to seven minutes. Usually, Greg has three or four people assisting him in this process, but we had only two assistants: Yoshimi Tanaka and Samantha Solomon, Greg's wife.

First, Greg applies a handful of the plaster to the actor's nose area. He has the actor blow out through his nose to create air holes so he can breathe throughout the rest of the process. Then Greg tells the actor to close his eyes (99 percent of all life casts are done with eyes closed), and it's on your mark . . . get set . . . go! Greg starts at the top of the head and works down to the face, neck and shoulders, quickly spreading handfuls of the goopy plaster in thick layers around the entire head.

The actor must resist the urge to move beneath the hands that are covering his head with this thick, gloppy, wet mess.

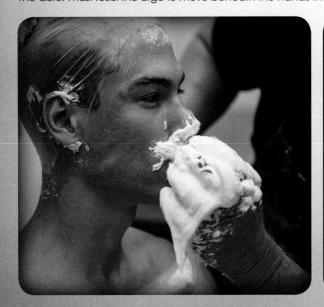 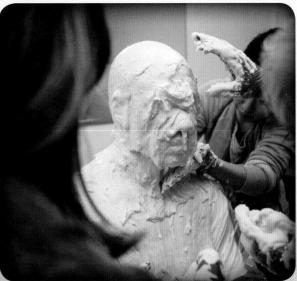

And the actor must remain still until the plaster sets, which takes about ten minutes. This type of molding plaster remains flexible, even when set, which is why the next step is so essential. Greg must now cover the flexible plaster with the type of plaster bandage that doctors use to create casts for broken bones. Again, he has to work fast, as this type of plaster bandage also dries very quickly. First he layers the bandage strips over the front half of the actor's head, being careful to keep the air holes free.

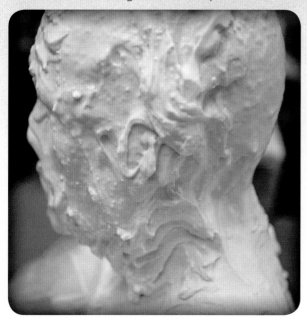
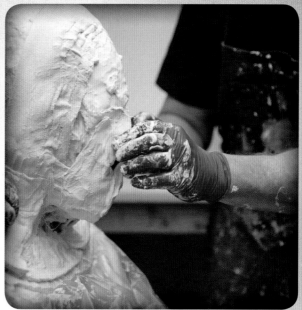

It gets very warm beneath the plaster, and it feels a lot like being stuck underwater. So, for the actor's comfort, Greg wants the process to go smoothly and quickly. After the front half of the actor's head has been covered with plaster bandages, Greg waits a few minutes for it to set. Then he brushes petroleum jelly all around the edges of the front half of the plaster cast so he can pop off the back half after it sets.

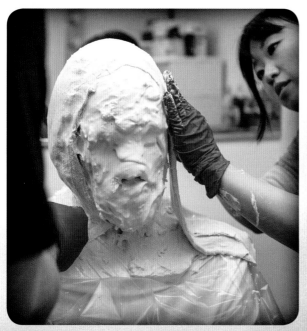
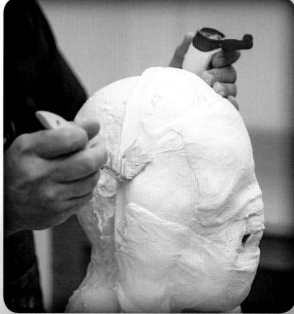

Once the plaster dries on the back half of the actor's head, Greg draws a center line with a marker all around the edge where it meets the back half. Then he draws short horizontal lines so that the two halves can be matched up again once they've been separated. Greg then pries off the back half of the hard-shell plaster cast. So far, so good.

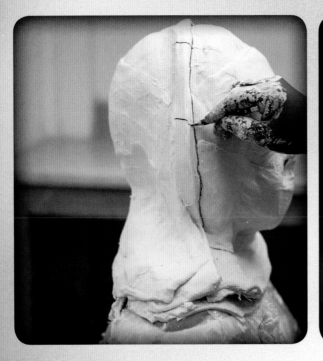
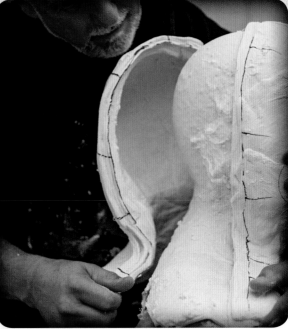

Now for the moment of truth. . . . Has the life cast process worked? Greg asks the actor to bend forward at the waist and scrunch up his face to break the surface tension of the inner flexible plastic mold.

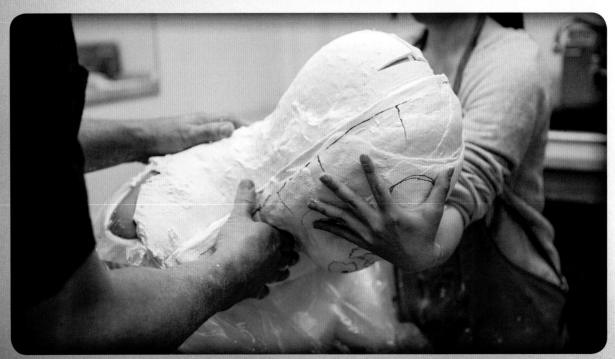

Greg slices the inner flexible mold so that the actor can slowly work his face out of the mold. *Aaah.* The actor's part in the life cast process is done. The actor won't be needed again until it's time to apply the prosthetic and bruising.

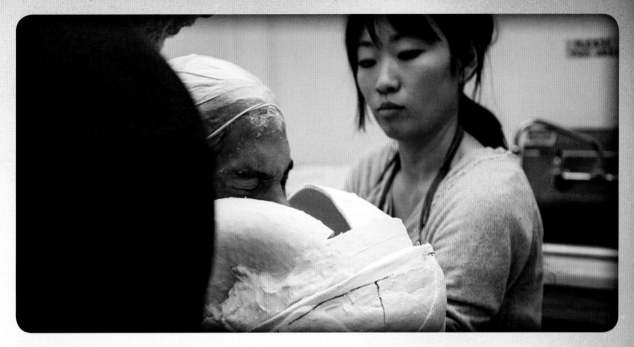

Greg asks Yoshimi to glue the two halves of the hard shell together and to plug up the nose holes and any possible leaks in the cast. After that, Greg places the hard-shell cast upside down, anchored securely, and pours the sculpture material into the head.

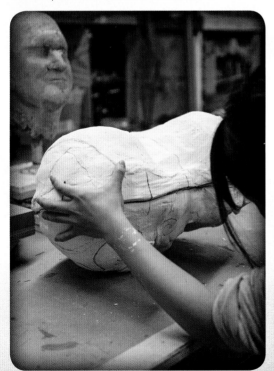

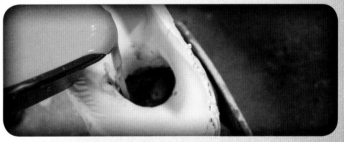

It will set for six to eight hours before it hardens completely. The life cast is almost done.

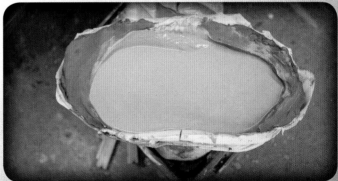

Once the sculpture material is set, the cast is once again pried open to reveal the inner plaster mold, and the cement life-cast sculpture beneath it.

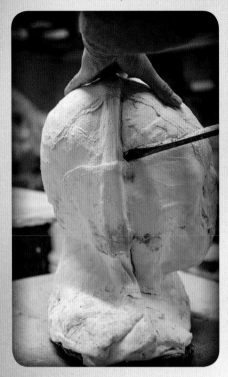 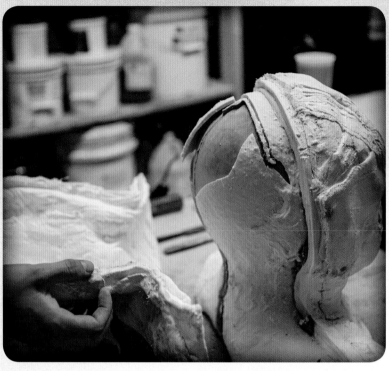

The life-cast sculpture, once fully released from the plaster, still needs some work! A little smoothing here, a little chipping there, and . . .

 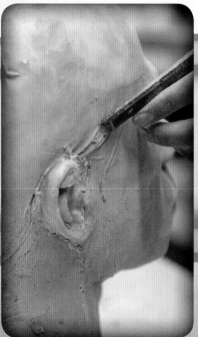 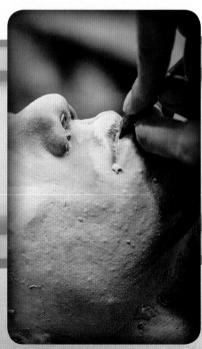

... the life cast is now complete.

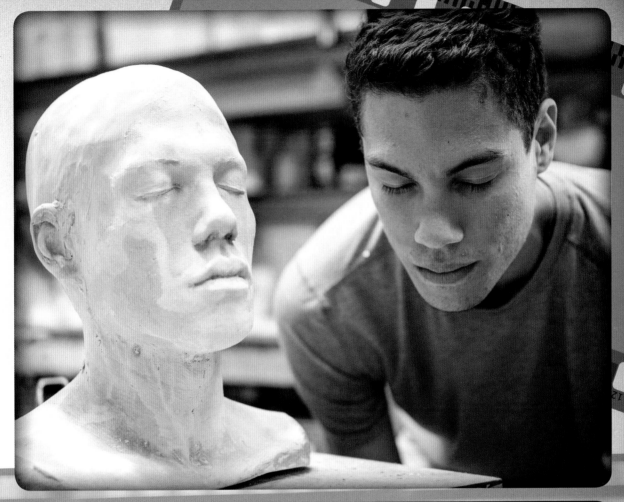

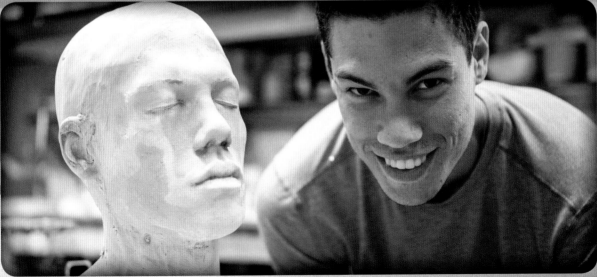

CASTING SILICONE PROSTHETICS
with Vincent Van Dyke

Vince has worked on feature films such as *Star Trek*, *Valkyrie*, *Tropic Thunder*, *Day of the Dead*, *The Fast and the Furious: Tokyo Drift*, and *Mission Impossible III*, His TV credits include *Scandal*, *Grey's Anatomy*, *Private Practice*, *Nip/Tuck*, *Modern Family*, *Medium*, and more.

From the time he was three years old, Vince knew he wanted to work in special effects. His first special-effects effort was to create a *Hunchback of Notre Dame* face out of Silly Putty on his own face! Vincent's favorite effect is aging, generating a look that's so lifelike it can pass for real on or off set. (See examples of Vince's aging makeup effects on page 75. Can you guess who that is behind the old-man makeup? Hint: *Portrait of the Artist as a Young Man*.)

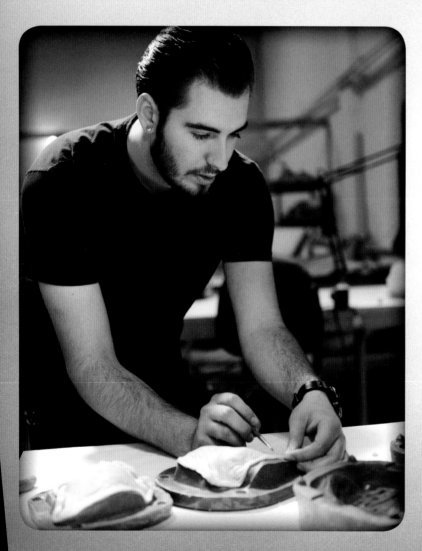

> "I've been creating special effects of one type or another since I was five years old. It's all I've ever wanted to do, and I've never given any thought to anything else."
>
> —Vincent Van Dyke

Vince creates negative and positive sturdy molds from the different parts of the sculpture's face: cheeks, mouth, nose, chin, and ears.

 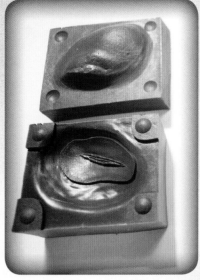 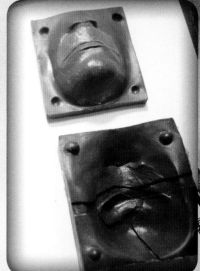

Since silicone is translucent, Vince adds silicone pigment to the brew. He adds a few drops of flesh tone and a few red-colored fiber strands (known as flocking) and stirs vigorously.

Then he draws a blue-marker "vein" line on a stirring stick to see if the fleshy-colored mixture looks like skin over a vein. If it does, then Vince knows the mixture is ready to pour into the mold.

 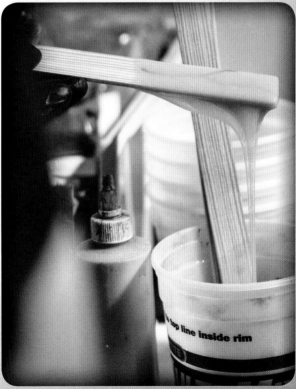

Once the mixture is ready, Vince does a "high-pour," to prevent air bubbles, into the prewaxed negative and positive facial-part molds.

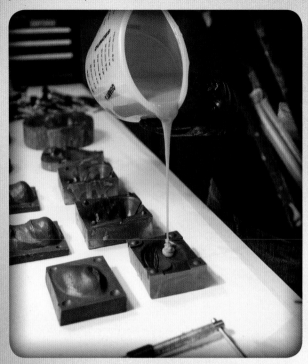
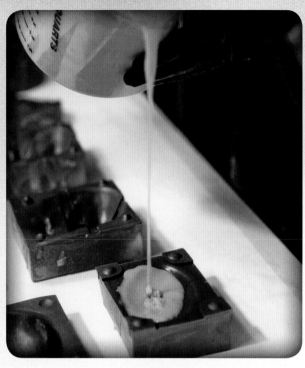

Once the molds are filled, Vince clamps them tightly together and lets them cure, or set, for about an hour.

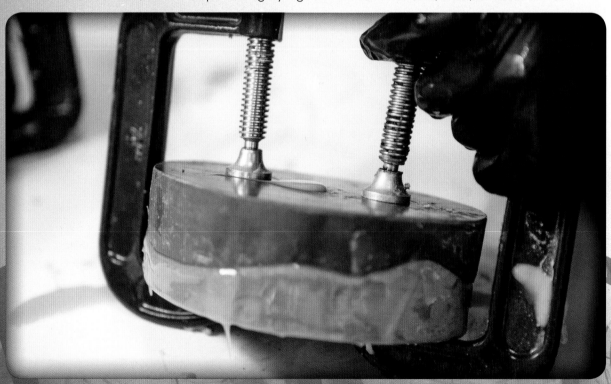

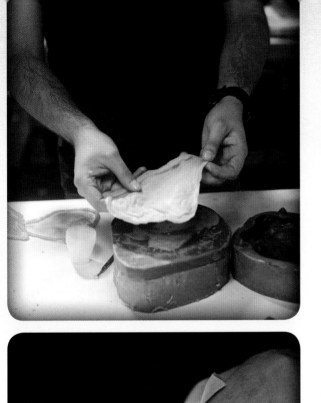

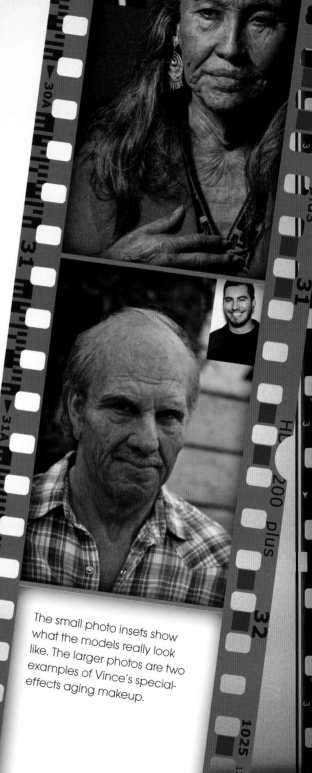

The small photo insets show what the models really look like. The larger photos are two examples of Vince's special-effects aging makeup.

APPLYING SILICONE PROSTHETICS
with Glen Griffin

Glen has worked on feature films such as *Men in Black*, *The Ring*, *The Cabin in the Woods*, *Planet of the Apes*, *How the Grinch Stole Christmas*, *Dante's Peak*, and more. Glen has had to improvise more than once on any given set. Sometimes, due to budgetary and scheduling constraints, the prosthetic that arrives for the makeup artist to apply isn't customized to the actor in the chair. Lots of prosthetic labs reuse molds and actually have a library of molds, which they use for multiple projects. That's when the artist has to, literally, take matters into his or her own hands and massage the appliance onto the actor's face to fulfill the director's vision for the character. Luckily, silicone prosthetics are a thing of beauty and flexibility. Here's how Glen took a prosthetic bruise (made from the cheek of a male actor) and made it work on our petite young model Jamie Frazer.

"I enjoy every stage of special-effects makeup— from the conceptual work of designing a character to life casting, molding and applying prosthetics, and painting. There's an art to it all, and each step is as important as the other."

—Glen Griffin

Glen removes the "flashing" (excess silicone) from the top of the cheek appliance so that he can place the prosthetic close to the actor's eye line under her eye. He makes sure that the prosthetic is flush with the skin to avoid air or sweat bubbles that will make the prosthetic bubble or buckle and ruin the effect.

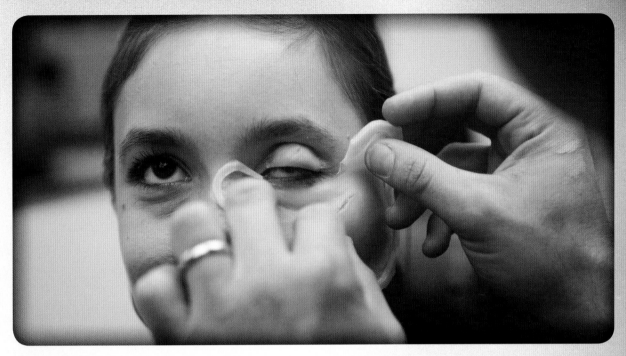

When pieces aren't customized beforehand to fit the actor, the makeup artist has to gently stretch and position the silicone to work with the actor's face.

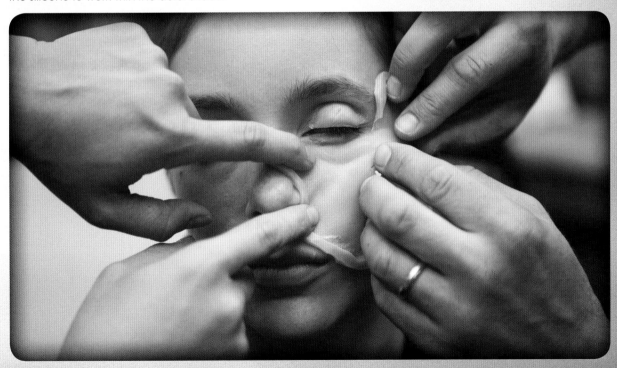

When Glen is satisfied with the appliance's fit to the actor's face, he presses the appliance against the skin, being careful to lay it flat to prevent bubbling. He glues it down on the skin, melting the edges into the skin with edger (acetone). To make sure that the appliance is glued down properly and completely, Glen asks the actor to scrunch his or her face in several different expressions, as Jamie does here.

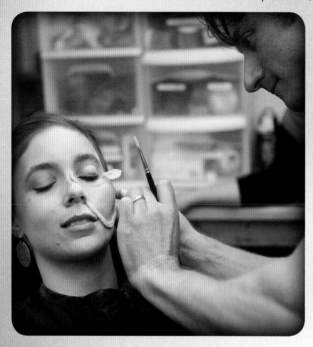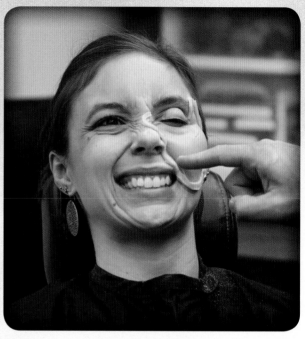

Once the appliance is glued down, Glen's next challenge is to match the flesh tone of the actor to the appliance. He'll create a palette using a mixture of ruddy-red color, with other colors (e.g., green, blue, and yellow) to get the skin color just right. Glen paints a ruddy-red line cut onto the appliance to create the actor's "character," and with a sputtering airbrush spray, he creates a mottled, bruised effect.

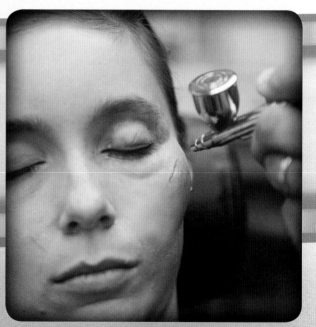

To indicate a broken nose or general trauma to the face, Glen adds a bluish-black to the palette and darkens beneath both eyes and around the nose, mouth, and brow, as well on the appliance.

Since this character's description calls for an older bruise, Glen uses darker colors like purple, dark yellow, and blue.

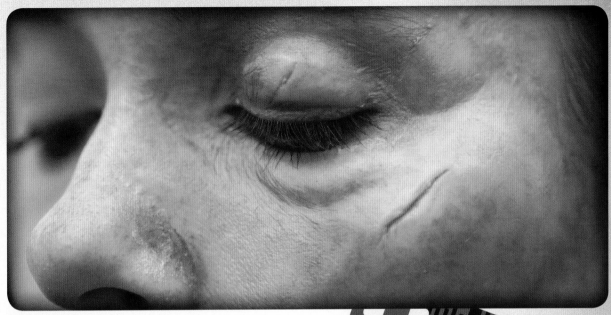

The actor is now in "bruised and battered" character.

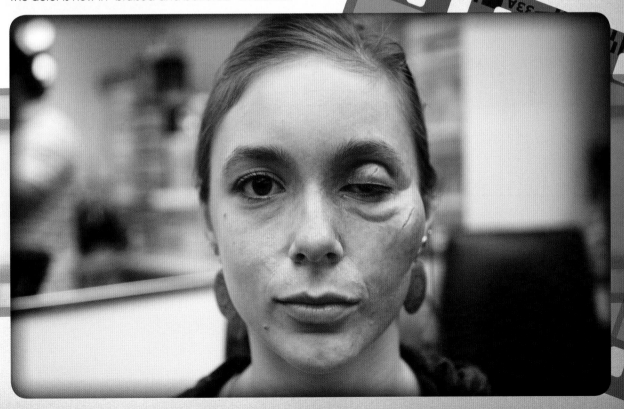

DO IT YOURSELF!

with Bruna Nogueira

If you are feeling creative, here's what you can use to create your own bruise.

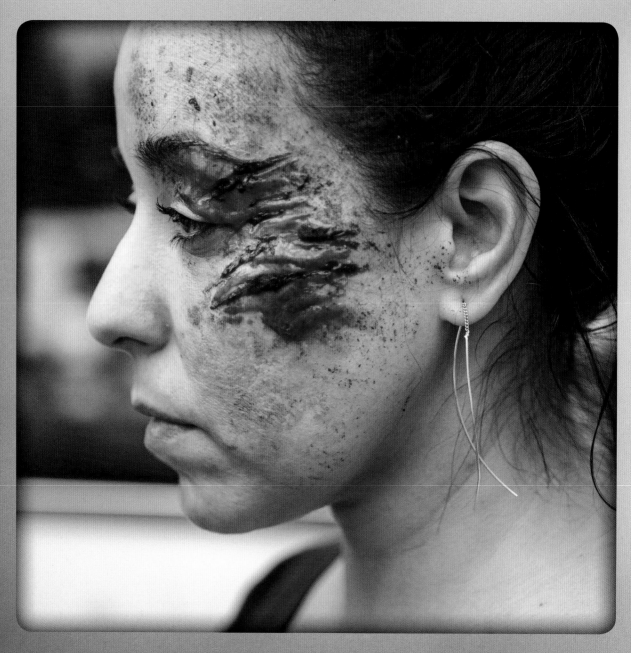

Here's What You Need:

Ready-made bloody-wound tattoos (available at Nigel's in Hollywood or other professional makeup supply houses) that can be applied directly to clean skin

Here's what you can use when the budget is super low and the schedule is super tight:

Blue molder sheet (sometimes found in something called a "Hurt Box")

Pros-Aide cream

Water

Small plastic cups

Red, yellow, blue, green flocking (coloring for Pros-Aide)

Wooden tongue depressor

99 percent alcohol in a spray bottle

Paper towel

Flat metal spatula

Trimmed fine paintbrush

Alcohol-activated makeup

Disposable palette paper

Plastic wrap

Glass square or aluminum foil

Ready-made prosthetic

Pros-Aide glue

Makeup wedge sponge or cloth

Fresh blood makeup

Fresh scar makeup

K-Y lubricant jelly (optional)

A and B jars of alcohol-activated silicone gels

Warm water

Gentle facial cleanser

NOTE: People with allergies and sensitive skin should check the ingredients before using.

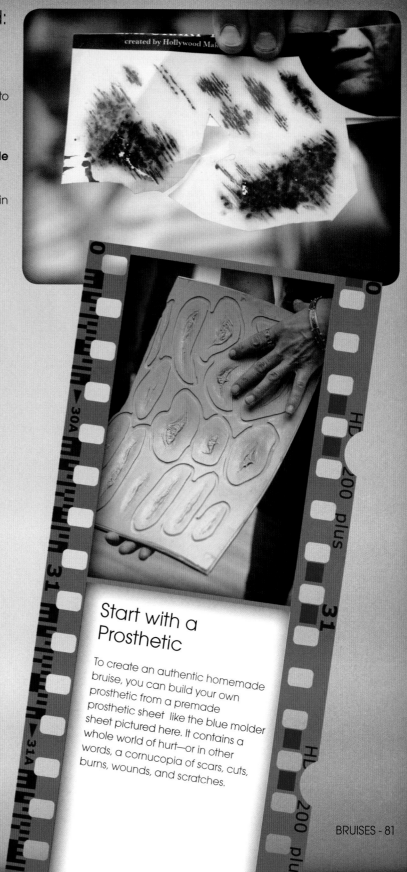

Start with a Prosthetic

To create an authentic homemade bruise, you can build your own prosthetic from a premade prosthetic sheet like the blue molder sheet pictured here. It contains a whole world of hurt—or in other words, a cornucopia of scars, cuts, burns, wounds, and scratches.

First select a bruise from the blue molder sheet. Then mix Pros-Aide cream and a tiny amount of water in a small plastic cup until the cream is the consistency of thick Greek yogurt. Add a sprinkle of red- and yellow-colored flocking, to match a skin tone of your choice, and stir in the flocking with a wooden tongue depressor. Add color as desired to get the flesh-tone effect you want.

Ladle the cream into the wound of your choice so that it fills the mold. Smooth it down with a flat metal spatula. Then cover the filled-in mold with a sheet of plastic wrap.

Leaving the plastic wrap in place, freeze the mold mixture for one to one-and-a-half days. Or, if you have a protected shady place outside, you can leave it outside to air dry for one-and-a-half days.

Once the appliance is dry, gently peel it up with the plastic wrap intact. Place the appliance directly onto a sheet of acetone-sided paper, plastic wrap-side up.

Flatten the plastic wrap so that the appliance adheres to the one-sided acetone paper.

Then, carefully peel away the plastic wrap, and the bullet-hole wound, made from the blue molder sheet, is ready to use.

Before applying the prosthetic to the skin, clean the area with a cotton pad sprayed with 99 percent alcohol. Brush Pros-Aide glue onto the appliance.

Place the prosthetic wound onto the skin, acetone paper-side up. Using a paper towel thoroughly dampened with 99 percent alcohol, press down on the acetone paper to transfer the bullet wound to the skin.

Melt the edges of the bruise into the skin with a fine paintbrush dipped in 99 percent alcohol.

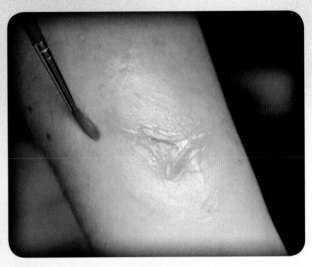

To make the wounds bloody and authentic, add red and purple alcohol-activated paints inside and around the wounds.

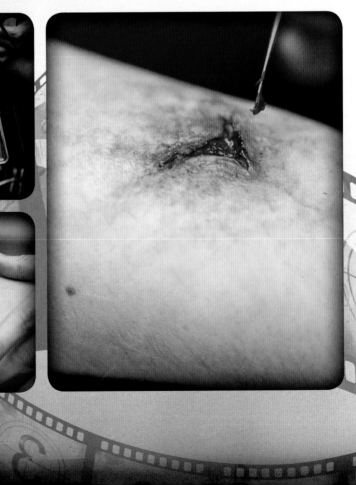
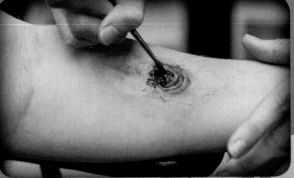

Add blues and yellows to create more bruising, or drip lines of blood to create a bloody gash, and now you have some serious-looking wounds.

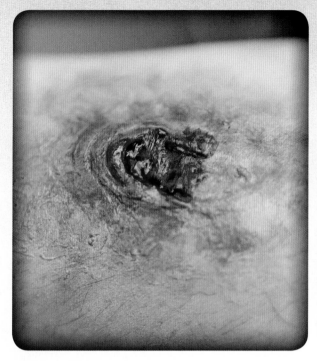 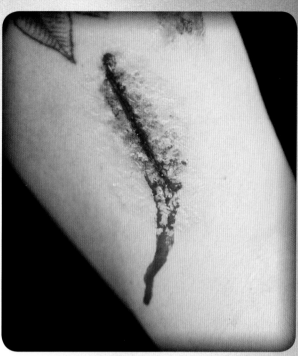

It's also possible to purchase ready-made prosthetics, in which you simply remove the prosthetic from its mold, brush with Pros-Aide glue, and apply to clean skin. These ready-made appliances are fairly expensive, so if you have the time and the energy, it might be worth your while to make your own.

You can create a nonprosthetic bruise by making your own bruise transfer tattoo.

On disposable palette paper, using a trimmed-down paintbrush, dot on alcohol-activated makeup. For a fresh bruise, red, purple, orange, and yellow work best. This creates a homemade transfer tattoo.

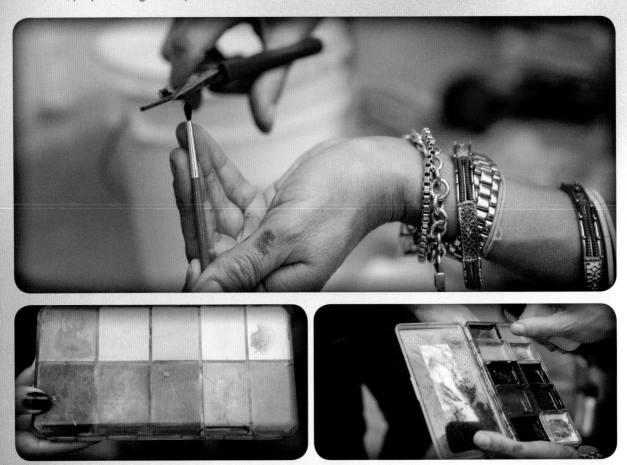

Place the transfer bruise-tattoo onto the clean skin, where desired. This method works on any part of the body, as shown on model Tina Sherer's arm and face.

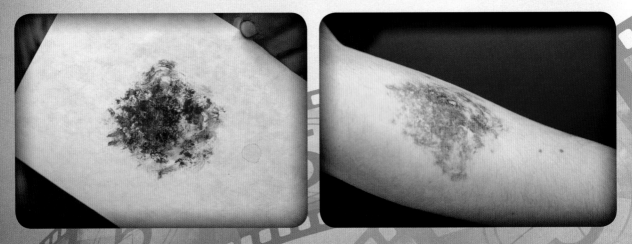

To make the bruise bloodier and fresher looking, you can dab on some generic "fresh blood" makeup with a fine paintbrush.

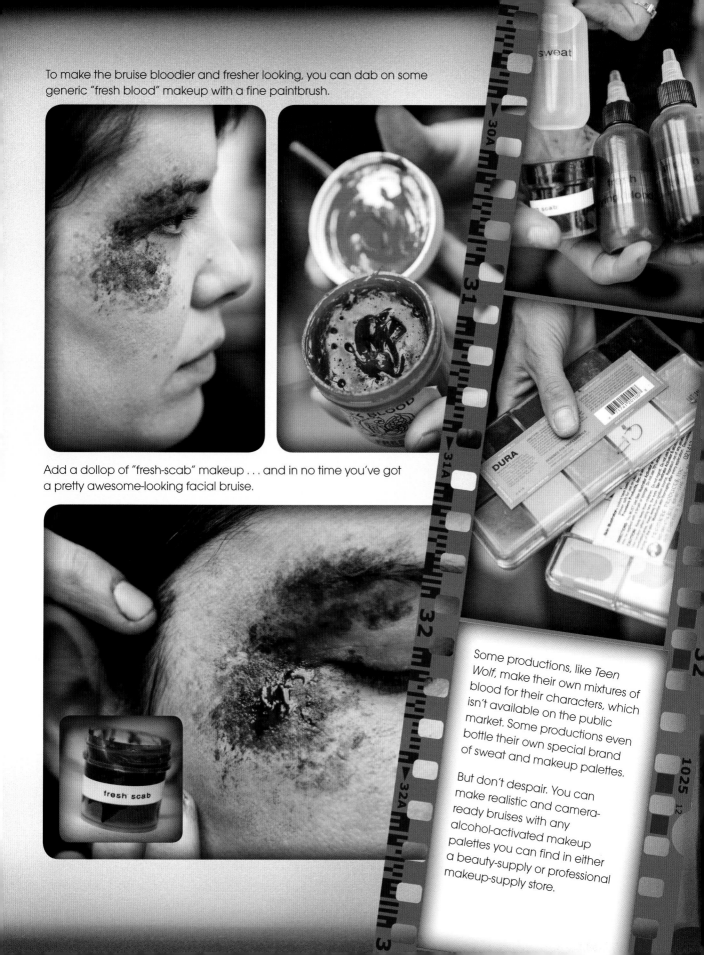

Add a dollop of "fresh-scab" makeup . . . and in no time you've got a pretty awesome-looking facial bruise.

Some productions, like *Teen Wolf*, make their own mixtures of blood for their characters, which isn't available on the public market. Some productions even bottle their own special brand of sweat and makeup palettes.

But don't despair. You can make realistic and camera-ready bruises with any alcohol-activated makeup palettes you can find in either a beauty-supply or professional makeup-supply store.

To add a nose bleed: Use a thin, flat, metal spatula dipped in "fresh-blood" makeup. Apply from within the nostril, painting/dripping it down toward the mouth. For a cut lip, add the "fresh-blood" makeup to the mouth, where desired. For a truly gruesome look, squeeze some "mouth-blood" makeup into the lower part of the mouth, between the teeth and the lower lip. (Mouth blood is a specially designed, edible makeup that tastes like a sweet syrup.)

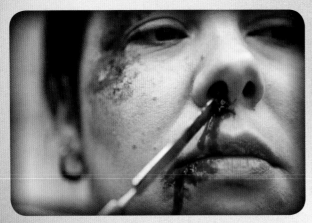 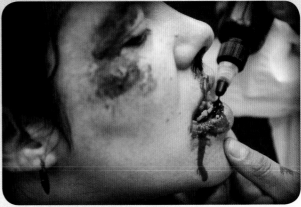

Have the subject swirl it around in her mouth, mixing the mouth blood with her saliva, and you've got a seriously gory-looking character.

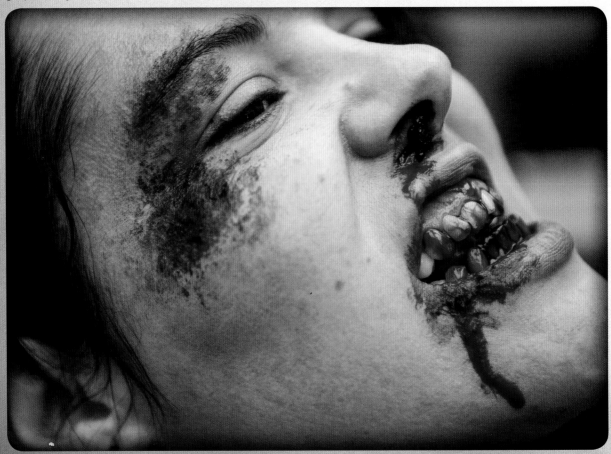

Here's a quick and easy way to create animal (werewolf) scratches. Using alcohol-activated paints and a prickly sponge, swipe the skin to create claw marks.

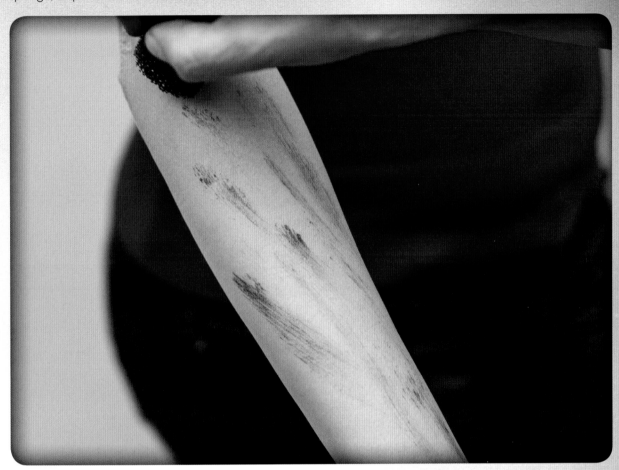

Brush on brown, burgundy, and red lipsticks, to deepen the color of the scratches.

Dab on tiny droplets of blood-red color paint, and these bloody animal scratches are good to go!

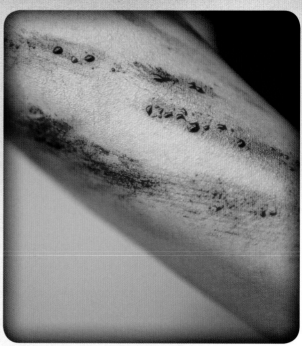

There's one more way to create a nasty homemade bruise. Use the same "transfer-bruise-tattoo" that we made on pages 86–87, and apply it to the side of the face.

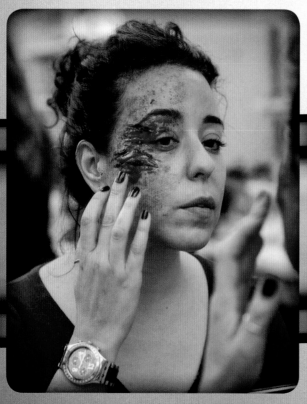

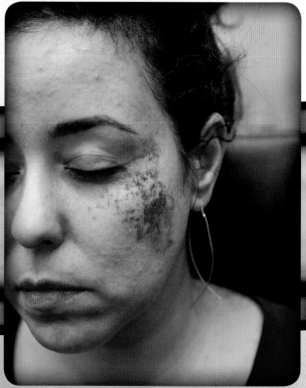

On aluminum foil or glass, place a dollop of equal parts of A and B silicone gel. Be careful to keep the lid to each jar with its jar, so as not to ruin the remaining silicone gel, since once this material cures, it can't be reused.

You have to work quickly before it dries. Mix the two gels with a flat metal spatula or wood tongue depressor. Then mix in "blood" colors to make a fleshy-looking goop.

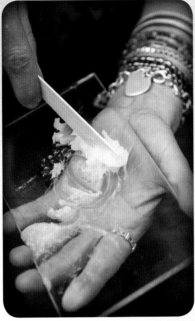
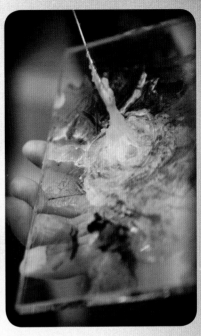

With that same tool, apply as much or as little of the bloody, goopy mixture to the "bruised" area as desired. On top of the gel, add "fresh blood" and "fresh-scab blood" to your taste.

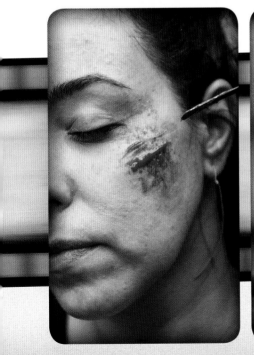
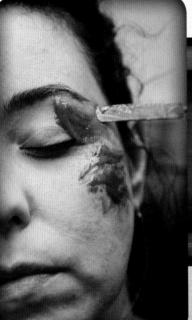
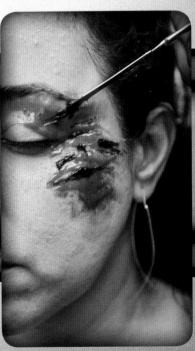

Apply the bruise transfer tattoo in several places above and below the freshly painted bruise.

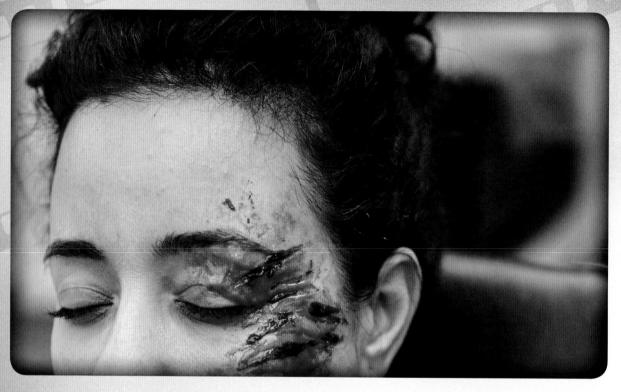

Use a cosmetic cloth or bristle sponge to mottle the appearance, and now you've got one nasty-looking bruise.

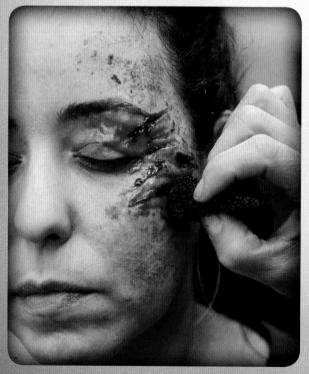
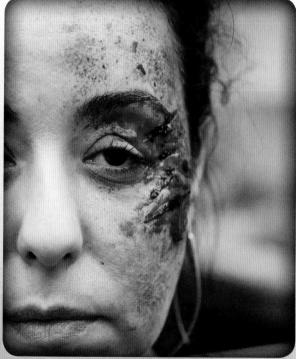

The bruise can be made to look even juicier and fresher with something as easy to find as K-Y Jelly.

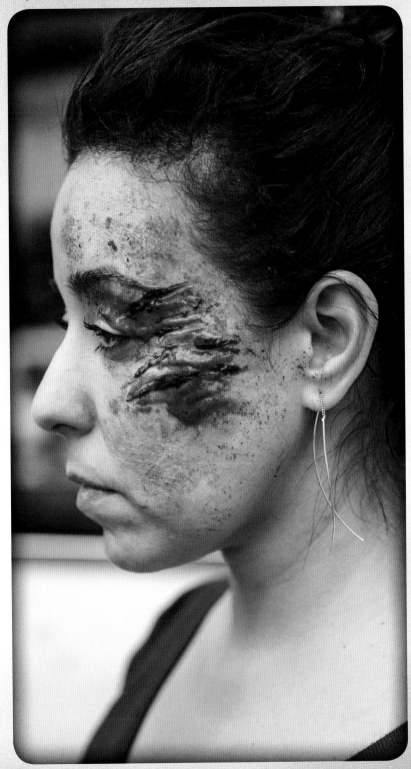

All the homemade appliances are easily removed, with care. And the alcohol-activated makeup comes off with warm water and any gentle facial cleanser.

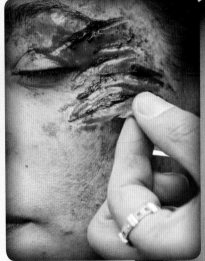

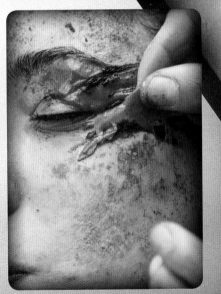

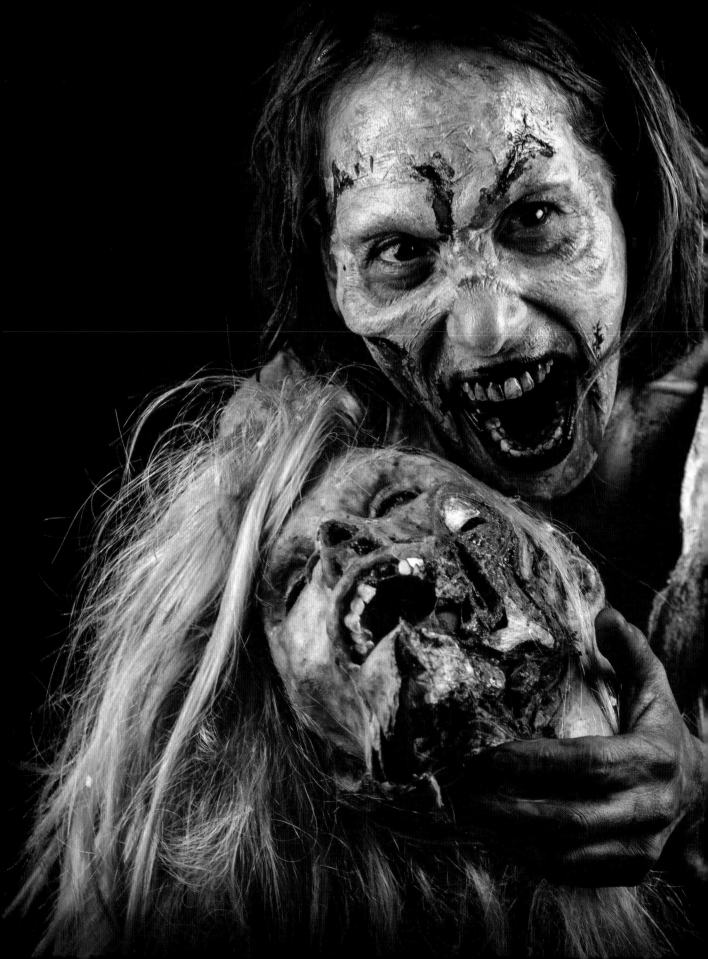

CHAPTER 4
BURNS AND ZOMBIES

*"In Haitian folklore, a zombie is an animated
corpse raised by magical means. I prefer
to use makeup . . . and nothing makes
me happier than creating a zombie-like
character out of a beautiful young woman
who looks nothing like one."*

—Robert "Kato" DeStefan

Workshop #10

BURNS
with Chris Escobosa

Burns are definitely something we'd all like to avoid in our real lives. In the world of film and television, however, creating authentic burns (first- , second- , and third-degree) is a skill that's in high demand.

Chris Escobosa demonstrates how it's done for shows like *CSI: NY* and *Criminal Minds*. Chris did his first base makeup application when he was eight years old on his makeup artist dad's client, actress Della Reese. Chris has worked on every aspect of special-effects makeup, from photo shoots for international editions of *Vogue* and *Harper's Bazaar*, to doing the makeup and wigs for Disneyland shows, parades, and rides. Chris made his way into the business as a wigmaker and then segued into the makeup departments on shows like *Seinfeld*, the original *Beverly Hills 90210*, and *Silk Stalkings*, and he's gotten the chance to work with some wonderful performers, such as Usher, Vanessa Milano, Mario Lopez, Danica Patrick, and Tori Spelling.

"Every day and every show is a new day, with new challenges and new character makeups to do."

—Chris Escobosa

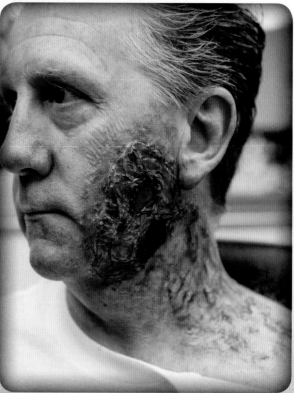

First, Chris shaves our model Tab Haas-Winkelman's arm to prevent his hairs from adhering to the makeup. Then he cleans the skin with 99 percent alcohol and spreads a thin layer of Pros-Aide that will help the silicone molding compound, used to create the burn, adhere to the skin.

Chris uses the Skin Illustrator "Necromania" palette (alcohol-activated paints) and ordinary plastic wrap to create first-, second-, and third-degree burns.

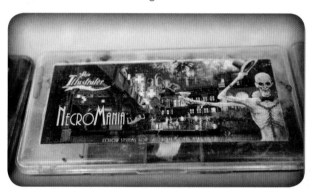

Chris mixes up a small batch of 3rd Degree A and B silicone modeling compound. He applies it to create a slightly raised slimy layer, blends the edges so they melt into the skin, and then blows it dry.

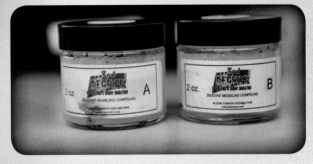

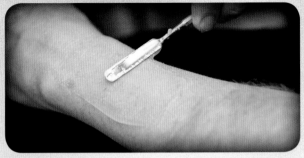

When the silicone is dry, Chris brushes on alcohol-activated red paint for a reddish-sunburn look.

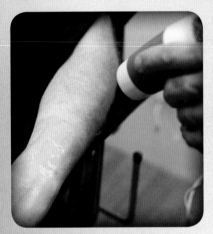

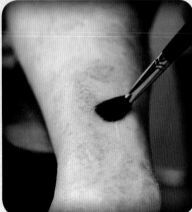

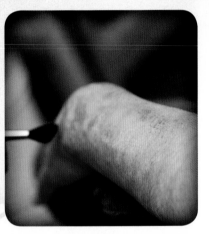

Then he adds every makeup artist's best friend, K-Y Jelly, to make the burn look watery and painful.

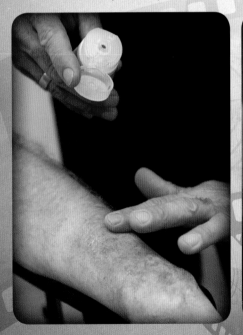

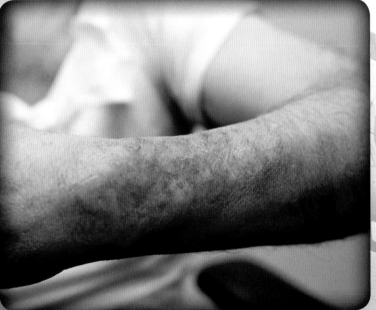

For a second-degree burn, Chris applies the silicone modeling compound to the model's neck. With the metal spatula, Chris lifts up the compound, then lets it fall back down naturally, to form the appearance of small blisters and pockets of pus.

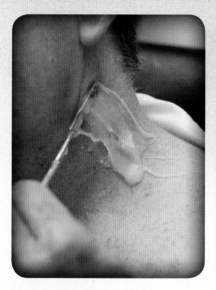 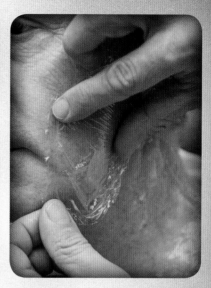

For a third-degree facial burn, Chris presses a piece of ordinary kitchen plastic wrap against the side of the model's face, leaving little pockets of air. He blends in the edges of the plastic wrap with the silicone compound.

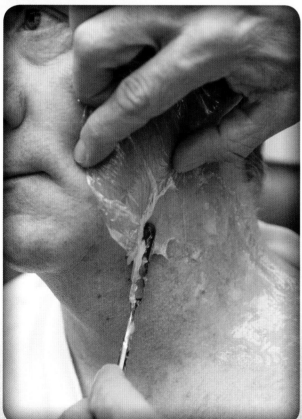 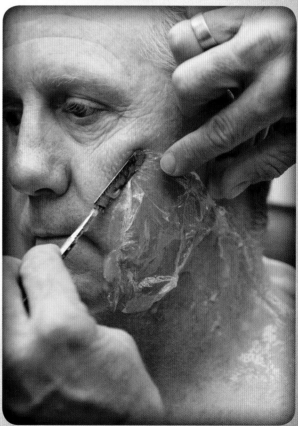

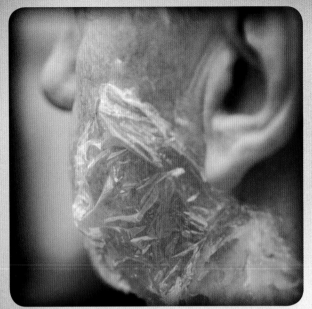

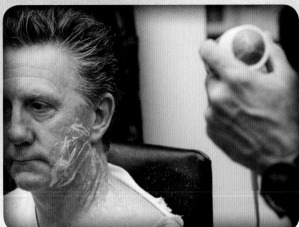

He applies latex to the plastic wrap (which will give the plastic a yellow-ish cast when it dries), blows it dry, stipples the plastic, and snips it to make it look like ragged, melted skin.

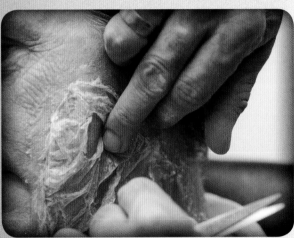

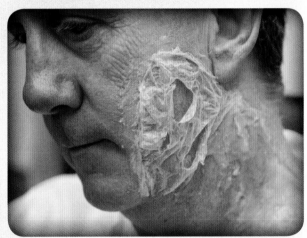

For bloody sores, Chris uses red alcohol-based paint.

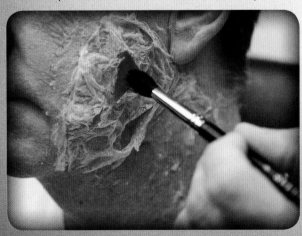

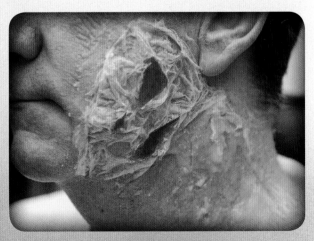

To create a diseased and charred effect, Chris uses purple, green, and black tones from the Skin Illustrator Necromania palette.

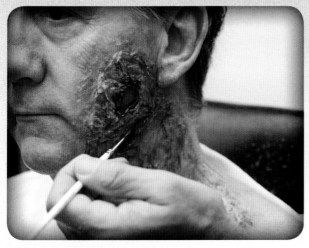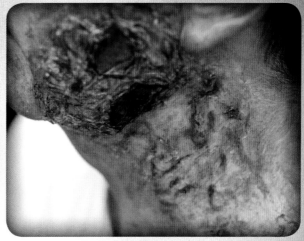

Chris adds bloody lines of color to the second-degree burn. He brushes K-Y Jelly into the open wound holes to give them an "oozy" down-to-the-bone look, to contrast against the dried-out charred skin.

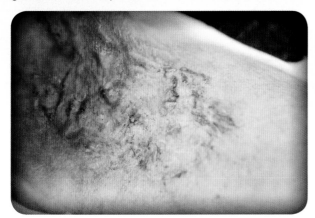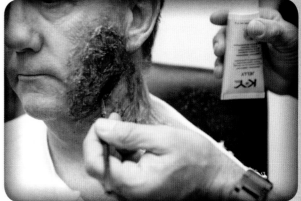

When the "burns" are removed, they actually look like pieces of burnt human flesh!

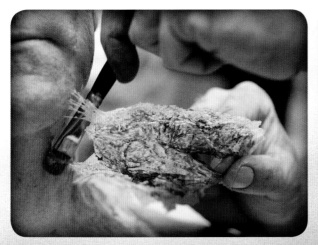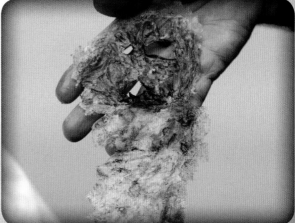

DO IT YOURSELF!

with Bruna Nogueira

Sometimes a tattoo can completely destroy a desired effect. What to do? Depending on the character, of course, a freestyle burn is a quick and easy solution.

Here's What You Need:

3rd Degree A and B silicone molding compound

Cotton swabs, art paint brushes, metal spatula

K-Y Jelly

Alcohol-based paints

Premixed blood and scab-color paints

NOTE: People with allergies and sensitive skin should check the ingredients before using.

To cover the tattoo and create a burn effect, mix together 3rd Degree A and B silicone compound, and apply liberally to the "affected" area. Remember to work fast, since the compound dries very quickly—and once it does, you can't mold or manipulate it.

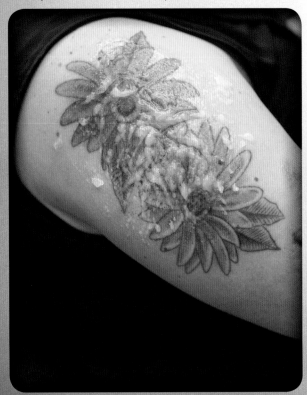

With the side of the brush bristle, make cuts and uneven ridges and grooves in the silicone compound.

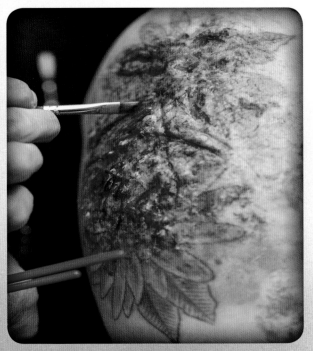

Paint in bruise and blood colors (purple, green, yellow, red, brown, black, blue, orange, and flesh tones). Add drops and clots of blood-colored paints to the ridges and grooves. Smooth on K-Y Jelly for a wet, oozy look.

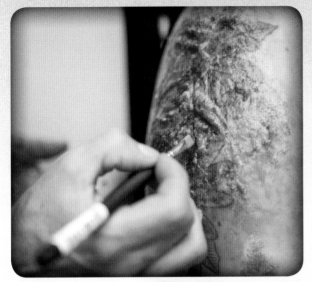 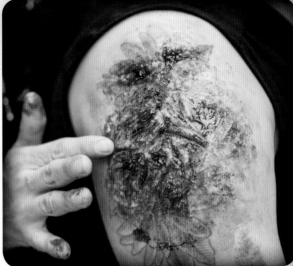

Now you've got a major burn, and a character cover-up for an unwanted tattoo!

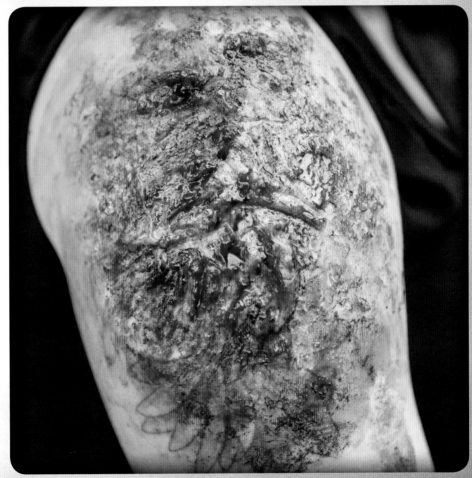

ZOMBIES!
with Robert "Kato" DeStefan

What do you get when you combine burn techniques, facial prosthetic appliances, and the multitalented special-effects makeup artist Robert "Kato" DeStefan? A zombie, of course!

Kato, an instructor at the Cinema Makeup Lab in Hollywood, came to turn me (Bruna Nogueira) into a ghoulish zombie creature from Kato's imagination. Kato's worked on dozens of productions, including the Undertaker character in Hulk Hogan's *Suburban Commando*, John Landis's *Innocent Blood*, *Horrible Bosses 2*, background actors in *Guardians of the Galaxy*, and *Bad Grandpa*. He was also working in Egypt on a cell phone commercial at a less than fortunate moment in history—during the Egyptian Revolution of 2011!

"As a makeup artist, you always have to have options: sometimes you get to use the most expensive state-of-the-art products, and sometimes you don't. Work smarter, not harder, is what I try to do."

—Kato DeStefan

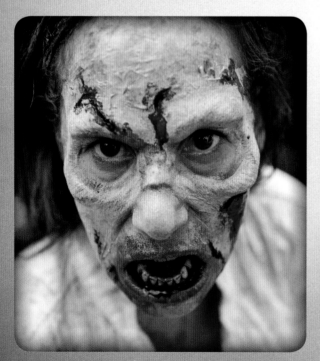

Kato cuts apart silicone wound appliances to have them on hand and ready to apply.

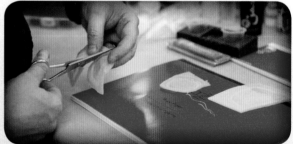

He fits foam latex facial prosthetics to the face. For a zombie makeup, Kato actually prefers foam latex prosthetics to silicone or gel—as it will give the character a "drier" look. Kato flattens down the eyebrows with silicone adhesive to keep the hairs from being painfully plucked out when the makeup is removed.

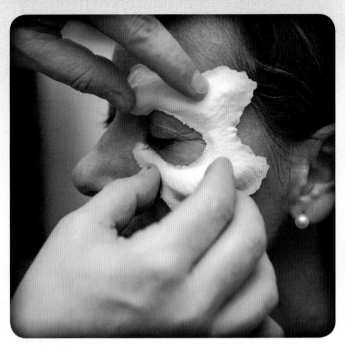

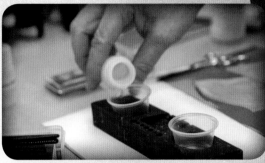

Kato glues down the nose-bridge appliance (which will ultimately make the face look decayed and rotting) with Telesis adhesive. He covers the eye sockets and brows with a foam latex appliance, blending the edges to the skin with a handmade red stipple "sponge pop" (a rubber band holds the sponge in place on an orangewood stick).

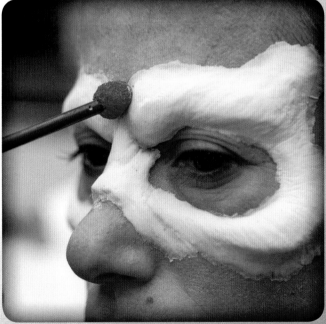

Kato glues the silicone appliance for an open cut to the neck. He removes the excess "flashing" or edging. Using edger (acetone), he blends the edges into the skin.

 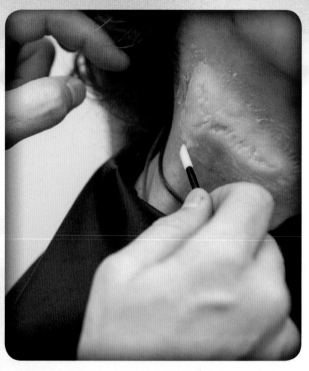

Kato applies soft sealer in small sheets to the skin, with 99 percent alcohol and a brush so that the sealer melts into the skin, changing the texture of it. (He learned this "burn" technique on the television show *CSI: New York*.) This technique is a lot faster and easier to apply than traditional burn makeup methods.

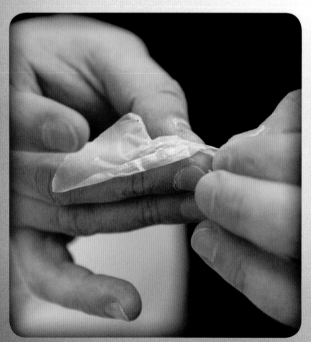 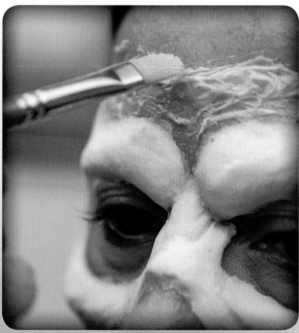

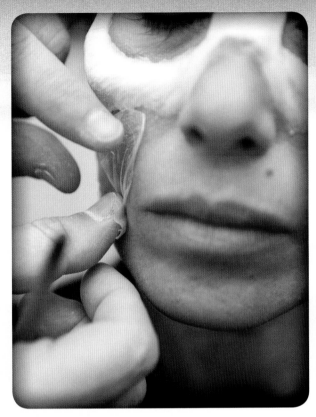

In minutes, the face and neck are covered with shriveled, dried, dead-looking pieces of skin.

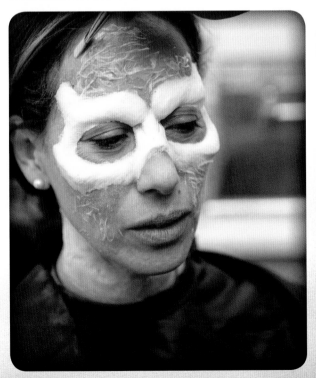
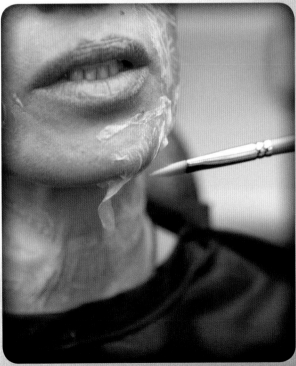

Now the real magic begins. Kato dabs on flesh-tone PAX paints.

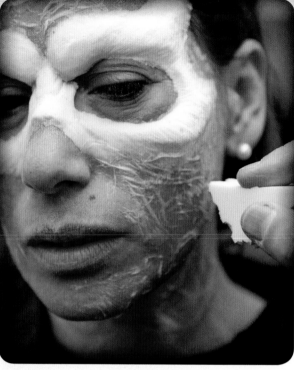

He sponges on and then spatters character-color paints ("Dust-to-Dust Brown," "Liver Mortis," "Dead Blood," and "Post Mortem").

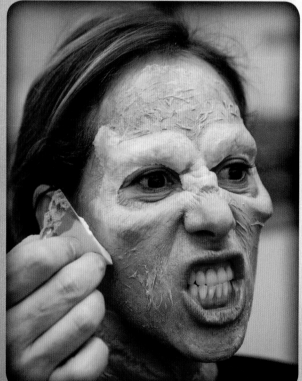

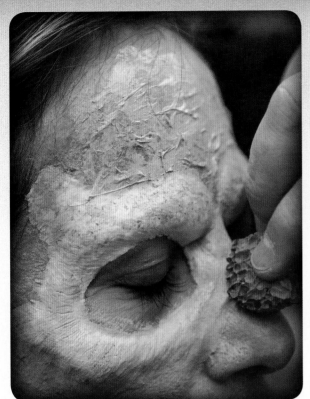

Kato paints a "wasting away" effect at the bridge of the nose, using colors with great names like "Infected Blood," "Grey Matter," and "Vein."

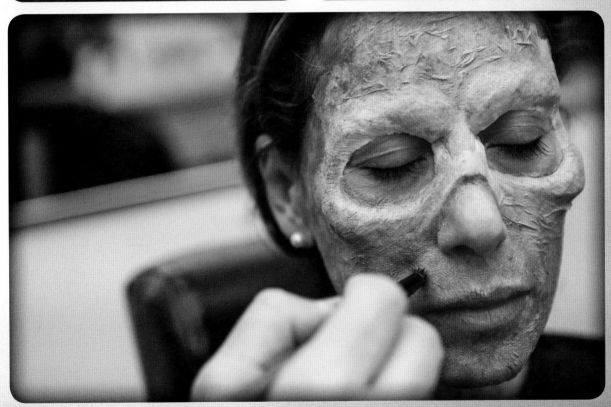

He paints in the wounds—the bloodier the better. He spatters the character colors with a brush bristle instead of an airbrush, in order to spackle the skin to add depth and dimension. Then he dribbles blood with the red sponge pop and a cotton swab.

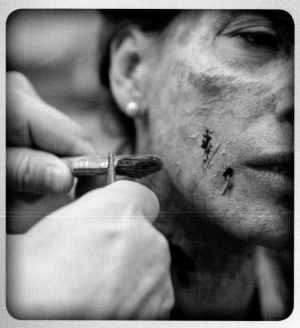

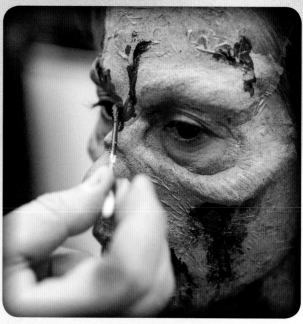

Kato mixes a special "dirt" brew for the hair, hands, and arms. No self-respecting zombie would be caught dead with pretty white teeth. So Kato sprays a mixture of food dye and mouthwash to create a decaying teeth stain.

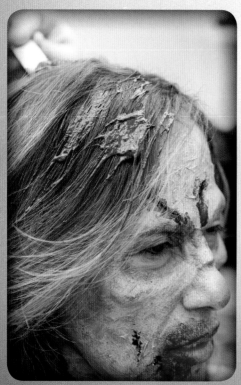

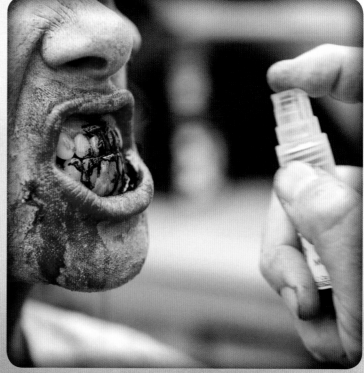

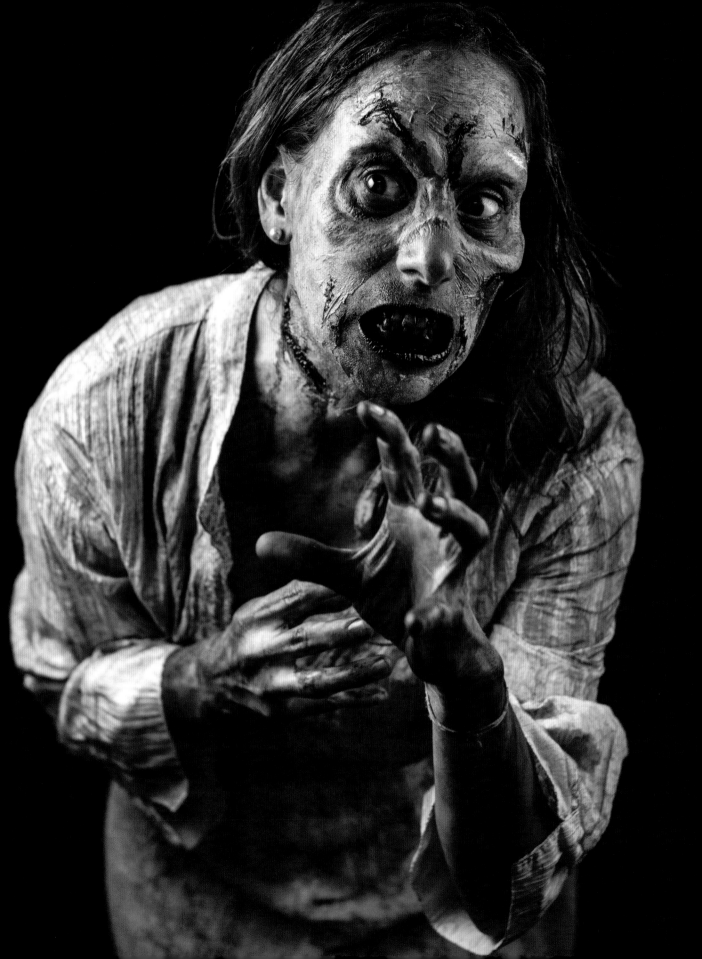

DO IT YOURSELF!
with Bruna Nogueira

I know a quick and dirty way to turn this fair maiden into a terrifying swamp creature.

Here's What You Need:

Mud Pack Masque

Brown shadow and blush powder

Metal spatula

Blow-dryer

Warm water

Hot towel

NOTE: People with allergies and sensitive skin should check the ingredients before using.

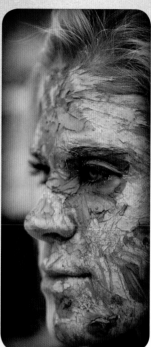

Mix together a squeeze of Mud Pack Masque and a pinch of powdered "dirt" makeup made from mixing several shades of brown shadow and/or blush powders. (Never use real dirt for an effect, as it can be easily washed or sweated off.)

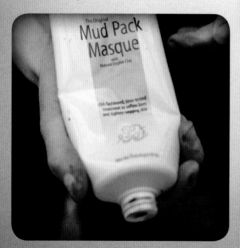

Apply the mud-dirt mixture to the skin with a spatula.

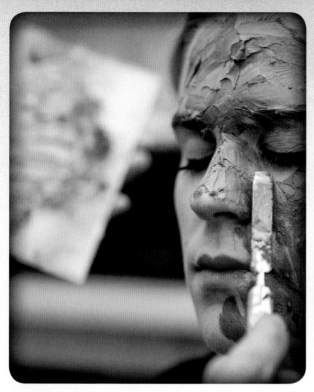

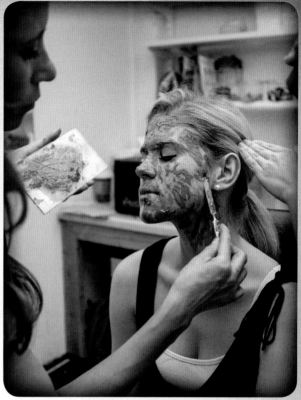

Blow-dry while you work, in order to create cracked, dry parts in the mud mixture. Instant swamp creature!

And to remove the makeup, just use warm water and a hot towel.

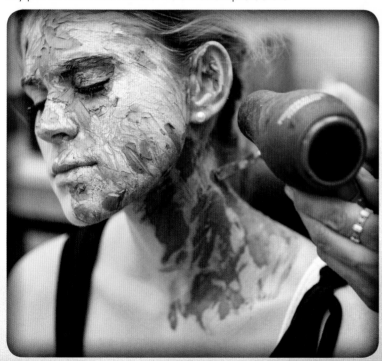

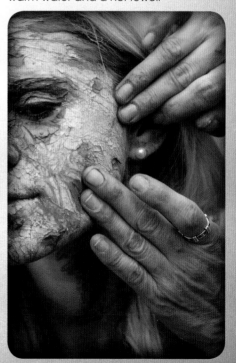

Workshop #14

DO IT YOURSELF!
with Bruna Nogueira

Every Zombie needs a victim. And we all know what happens when a zombie bites you. Here's how we turned the lovely Julia Ruiz, Brazilian actress and model for the day, into a zombie-in-progress.

Here's What You Need:

Ready-made bite-mark silicone appliance

Cotton swab

Pros-Aide or spirit gum

Acetone

Blow-dryer

99 percent alcohol

Fine and medium paintbrushes

Bristle sponge wedge

Alcohol-activated paints (green, red, blue, black, brown, and yellow)

Blue and purple eyeshadow (over the counter)

Electric-blue fake eyelashes

Eyelash adhesive

Dirt powder (or loose dark brown face powder)

Shaving cream

NOTE: People with allergies and sensitive skin should check the ingredients before using.

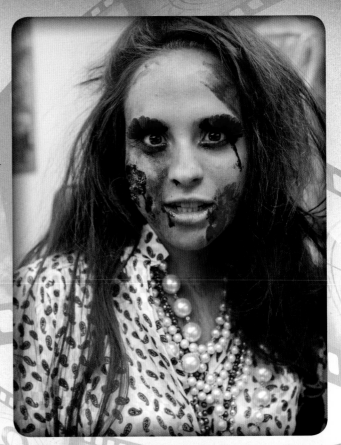

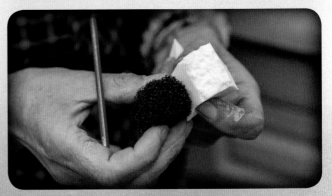

Glue down a ready-made bite-mark silicone appliance with Pros-Aide or spirit gum. Remove the excess flashing or edging, blend the edges with Pros-Aide, and blow-dry.

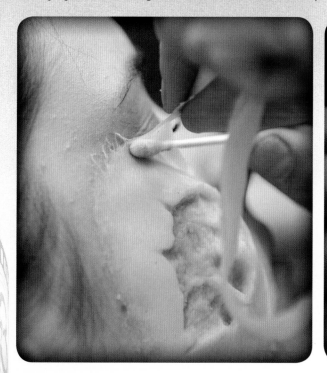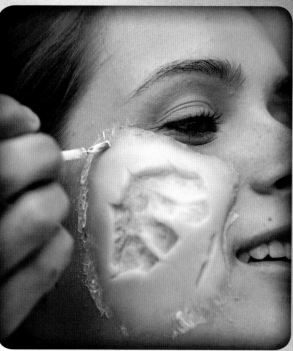

Use a mixture of green, red, blue, black, and yellow together to make a deep, decomposing skin color. Paint inside the wound with black and brown paints mixed together, to make it look darker, disgusting, and nasty.

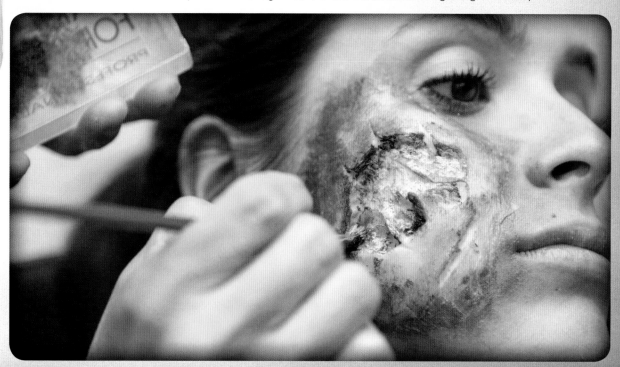

Mix blue and purple eyeshadow under the eyes and add flirty, feathery, electric-blue fake eyelashes.

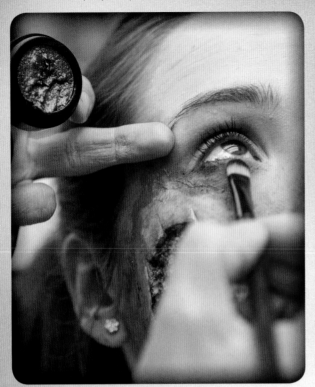

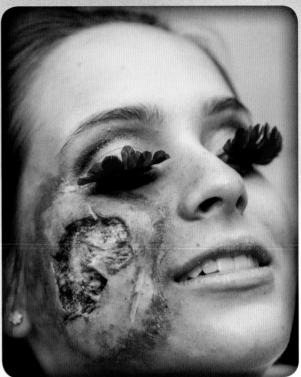

With a bristle sponge, add red blood paint to the bite mark.

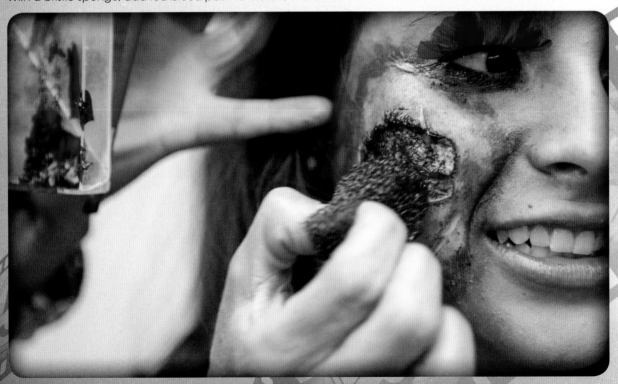

Brush on a touch of dirt powder.

Dribble fake blood into the bite mark, the nostril, and the lower lip.

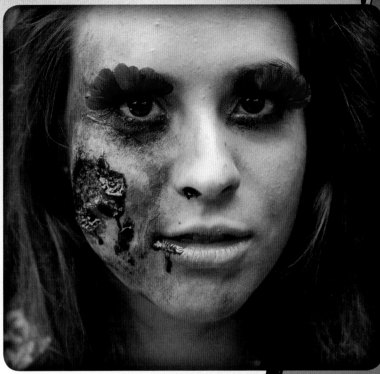

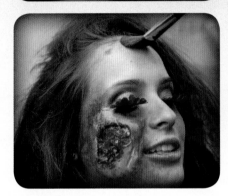

Brush on red food dye and mouthwash for bloody teeth.

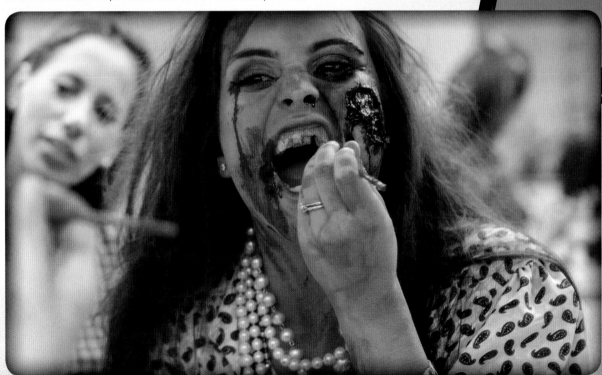

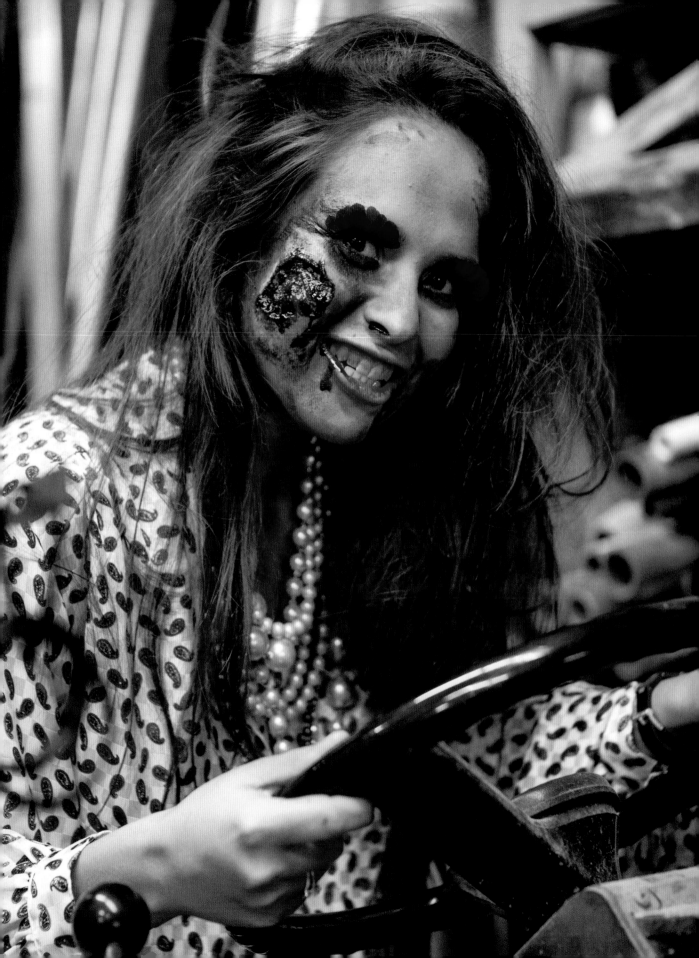

To return to normal, carefully pull off the appliance.

And save it for next time!

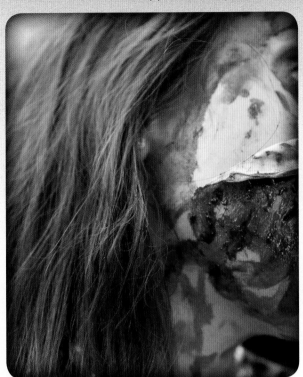

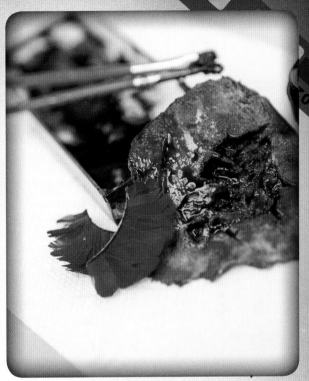

To remove the fake blood, use shaving cream! It really works!

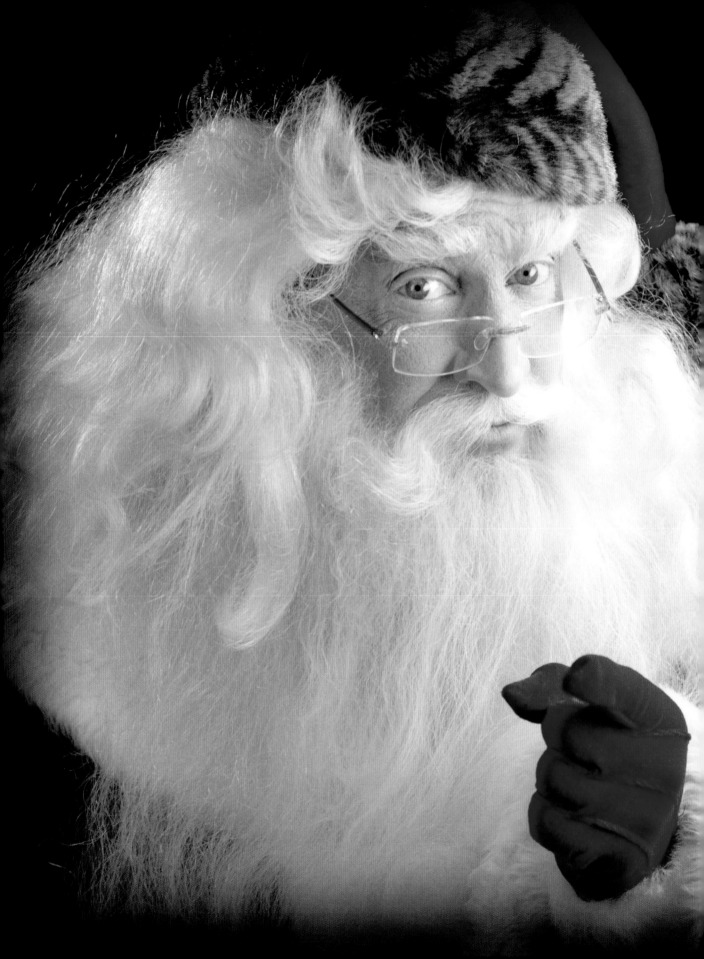

AGING AND SANTA

"It's hard to believe that anyone would actually want to look older. But Hollywood is a mercurial place. So, while it casts young actors, if the part calls for an older person, or someone who ages over time, the special-effects makeup artist has to add wrinkles and saggy chin and neck skin—pronto!"

—Bruna Nogueira

AGING
with Robert Romero

Robert Romero (aka Bob) started doing special-effects makeup in 1965, when he went to visit his dad, Ray Romero, on set at Fox Studios. One minute he was meeting his dad for lunch. The next he was throwing makeup dirt on over 400 actors for the film *Van Ryan's Express*. When Bob got to the last actor, it turned out to be Frank Sinatra! Since then he's worked on an incredible number of productions: commercials, films and television, e.g., *Planet of the Apes*, *Family Ties*, and the *Batman* and *Green Hornet* series, as well as worked with some of the greats, like Barbra Streisand, Clint Eastwood, and more. But his favorite makeup to do, hands down, is Santa Claus. He started creating his Santa Claus makeup for commercials, and never stopped. He's made more than 500 Santas in his career, and no two are alike.

When I asked Bob to share his aging techniques with us, he chose to transform Topher Morrison, our model for the day, into Santa Claus.

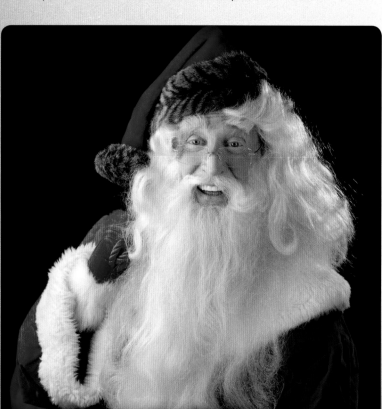

"I'm from the old school of makeup effects—use what you have and make it work, especially when working in parts of the world where the fancy products aren't available."

—Bob Romero

Bob still uses his dad's original handbuilt makeup box and his own very substantial supply of tools, products, and classic Santa reference photos.

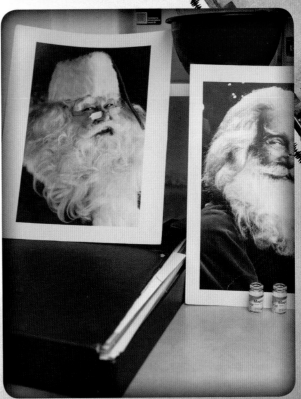

First, Bob cleans Topher's face with witch hazel. Then he applies a latex surgical adhesive (also used as eyelash glue) to Topher's skin. Bob blow-dries the first latex layer, while the skin around Topher's eye is pulled tight.

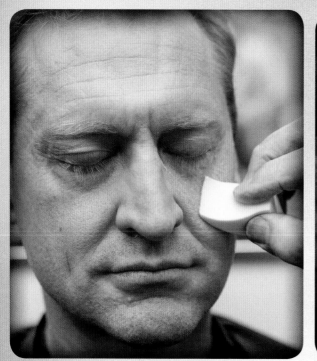

Once the first layer is dry, Bob applies another layer, and then another.

After applying several layers of latex, Topher's skin is sufficiently aged. Bob uses pink and other flesh-tone colors to cover the latex.

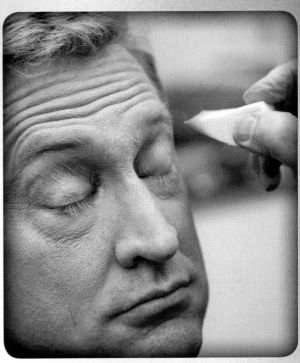

Bob uses a makeup brush and a prickly sponge wedge to apply the flesh-tone makeup.

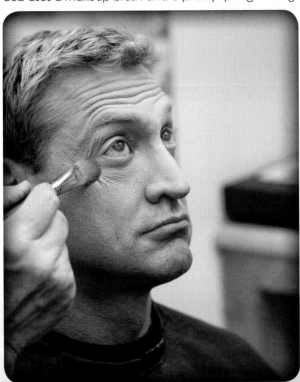

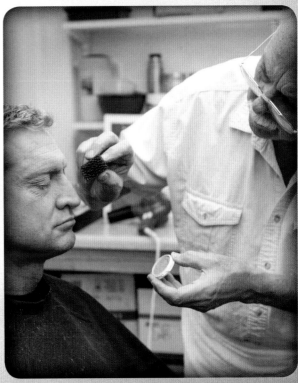

Bob creates texture using an air conditioner filter as a bristly sponge, and he uses a bright pink to create Santa's rosy cheeks.

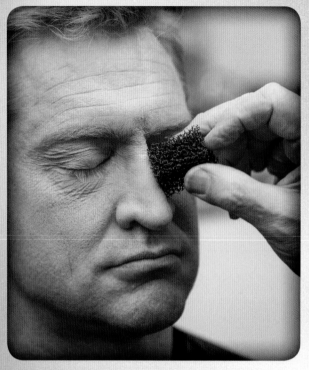

Bob intends to use a wig, full beard, mustache, and eyebrows, so he only ages and colors the portion of the face that will be exposed. The aging and painting process is complete. Now it's time to add the hair prosthetics.

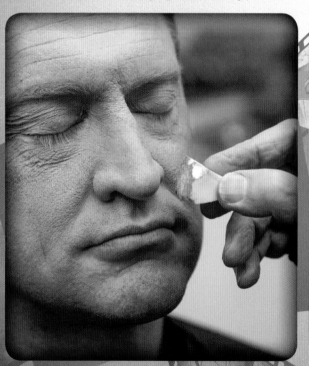

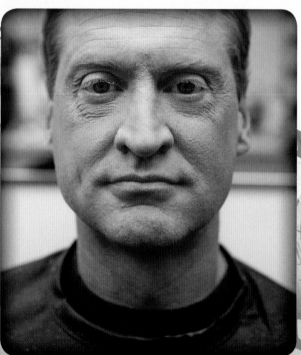

Bob chooses the perfect Santa beard and then brushes the model's chin with spirit gum. To speed up the drying process, he uses two types (Max Factor and Joe Blasco products). After choosing the best-fitting beard, Bob glues it to the chin.

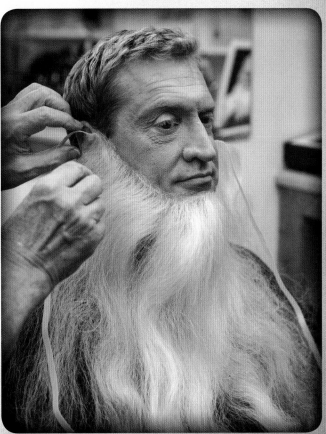

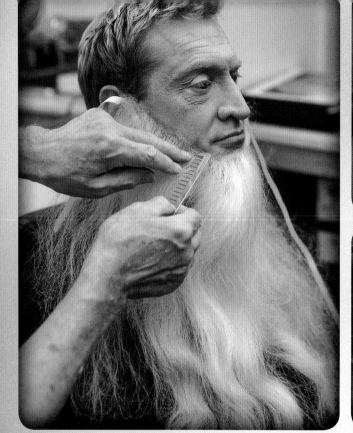
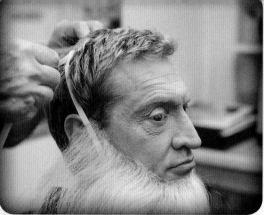

Then Bob chooses loose hairs from the hackle, also known as the hedgehog board. It is a board spiked with nails (shown here covered with cardboard for Bob's protection). He applies the loose hairs with spirit gum to fill in the beard and the chin.

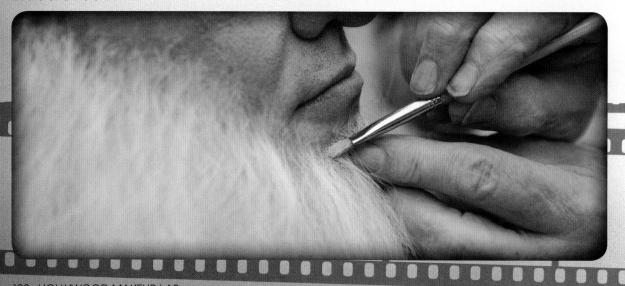

Bob clips and trim. He fluffs and primps the beard until it's full and Santa-like.

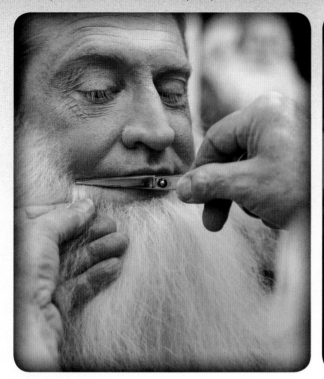 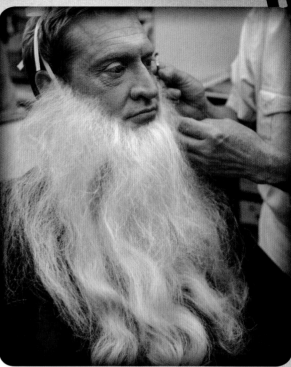

Bob sets the beard with a gentle seaweed-and-water hair spray, and then peruses his impressive handsewn mustache collection.

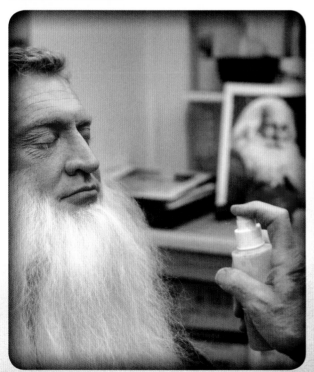 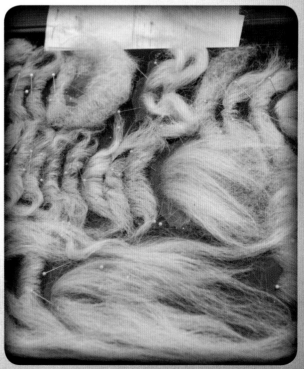

Bob selects the perfect Santa mustache, and brushes spirit gum on the model's upper lip.

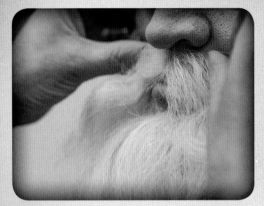

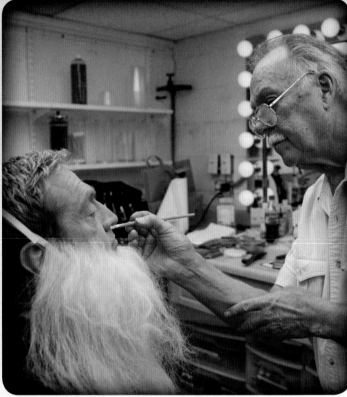

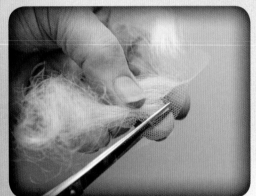

Bob trims the mustache and glues it down. Then he snugly fits a Santa wig onto the model's head.

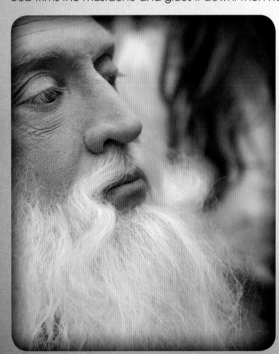

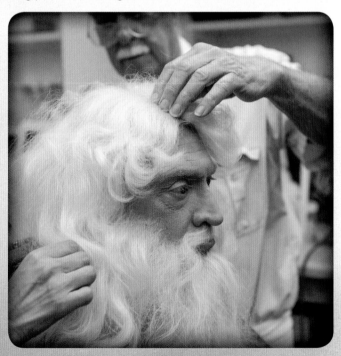

Then come the eyebrows.

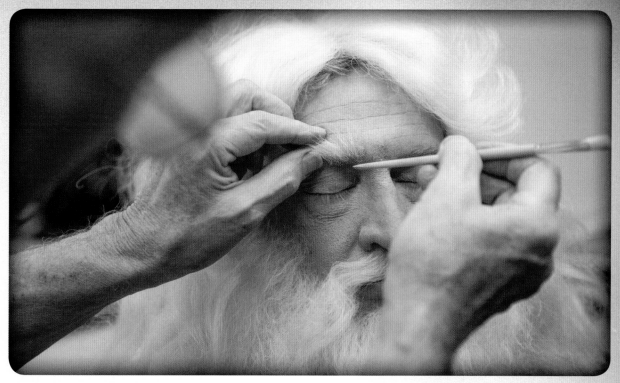

Bob adds a red fur-trimmed Santa hat. (He never travels without one!)

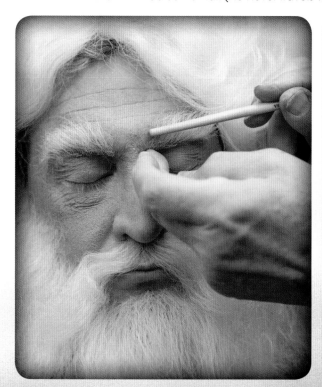

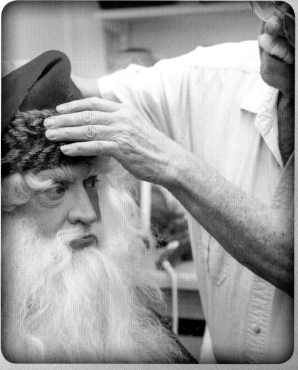

Bob dresses Santa in a pair of specs and a red velvet suit.

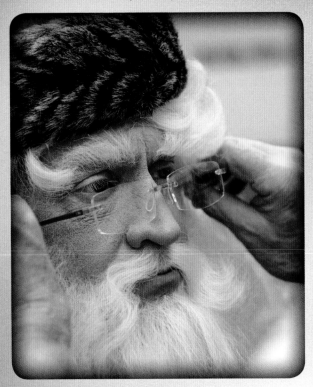

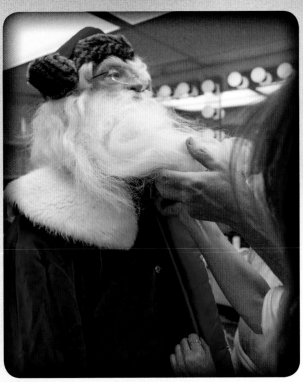

Bob provides a pair of bright-red gloves. (After all, it's cold in the North Pole—and this way, Bob doesn't have to age the hands!)

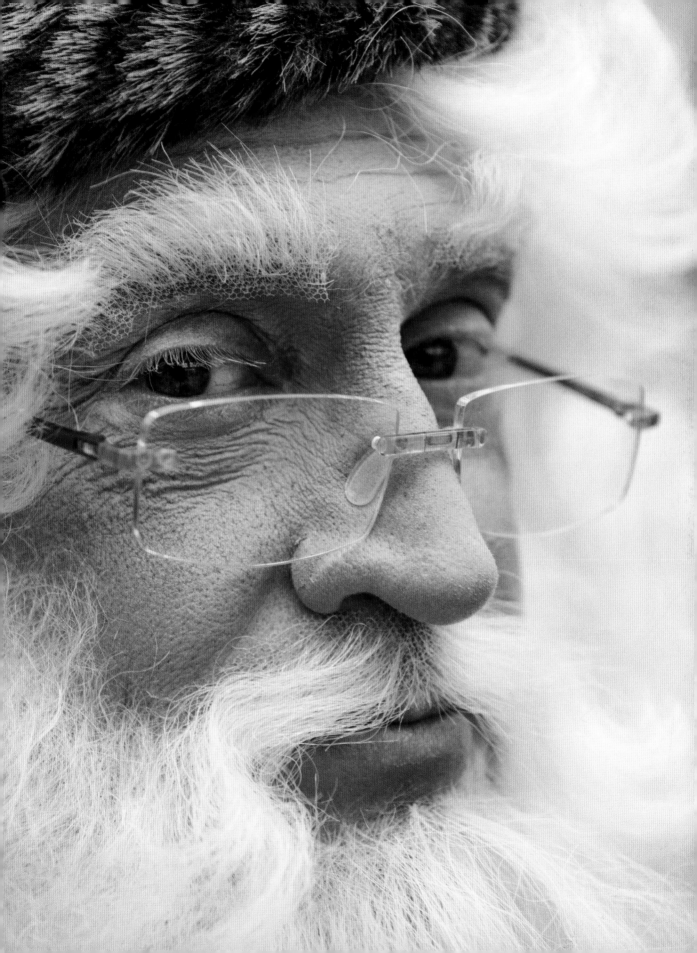

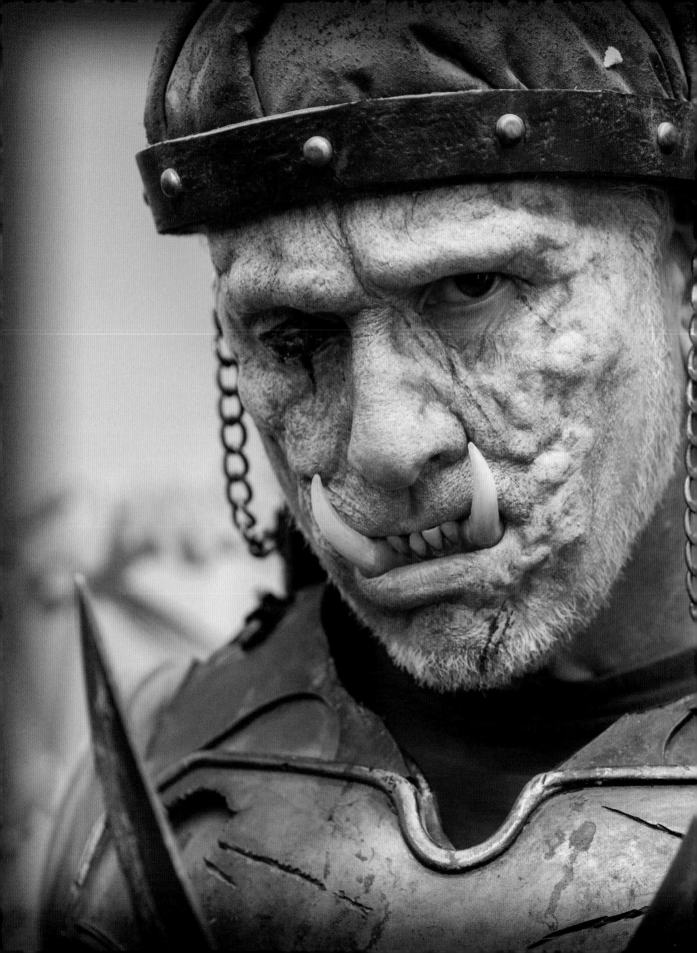

DENTAL PROSTHETICS AND FANGED DEMONS

" . . . Creating characters, aliens, mutants, and freaks is a makeup artist's dream job."

—Chris Nelson

DENTAL PROSTHETICS
with Tony Carrillo

How do demons, vampires, zombies, werewolves, and all variety of creepy characters get their gnarly teeth? Well, believe it or not, it all starts with a dental mold, very much like the kind that dentists make when fitting their patients for braces or crowns.

Tony Carrillo, one of the special-effects makeup artists at Mark Rappaport's Creature Effects, Inc. workshop, shows us how to turn an ordinary dental mold into a set of ferocious teeth with a personality of their own. Whether it's a dental mold designed to create an appliance for a specific actor, or one that can be used to create a "generic" appliance used by anyone, the process is almost exactly the same.

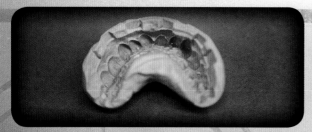
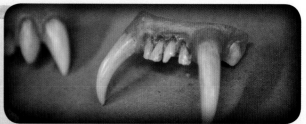

This dental-stone sculpture was made using the pink dental alginate cast of someone's ordinary teeth. (If it's custom-made for the actor, then it will be a cast of his or her teeth. If not, then anyone's teeth will do.)

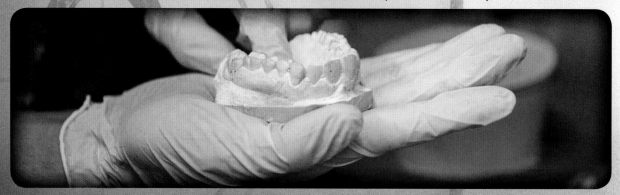

The artist usually works from a visual representation of how the teeth should look and sculpts the stone to create the final look. The sculpture is then inserted into silicone.

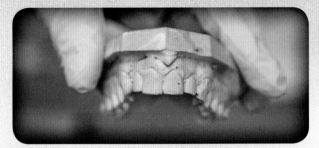 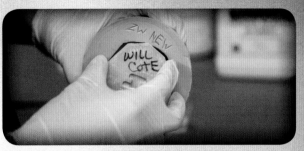

When the sculpture is removed from the silicone, the dental impression is revealed.

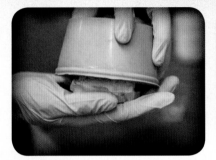 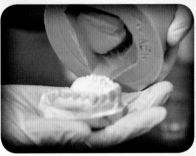 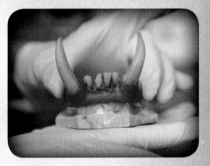

(The mold Tony is making today is a replica of an ordinary set of teeth, but the same process is used when creating the gnarly set pictured here.)

Before pouring in the acrylic sculpting material, he brushes the mold with petroleum jelly for easy release, paints on a substance called monomer, and injects tooth powder shade 62 in the individual teeth.

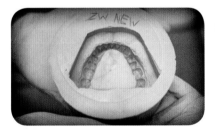 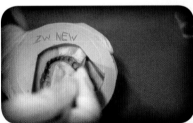 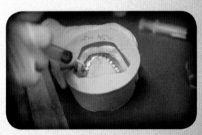

He repeats the process again for several layers. He continues to layer the monomer and tooth powder color until the mold is filled a bit over the top. It then takes several hours for the mold to set. After the mold has set, Tony removes it.

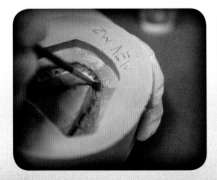 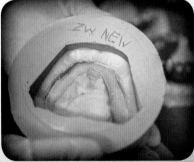

The excess material above the teeth needs to be sanded down so that once the gums are added, no white shows through.

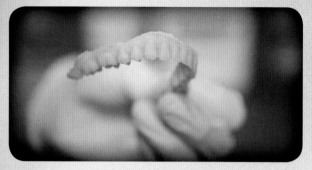 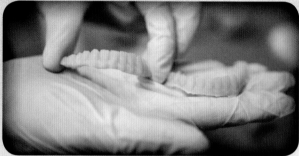

Tony uses a rotary sander to remove excess material and smooth out the edges.

 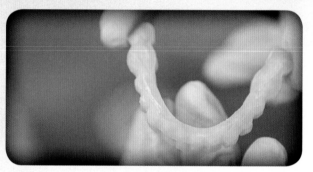

Then he reinserts the teeth back into the silicone mold. To make the gums, he pours flexible soft monomer into a cup of pink Flexacryl.

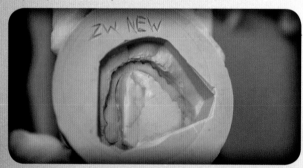

He mixes up a batch of pink acrylic "gum" goo and pours it on top of the teeth cast.

 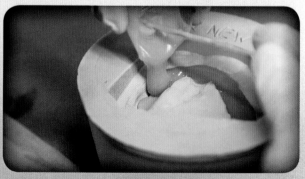

Tony pours boiling water into the silicone mold, around, but not directly onto, the pink gum acrylic so that the gums will cure in ten to twelve minutes instead of forty minutes.

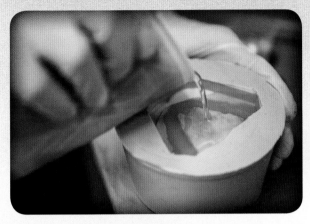

He trims the extra gum material to ensure that the appliance will fit nicely into the actor's mouth. (A comfortable dental appliance will make all the difference in the world to an actor's performance, so it's extremely important that the makeup artist do whatever it takes to make the appliance as close-fitting and easy-to-wear as possible.)

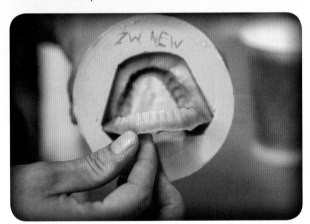 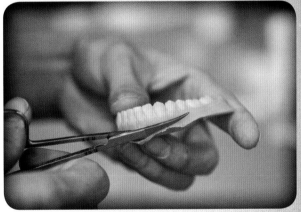

If Tony were to make a custom-fit gnarly appliance below from scratch, he would take a dental alginate cast of the actor's mouth, add the snaggle teeth to the cast with molding clay, make a stone sculpture of the "corrected cast," create a blue mold of the snaggle teeth, and then follow the same steps outlined earlier to generate the appliance. And it's the exact same process no matter what kind of teeth are being made.

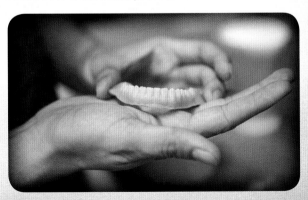 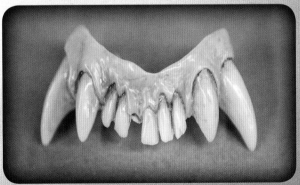

SNAGGLE-TOOTHED DEMON
with Chris Nelson

Chris Nelson is a four-time Emmy-nominated special-effects makeup artist for his television makeup effects work on *American Horror Story*. That show, according to Chris, is a makeup artist's heaven. Chris has also worked on *The Cape, Nip/Tuck, NCIS,* and *Criminal Minds,* and on films like *Kill Bill* with Quentin Tarantino (in which Chris also acted the part of "Groom" to Uma Thurman's "Bride"), *Sin City, Thor: The Dark World, World War Z, The Hangover Part III, The Amazing Spider-Man, Star Trek Into Darkness,* and dozens more. One of the first makeups Chris ever did as a child (on himself and his brother) was the signature look of Gene Simmons of the band Kiss. Throughout his twenty-five years as a makeup artist, Chris has worked with some of the best actors in history, including Dustin Hoffman, Robin Williams, Christopher Walken, and others. Watching their process and assisting their transformations into characters has taught him to be a better actor and a better makeup artist.

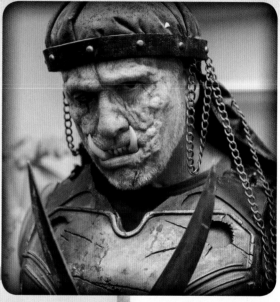

Chris will use a variety of foam latex facial appliances, silicone dental appliances, and alcohol-activated paints to create a Snaggle-Toothed Demon.

Using Pros-Aide and Telesis 5, Chris glues down the gouged eye and scarred skin mutation appliances.

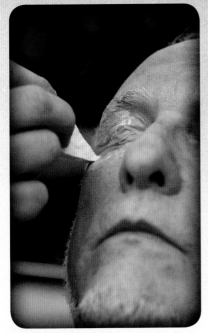 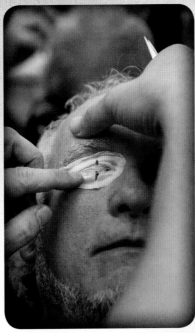 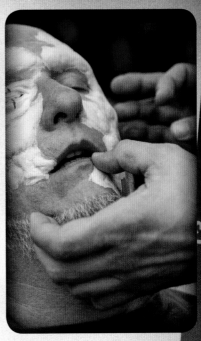

He blends the edges into the skin with Pros-Aide, using Bondo for a few of the thick edges of the prosthetic. Chris tells the actor to keep his mouth open, to allow the prosthetic to lie flat while he blow-dries the adhesive so that it will dry quickly.

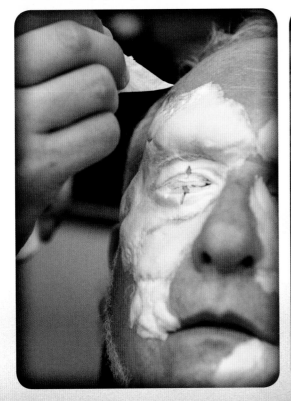 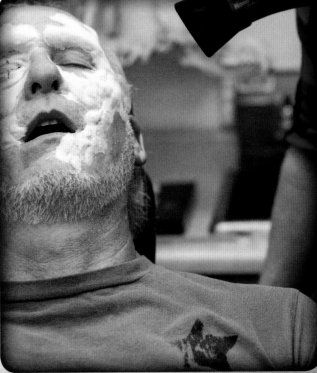

After the Bondo has dried, Chris dabs on translucent powder before applying the Pax paint base.

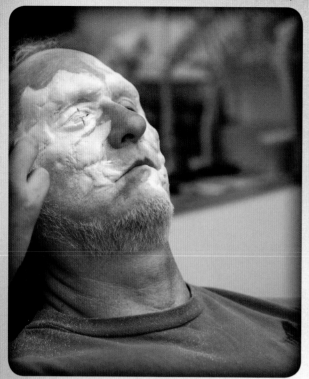
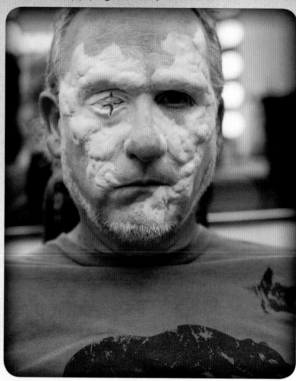

Chris picks out pieces from a sponge wedge to create a mottled-skin effect. He mixes up a reddish flesh-colored base color.

Chris liberally dabs on the flesh color with the mottled sponge.

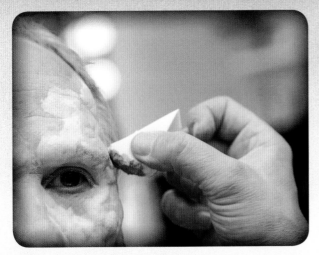 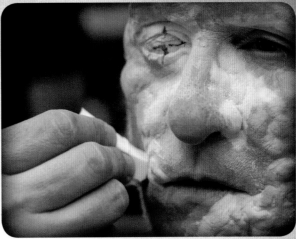

He creates a mixture of flesh tones to warm up the skin color.

 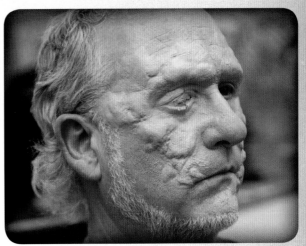

Chris fills in the gouged eye with reds and brownish reds.

 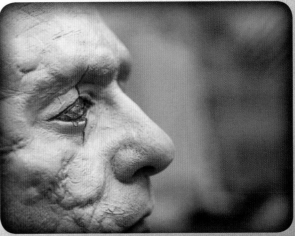

Chris uses an airbrush to layer skin tones on the skin that surrounds the prosthetics.

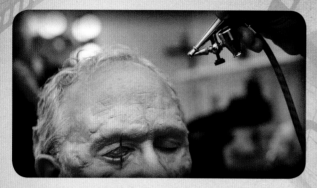

He adds alcohol-activated deep purple paint in the appliance crevices to create length and dimension. He adds brownish purple with fine brush strokes to create a "diseased" look.

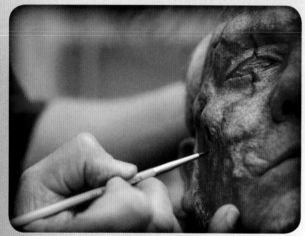
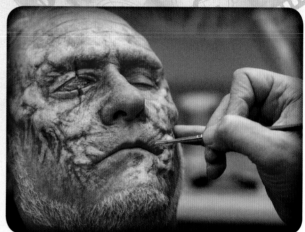

After the dental prosthetic, hat, chest plate, and a couple of prop swords are added, the Snaggle-Toothed Demon efffect is complete.

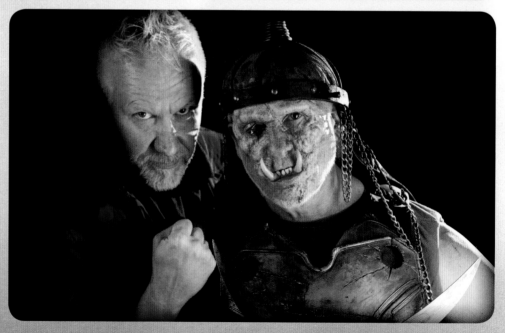

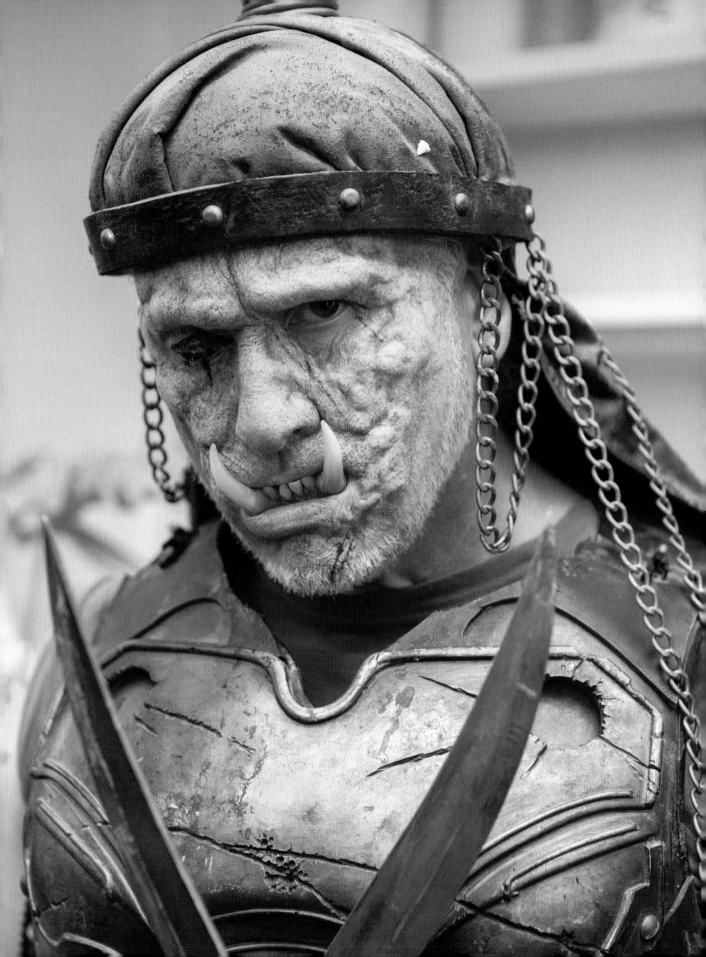

DO IT YOURSELF!
with Cary Ayers

Cary Ayers, special-effects makeup artist, started out as an intern for Joel Harlow at his Harlow Designs workshop. He has since worked on a variety of productions: *Battle Los Angeles*; *Lone Ranger*; *American Horror Story*; *Glee*; and *Parks and Recreation*. Cary worked at lightning speed, working out of kit, to demonstrate how to make a vampire on your own.

HERE'S WHAT YOU NEED:

Pancake makeup

Sponges

Skin illustrator paints

Airbrush

Black stick-on nails

60 percent alcohol

Mascara wand

Snap-on eyeteeth

NOTE: People with allergies and sensitive skin should check the ingredients before using.

Sponge on water-based yellowish white pancake makeup. Use broad strokes to cover the skin. Dab on the color cream with a wedge sponge to blend the color into any facial hair and into the nooks and crannies of the face.

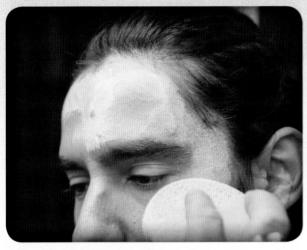

Extend the makeup coverage to the model's neck and hands, as the skin will be exposed and not covered by the costume.

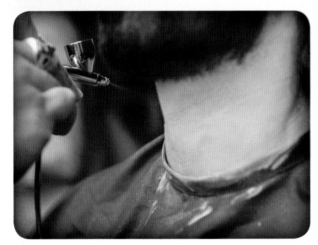 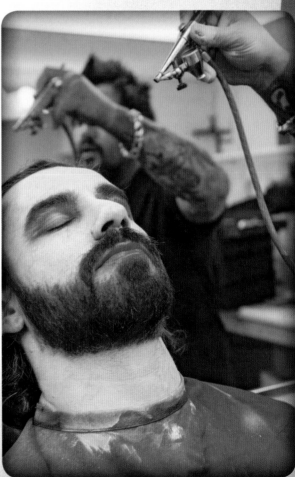

Reinforce the shadows around the eyes with a purple wash. Glue on black nails, and then add several coats of red paint to turn it purple.

Use a mascara wand to bring the model's own beard and eyebrows into the makeup. For eyeliner, eye shadow, and lip color, use watercolor red with a brush.

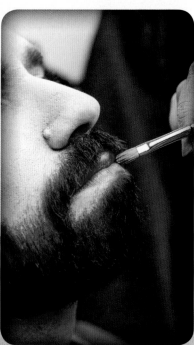

Airbrush red paint thinned down with 60 percent alcohol around the eyes and cheekbones and into the creases, to create contour and depth.

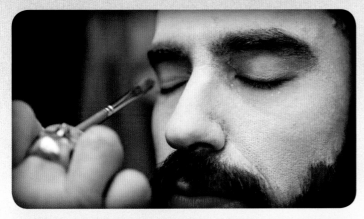

As a final touch, airbrush spatter a custom color of aged blood and lividity to give depth to the skin color.

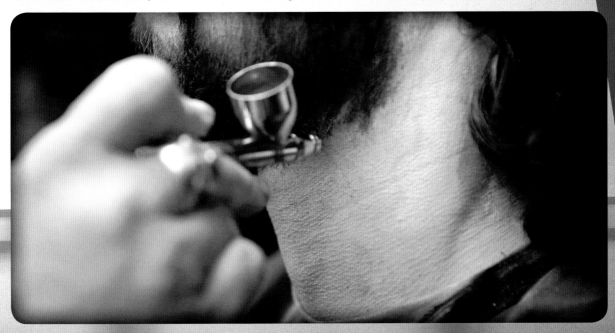

Snap on a couple of ready-made vampire teeth. Add a shirt and hooded jacket, and the vampire look is complete!

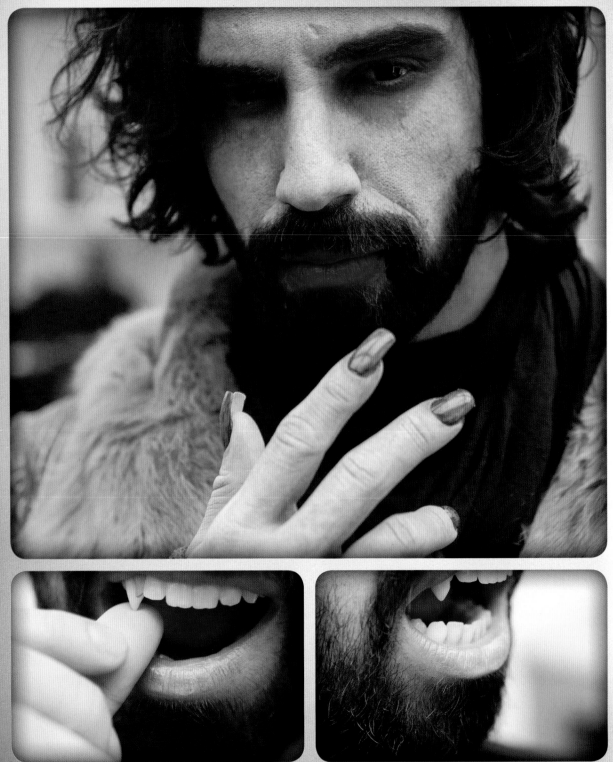

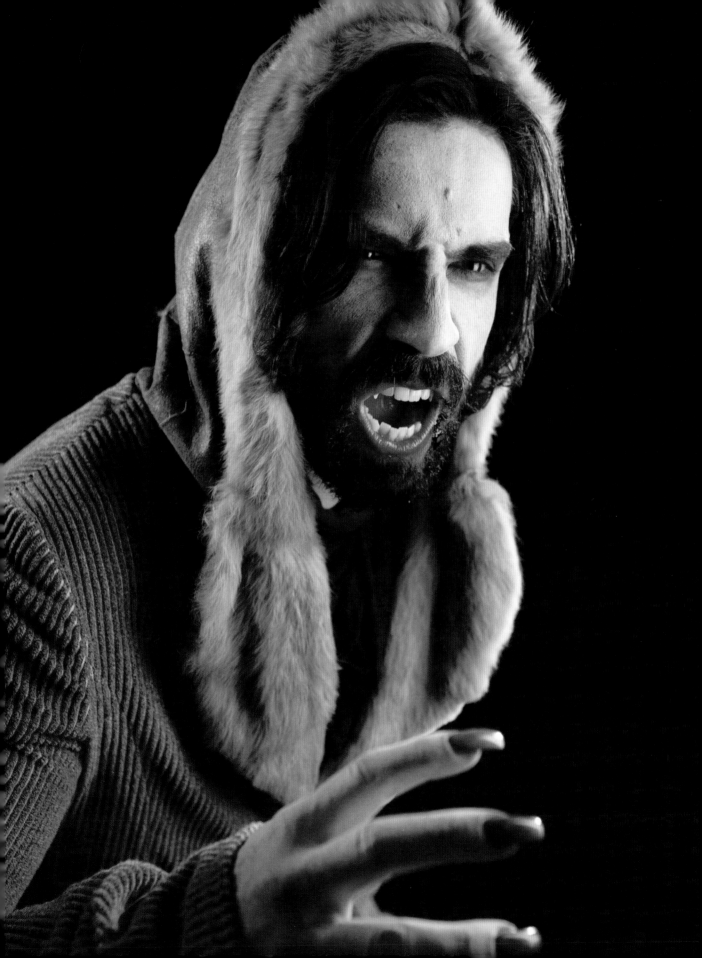

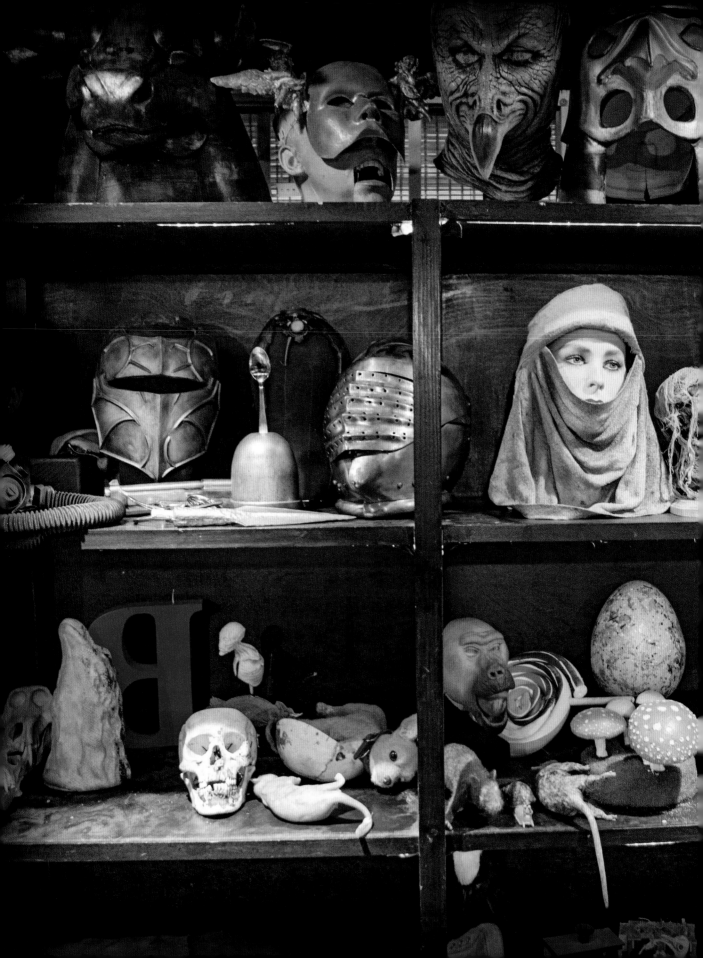

CREATURE EFFECTS

"In creating a special-effects creature, it's all about specifically tailoring it for an individual shot, which might end up being fewer than ten seconds of the film. But that's the job, generating an effect to create a perfect emotional moment."

—Jeff Cruts

CREATURE EFFECTS
with Mark Rappaport

In the heart of Hollywood, just down the street from Universal Studios, is one of Hollywood's busiest creature effects workshops, run by Mark Rappaport.

"It's essential for a creature effect to cast an aura of authenticity into a scene so the actors can genuinely emote and interact with the creature. There's no real way to do that with a green screen."

—Mark Rappaport

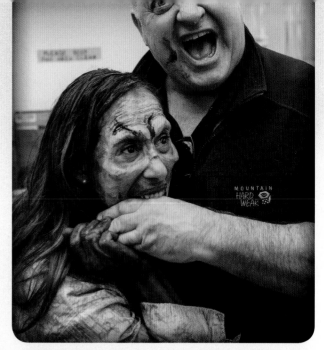

Mark's shop is a veritable warehouse of creature effects, chockfull of everything from warm and fuzzy critters to dead bodies and mangled body parts for the *CSI* shows, from a talking moose for a Melissa McCarthy film to an oversized asteroid creature from a Seth Rogan film, from dogs and babies to an impressive array of mechanical horses.

This hero horse for *The Last Samurai* was powered by an enormous hydraulic pump so that it could do everything: gallop on front and rear legs, rear up on its haunches, be knocked over in battle, and in every way give the impression it was a living, breathing animal.

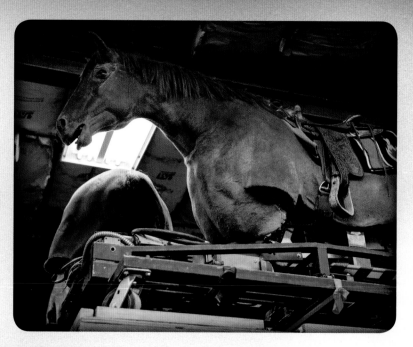

Host to dozens of makeup and effects artists, including the Hollywood Makeup Lab Intensive Workshop, Mark oversees the creation of hundreds of animatronic creations for dozens of big-budget Hollywood releases like *The Last Samurai*, both *300* films, *The Lone Ranger*, *TED*, and *Star Trek*, to name just a few. He also does many commercials and most recently the viral video known as *Devil Baby*.

Jeff Cruts, whom Mark refers to as the "master creator of animal flesh," is in the process of creating a "wounded, dying horse" for the Reese Witherspoon film *Wild*. Creating a dying horse is actually quite difficult.

Jeff uses a young, live-horse mold as a base, but flattens out the original sculpture, in certain areas, to create the illusion of the dead weight of a horse lying on its side, its skin slack and lifeless.

Yoshimi Tanaka painstakingly researches the type of wound that the director has indicated to Mark that he would like to apply to the dying-horse creature. Then she makes a clay model of it so that it can be made into a silicone prosthetic appliance, which will be applied (on set) to the horse's right side.

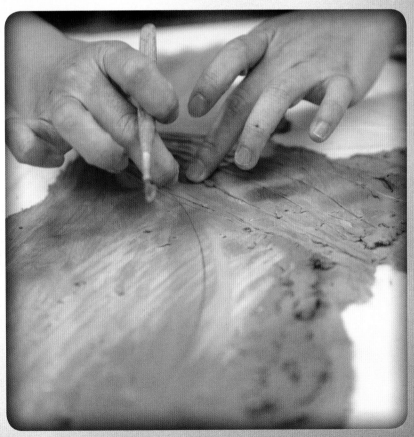

Working from photos of the actual horses to be used in the production, Jeff re-creates the horse. Then he paints the underskin to match the color of the production's live horse or horses.

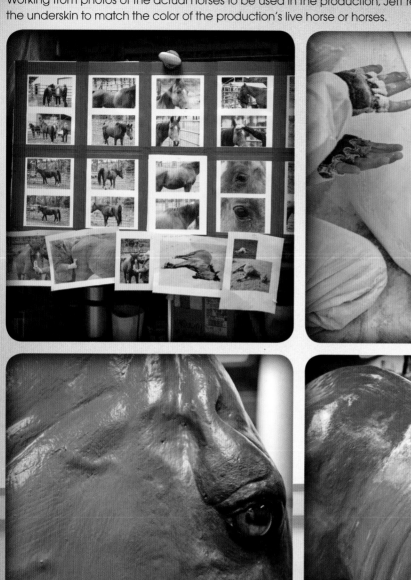

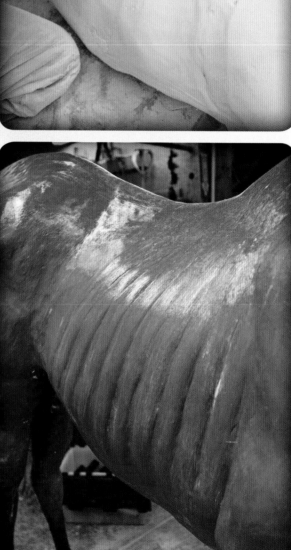

Jeff uses a combination of colored "flocking" material made of tiny synthetic fibers in different lengths to give the painted horse sculpture a "coat" of horsehair.

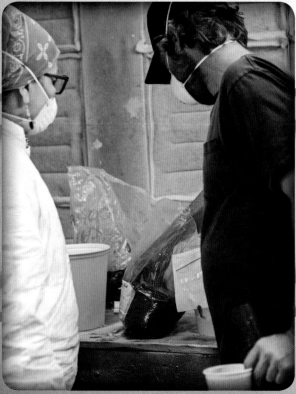

With a compressor, Jeff lays down the flocking to create the horse's coat.

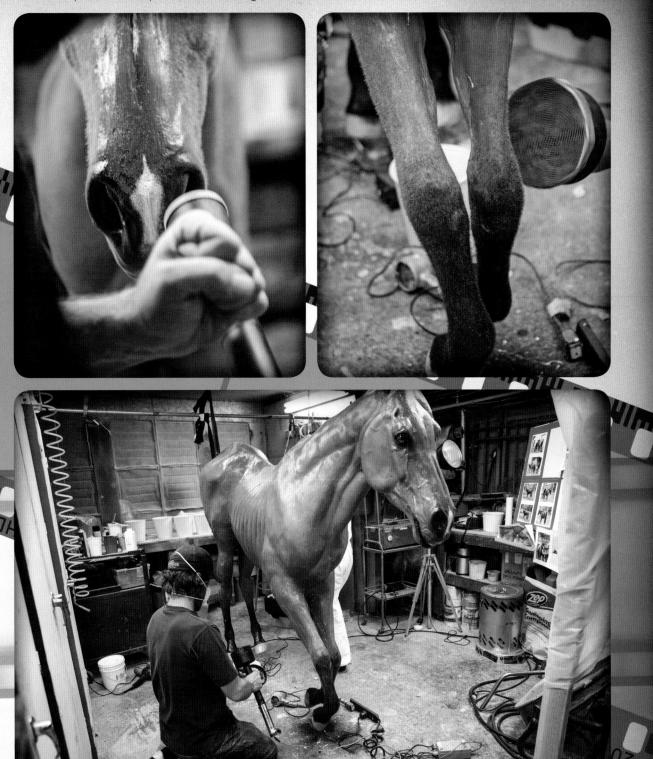

To "flock," Jeff grounds the horse with an electrode with a negative charge. The positive charge of the flocking machine magnetizes the tiny pieces of flocking material, ensuring that they adhere to the horse's exterior.

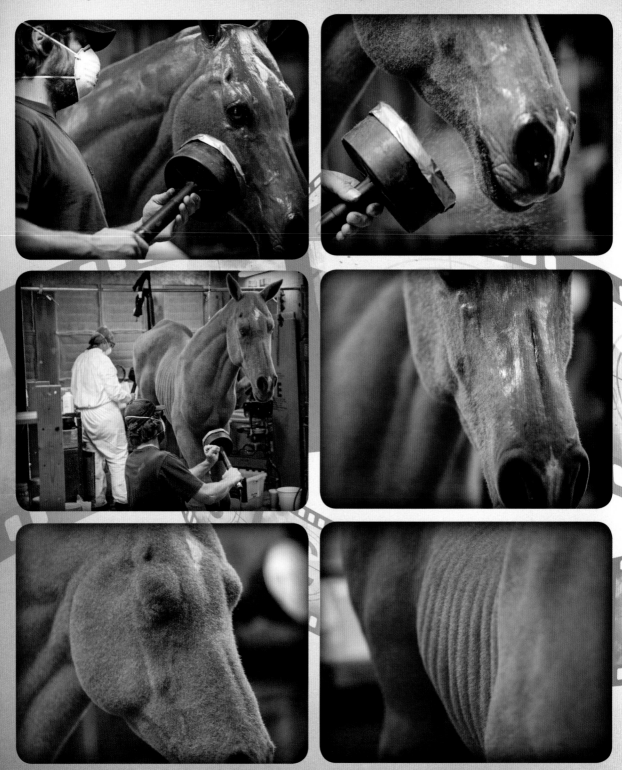

The flocking is then blown dry to whisk away any excess unglued fibers.

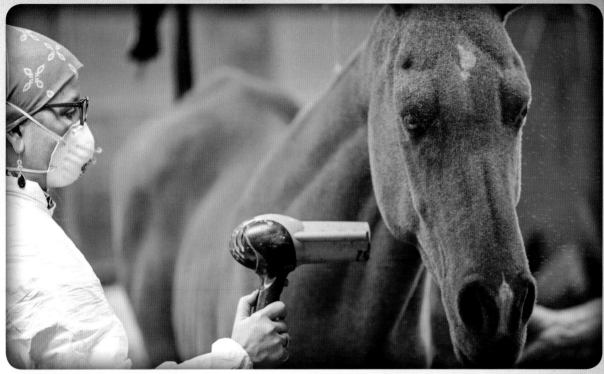

Now for the finishing horse touches—mane and tail, eyes, and ears. Mane and tail hair is usually made of synthetic hair for easier handling.

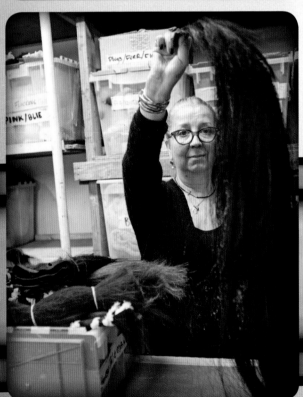

The dying-horse creature is boxed, crated, and shipped out to the production.

The fatal-wound prosthetic is applied on set, and the dying-horse creature effect is heartbreakingly ready
for camera.

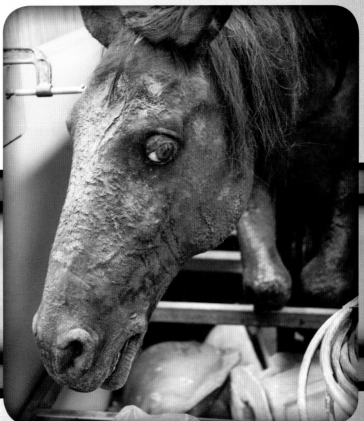

INANIMATE CREATURE MAKEUP
with Bob Romero

Makeup artist/hair specialist Bob Romero shows us how he (with the help of assistant Yoshimi Tanaka) transforms a practically hairless dummy baby into a very hairy baby gorilla!

"Hair application is a painstaking process, so it's important for everyone involved in the production to keep a sense of humor. Orson Welles once told me, when we were working together on set, 'If they're not laughing, fire 'em.'"

—Bob Romero

First Yoshimi repositions the human baby's fingers and toes to make them more simian.

Next the skin color has to be painted.

Yoshimi paints the baby's skin color to more closely match the appliances and hair that Bob will apply after the paint has dried.

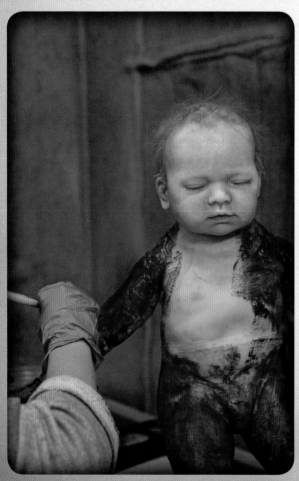

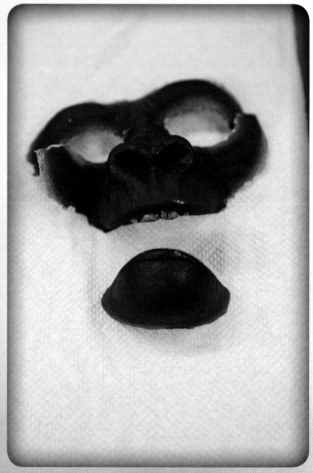

From his days on the sets of *Planet of the Apes* films, Bob has an impressive collection of original foam latex facial prosthetics. Some of these foam latex appliances are almost fifty years old (as the writing on the prosthetics jar lid attests.)

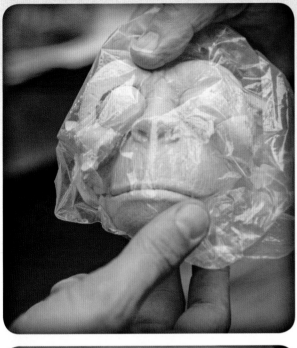

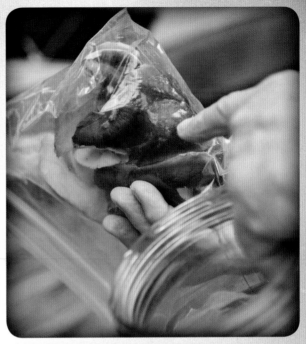

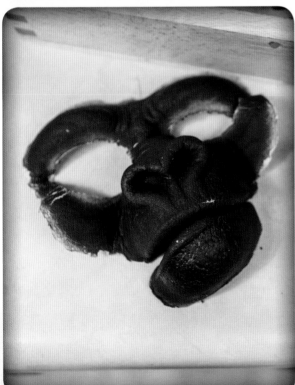

Bob selects the appliance that is the best match for the face of the dummy human baby. It's a lot harder to manipulate the appliance for an inanimate creature than it is on a live actor.

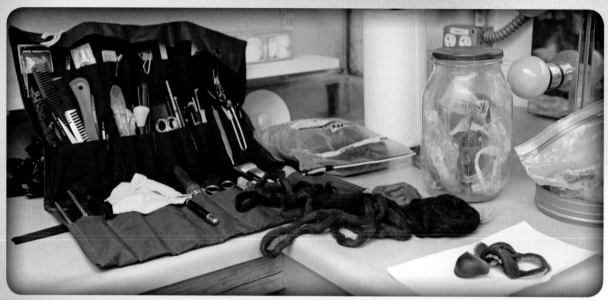

Bob's never applied a foam latex facial appliance to a dummy baby before, so he's hoping that the Telesis glue he's chosen will work.

Before Bob applies the prosthetic, he selects the hair so that it's ready to be glued on while the prosthetic is drying on the baby's face.

Bob will use an air conditioner filler sponge—one coarse, one fine—to stipple on the glue in small spots.

Bob brushes the Telesis glue onto the baby's face and onto the facial prosthetics (upper and lower) and applies them.

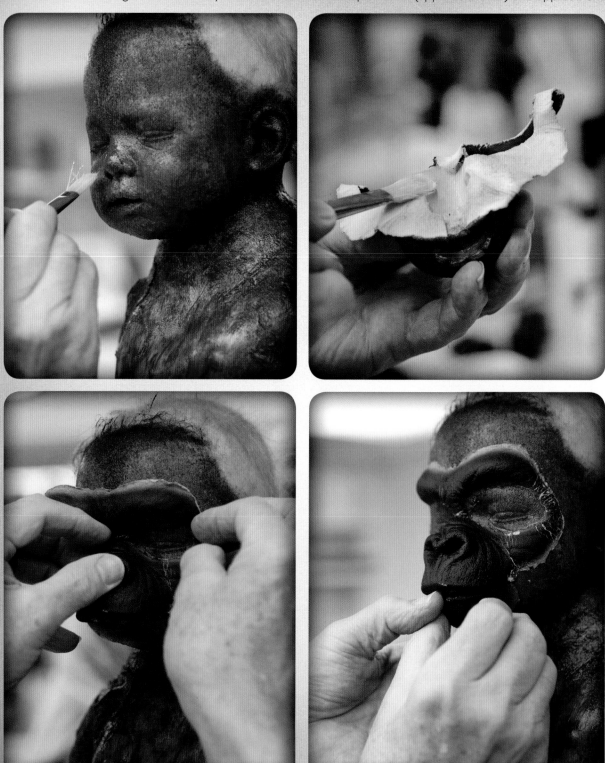

With the prosthetics in position, it's time to apply the hair.

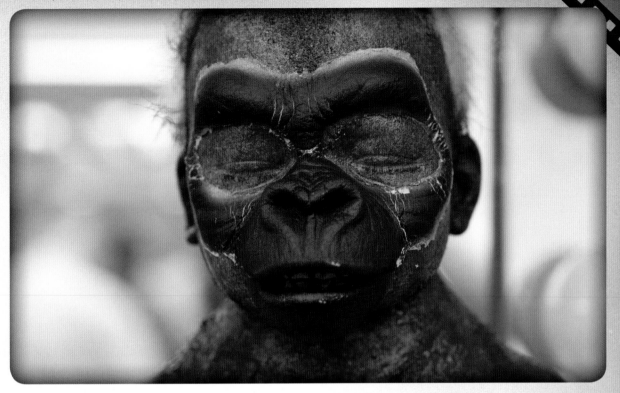

While the gorilla baby's prosthetic appliances dry, Bob prepares the hair he'll use to create the gorilla baby's coat.

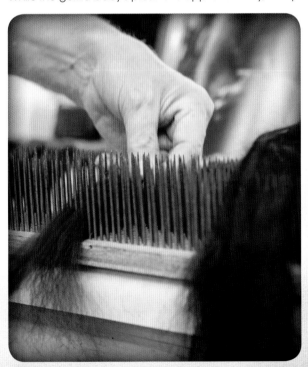 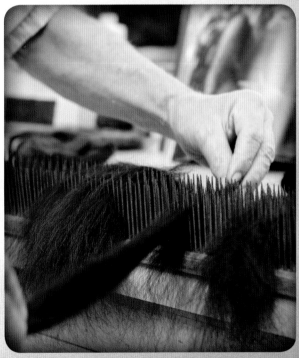

Just as he does for a live actor, Bob prepares different shades of hair to glue down on the dummy baby's skin by combing it through a hackle board.

This is a full-body application, and in spite of the fact that it's a baby-size body, it takes a surprising amount of hair.

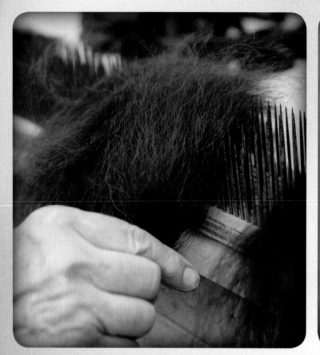 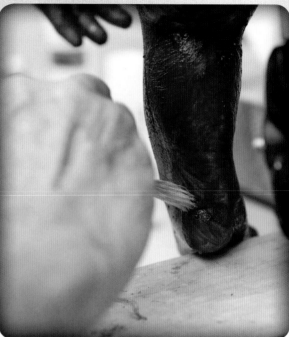

Bob glues and trims one strand of hair at a time.

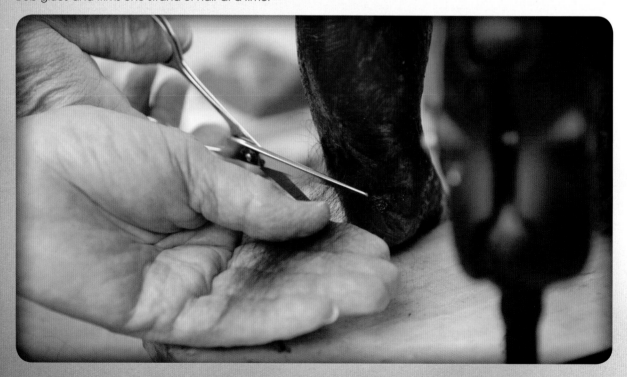

Bob glues and trims, hair by hair, until almost the entire body of the baby has been covered. (This process can take anywhere from six to ten hours!)

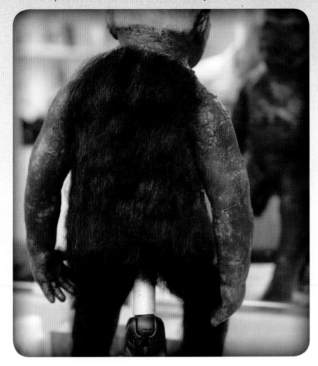

Now that the prosthetic appliances have dried, Bob takes a break from the hair application to paint the appliances so they blend into the "skin" and hair.

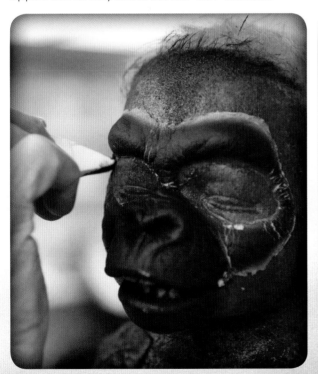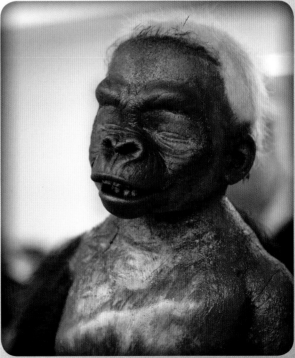

While the paint dries, Bob covers the rest of the baby's body with hair.

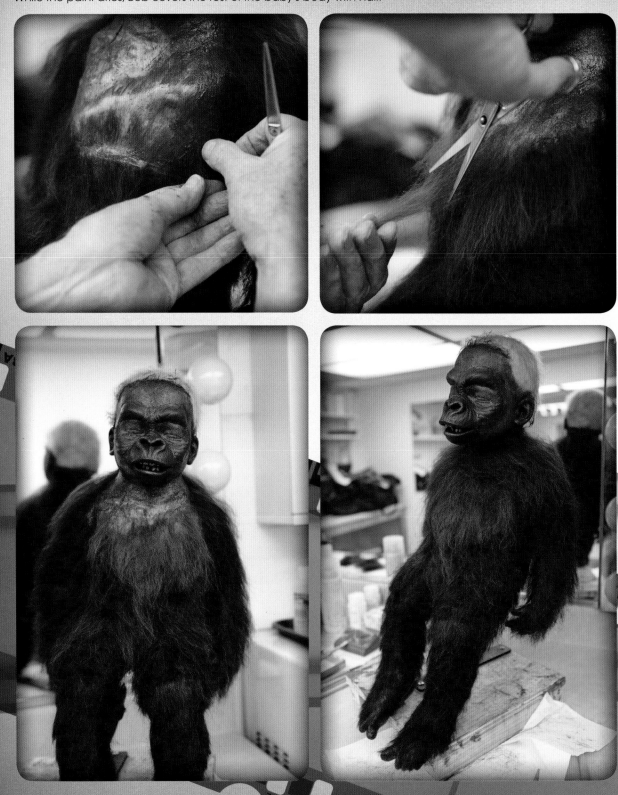

Bob sprays hair dye to transform the blond hair on the dummy human baby's head to a dark black/brown to match the baby gorilla's face and fur.

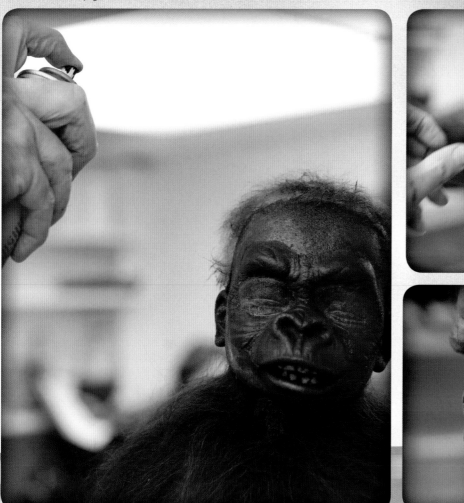

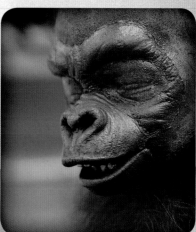

Then Bob brushes on more glue. He layers on more hairs, trims, and repeats. All the baby gorilla needs now is some facial hair.

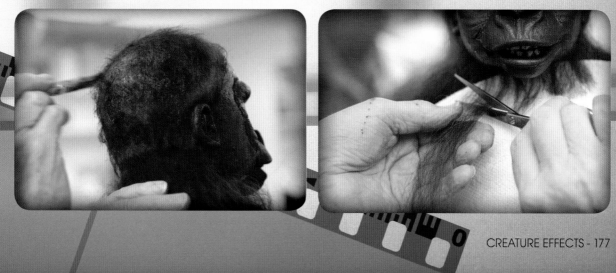

And as Bob snips and trims the finishing touches, the human dummy baby disappears. Bob sprays the hair with both an "old school" hair spray (made from seaweed and water, which keeps it in place but malleable, without making it sticky) and Krylon to set it.

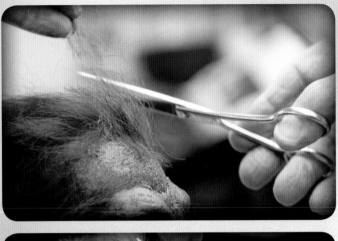

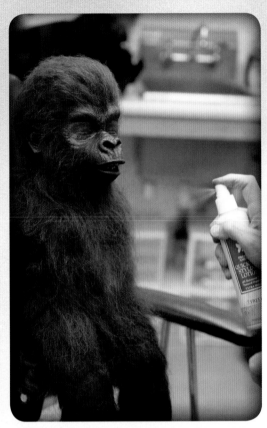

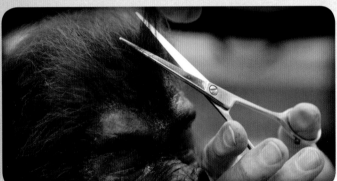

The tranformation from dummy baby to baby gorilla is complete.

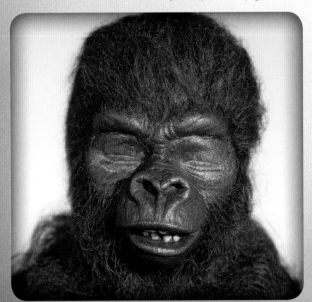

This baby gorilla is ready for his (or her) close-up.

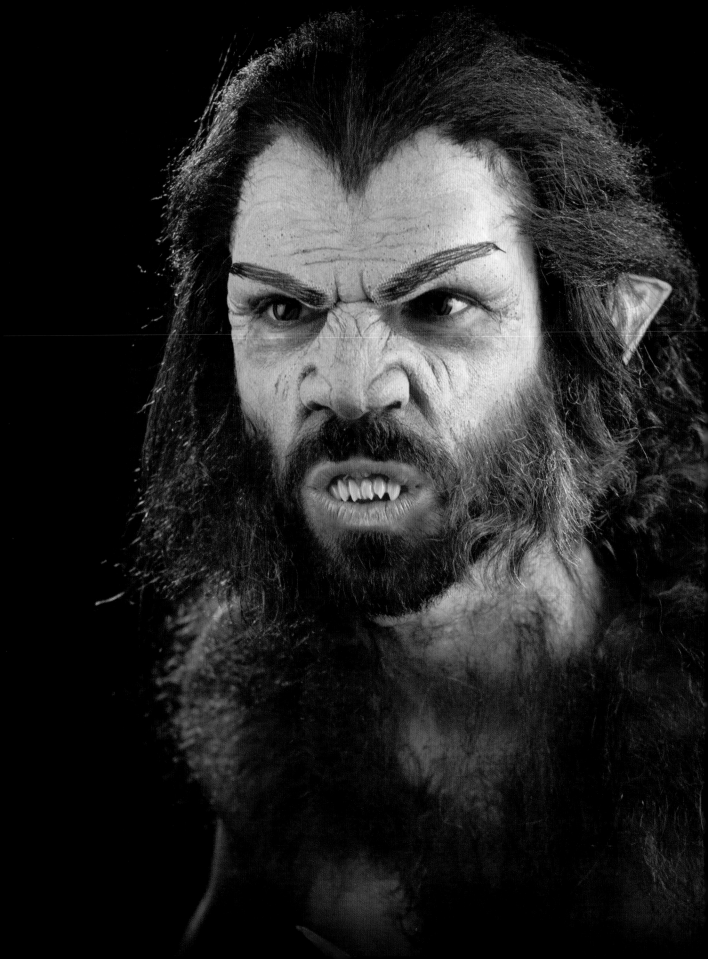

HAIR AND WEREWOLVES

"How does a makeup artist grow hair for a character? There's no magic tonic or shampoo that can generate the kind or volume of hair that productions require. Luckily, there is a rare breed of makeup artist that weaves and sews, by hand, custom-made hairpieces for every occasion. It takes the patience of a saint, as most beards each take fifty hours or more to make, and a complete hair wig can take over a week to create!"

—John Blake

HAIR APPLIANCES AND APPLICATION
with John Blake

We consulted with special-effects makeup artist John Blake to discover the mystery behind the magic.

John Blake has been the go-to makeup artist for all types of special-effects makeup for some of Hollywood's biggest films: *Fast and Furious 6*, *Iron Man 2* and *3*, *The Avengers*, *Pirates of the Caribbean: Dead Man's Chest*, *Men in Black 2*, *Planet of the Apes*, *Tropic Thunder*, *Nightmare on Elm Street*, *Pet Sematary*, *Fargo*, *There Will Be Blood*, and the list just keeps on going. He's worked with some of the biggest names, such as Martin Scorcese, Johnny Depp, Robert Downey, Jr., Ben Stiller, Tom Cruise, Natalie Portman, and more! John saw that the hair appliance aspect of the business was underserved, so he wholeheartedly leapt in (being a former acrobat performer) to make himself an expert in this area, as you can see from his website www.johnblakeswigs.com.

"Preparation is everything, and painstaking attention to detail is key to making hair appliances authentic."

—John Bake

John Blake shows us how he turns clean-shaven actor (Bill Myer) into a hairy biker dude complete with beard, mustache, and sideburns appliances.

If John has the time and the budget, he creates a custom appliance, which is made to fit the specific actor on whom he's working; and he generates hair patterns of his own design.

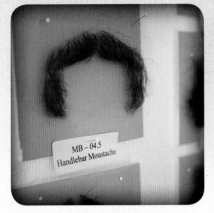

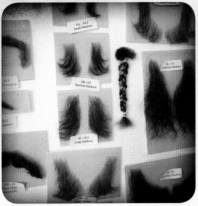

John applies plastic wrap and adhesive tape to the areas in need of facial hair and draws the outline for the patterns.

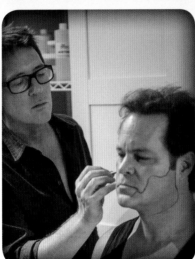

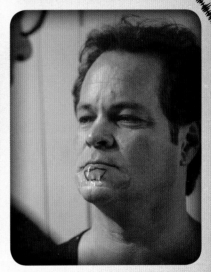

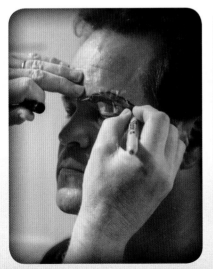

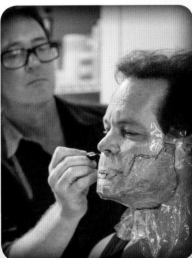

John then molds the plastic wrap pattern to fit the actor's face.

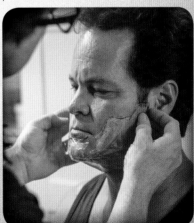

John makes a partial life-cast mold of the lower half of the actor's face and then presses the patterns against that mold once it has dried to assess the size of the appliances he'll need. If he has a beard and/or mustache in the actor's size, he'll use that. If he doesn't, he'll use a loose hair application, the quickest and best way to add facial hair to a character.

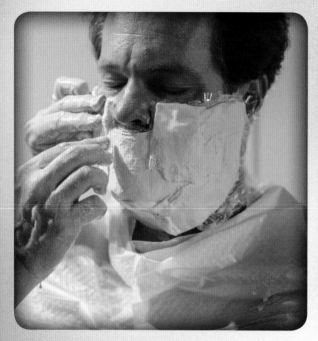
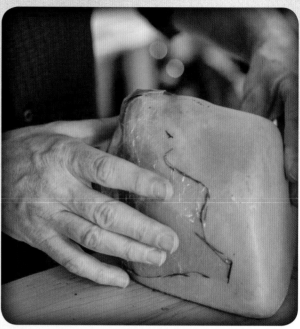

If John wants to generate a custom handsewn appliance, like a mustache, he traces the plastic wrap outline onto a piece of blue paper and then cuts it out.

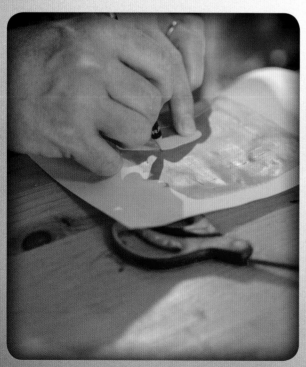
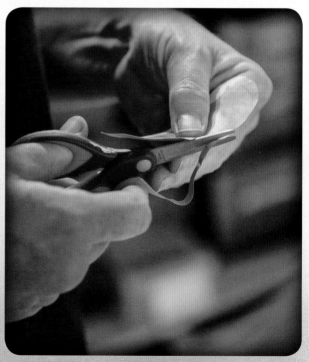

John takes a sheet of nylon netting, known as "lace" (originally intended as the material for women's stockings, invented by DuPont in 1938) and attaches the blue patterns to the nylon. He lays down the pattern on the sewing dummy's head.

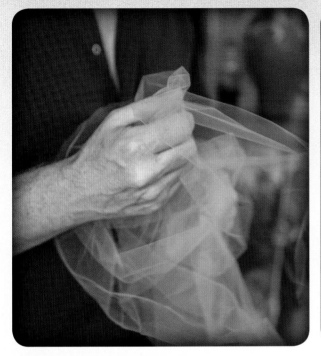

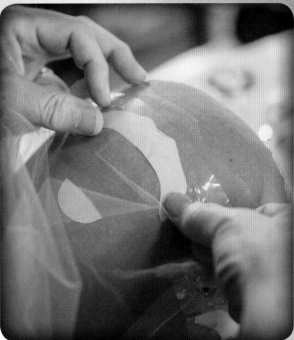

He then pins the patterns to a sewing dummy's head and cuts the lace into workable sizes.

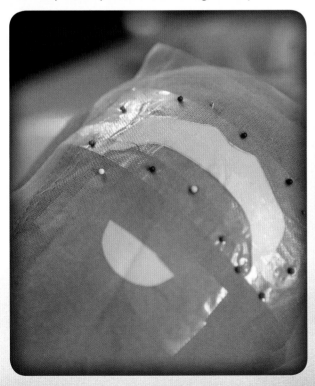

With the patterns in place, now it's time for John to prepare the hair.

What type of hair do makeup artists use? It varies. Some hair is authentic human hair. But most of the hair used in appliances for modern-day productions is yak or goat hair, or dyed and treated wool.

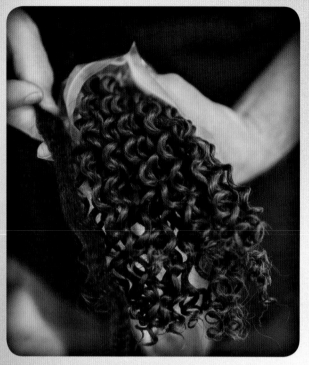

After John selects the hair he wants to use, he runs it through an antique fluting machine to unwind and straighten the hair to make it workable. Then he fits the hair into a hackle (a spiky board of nails that could double as a deadly weapon) to separate good material from bad, and to blend different colored strands together.

 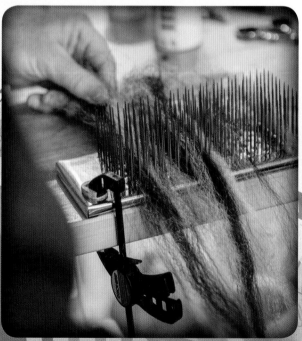

To sew a complete set of custom facial-hair appliances, like the ones that John has fitted Bill for, could take a week or more.

Using the tiniest of threaders and a supersized magnifying lamp, John pulls each individual hair through the nearly invisible holes in the lace, knotting each hair at the back.

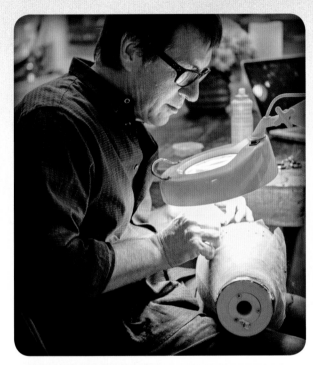
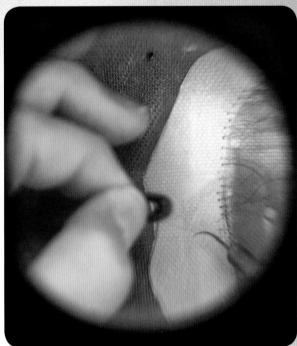
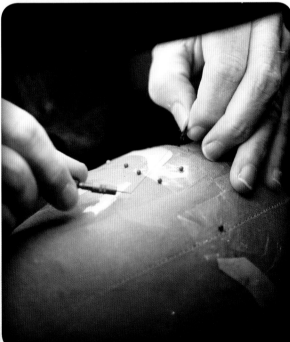

When there's no time or budget for a handsewn appliance, John will opt to do loose layups, especially for something like a biker's beard and sideburns. "Loose layup" means he'll apply loose hair freehand directly to the skin, or to a thin sheet of silicone, and then apply the silicone sheet to the actor's skin. Loose layups are faster, less expensive, and the actor has greater range of motion when the hair is applied in this way. The downside of a loose layup is that it needs to be applied daily, and in precisely the same way each time, whereas a handsewn appliance can be reused for multiple days of production and is an easier way to maintain a consistent look.

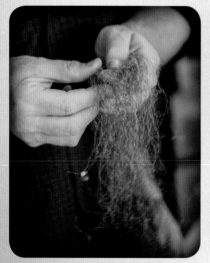

John applies the longer loose hairs with Pros-Aide, a fast-drying adhesive.

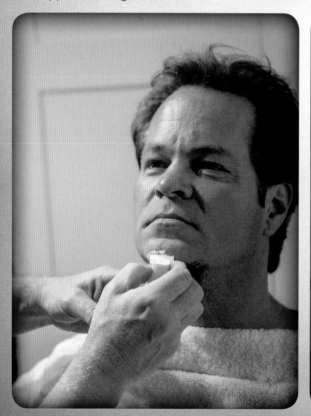 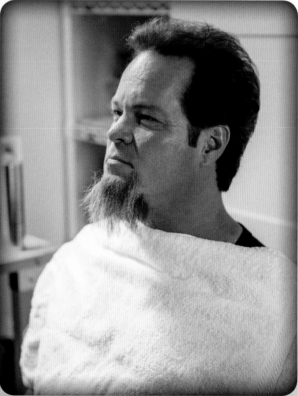

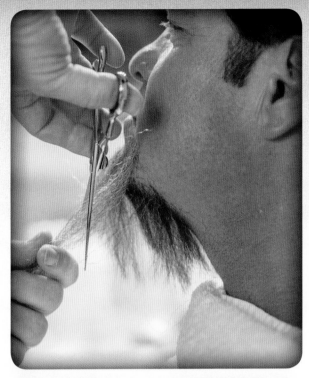

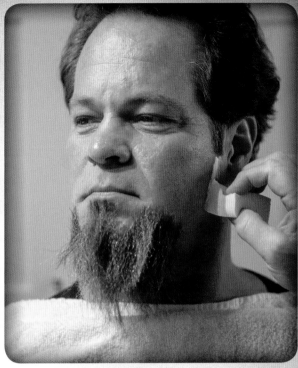

John cuts, trims, and shapes the sideburns and the beard until he's happy with the look, which he sets with a seaweed and water hair spray.

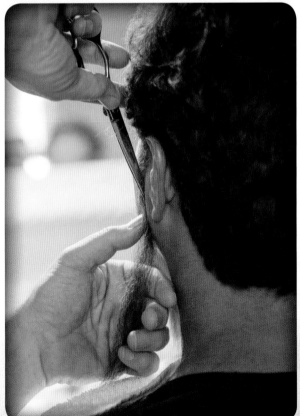

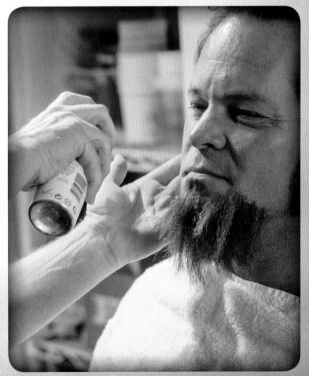

John glues down short pieces of hair to fill in the gaps between the sideburns and the beard for a scruffy, unkempt biker look. When Bill is scruffy enough, it's time for the pièce de résistance—the mustache, which John always applies last.

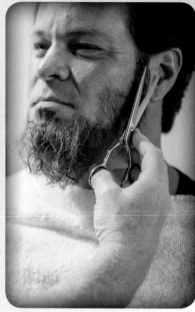

John sometimes premakes this type of silicone-backed mustache appliance. He traces a pattern onto a thin layer of silicone, and glues the hair directly onto the silicone.

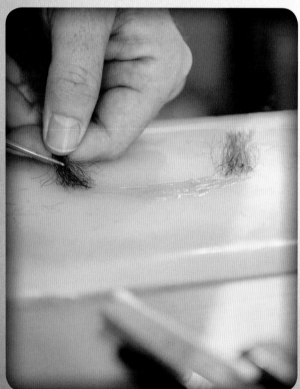

Before applying the mustache, John shapes, layer-cuts, combs, and trims the mustache hair.

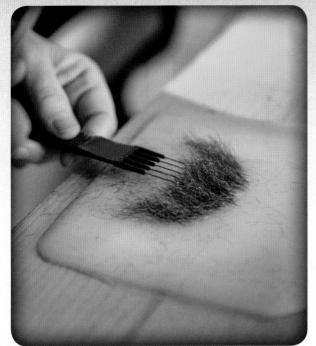

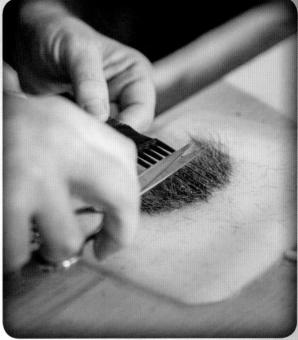

He then places the mustache on the actor's upper lip while gently brushing the skin behind with glue and carefully sealing the edges.

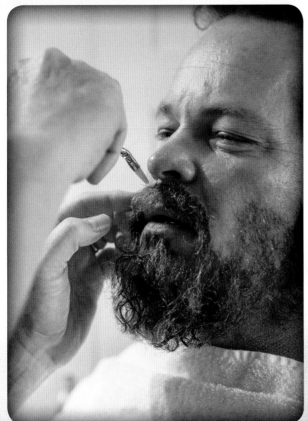

THE WEREWOLF AND THE HAIR
with Tony Carrillo and Bob Romero

Tony Carrillo, a special-effects makeup artist at the Creature Effects, Inc. Lab owned by Mark Rappaport (www.creaturefx.com), along with consultant Bob Romero (special-effects makeup artist and hair specialist), shows us how the hair-application process, combined with facial, ear, and dental appliances, turns actor/trainer Ricardo Vargas into a terrifying werewolf.

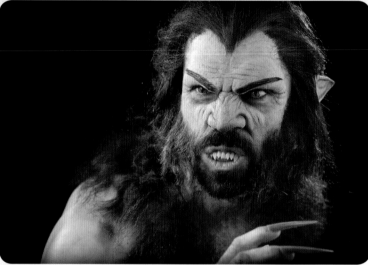

Tony has a variety of different hairpieces to create this fierce werewolf's hairy exterior, ranging from ready-made handsewn appliances to loose hair, using yak and goat hair for the face and human hair for the body.

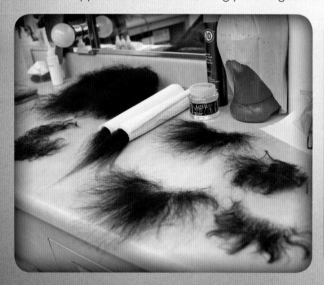

To begin, Tony pins back Ricardo's hair so that he can glue down the foam latex pointy wolf ears and the facial appliance for the werewolf's brows and nose.

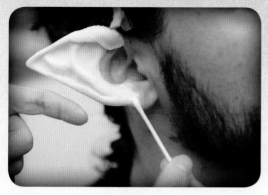
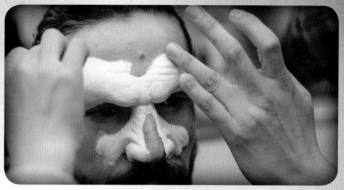

Then Tony mixes flesh-color paints to blend the ear and facial appliances into the actor's skin. He paints in more color details around the eyes to create a fierce-eyed werewolf, and spackle-spatters color to give the skin the effect that there's blood coursing through it.

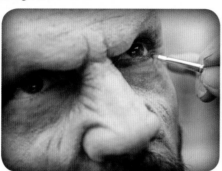
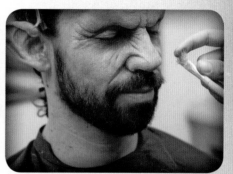

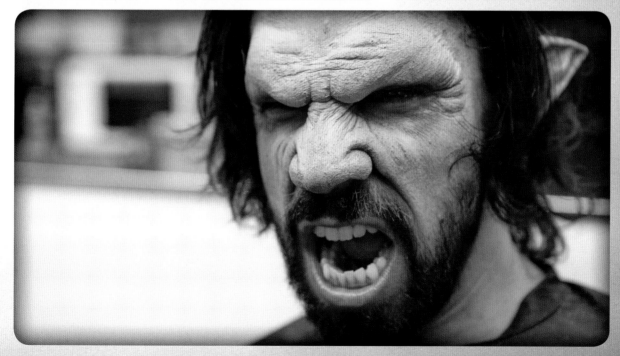

Tony adds eyebrow appliances to the actor's own brows.

 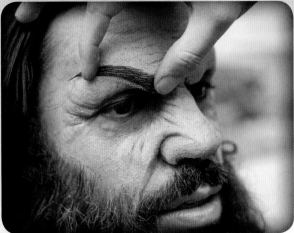

Then he glues down sideburn appliances to blend in with the actor's own facial hair.

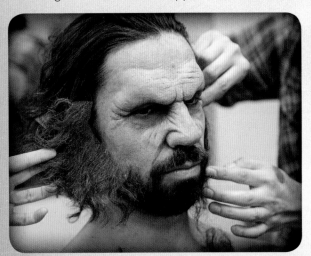 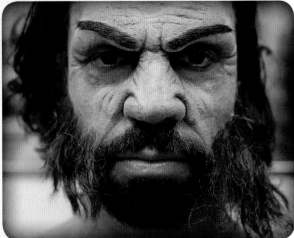

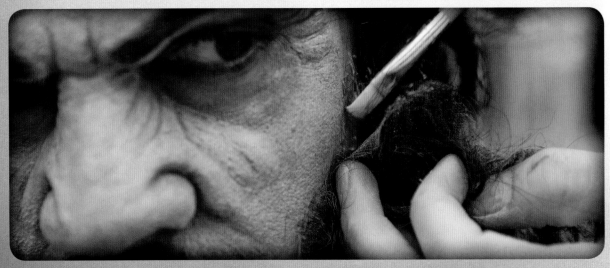

Tony glues down loose hairs on the actor's neck and chest to blend with the actor's own body hair.

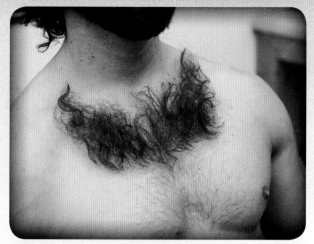

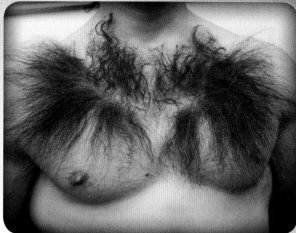

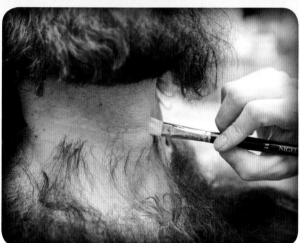

To create a widow's peak hairline, Tony glues down several strands of coarse hair to the actor's forehead and adds forelocks to the temples.

Bob Romero lends Tony one of the hair-shawl appliances that he handsewed to create a wolf-like pelt on the actor's hairless back and shoulders. Tony adds premade werewolf teeth, uppers and lowers, which he fixes in place with denture adhesive.

 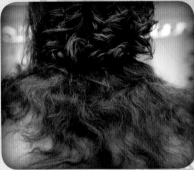 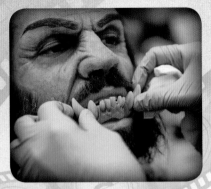

Long, sharp nail-claws and some powdered dirt, along with fine loose hairs glued to the fingers, adds to the animal effect.

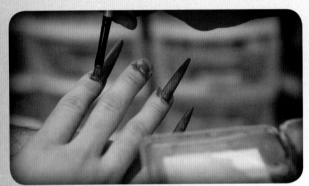 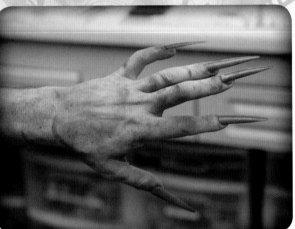

The finishing touch is the pair of wolf-like red-colored contact lenses. Tony pops those into Ricardo's eyes, and the werewolf is ready for his close-up.

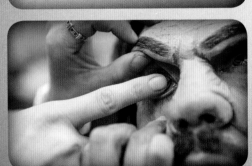 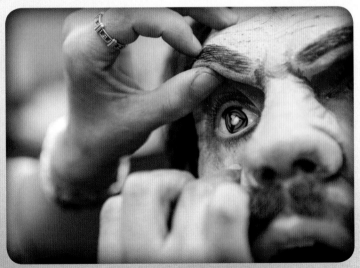

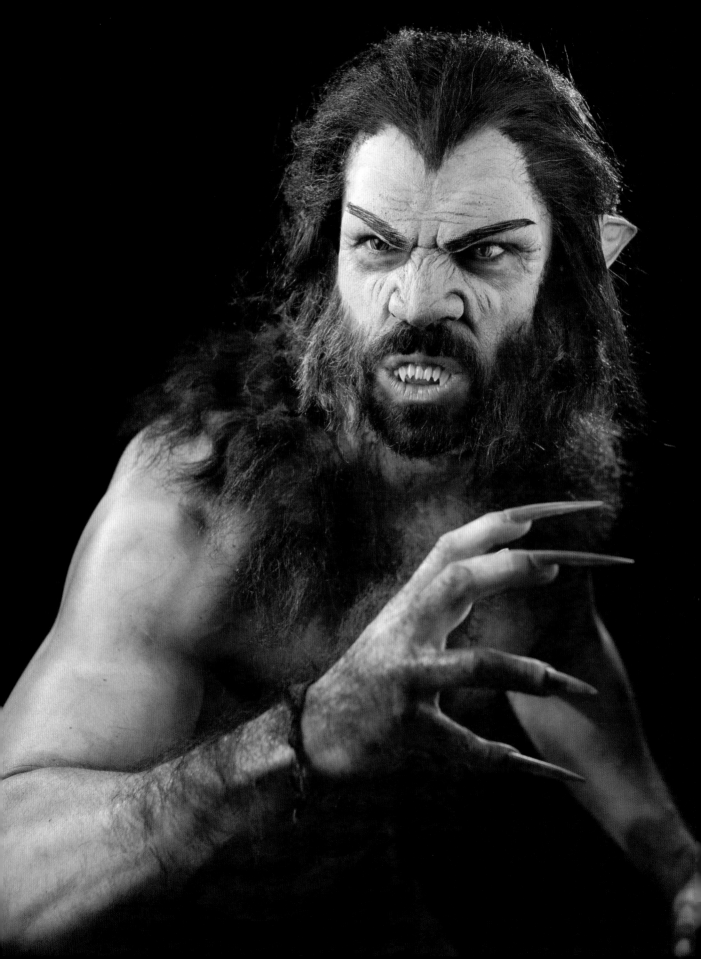

DO IT YOURSELF!
with Yoshimi Tanaka

Create a Werewolf of Your Own

Yoshimi Tanaka, assistant at Mark Rappaport's Creature Effects, Inc. shop in Hollywood, shows how to transform our model for the day, Manon Parisot, into a werewolf out of ready-made, store-bought materials found at any beauty supply or local variety or costume store.

HERE'S WHAT YOU NEED:

Cotton pads and Cotton swabs

Astringent

Fine and medium paint brushes

Derma Shield

Nose and Scar Wax/petroleum jelly

Ready-made, precolored foam latex brow and pointy-ear appliances; ready-made "dog-nose" appliance

Premade dental appliances

Foam latex wedge sponges (stippled and smooth)

Pros-Aide

Handheld blow-dryer

Telesis

Warm water

Translucent powder and puffs

Small plastic cups

Flat metal spatulas

Flesh-color, cream-based paint (Kryolan or Graftobian)

Final Seal Matte Makeup Sealer by Ben Nye

Alcohol-based paints (Skin Illustrator)

99 percent alcohol

Black eyeliner

Beauty makeup eyeshadows: white, gray, and brown

Hairpins

Synthetic hair (available at Halloween stores)

Beauty lip color and brush

Makeup remover

NOTE: People with allergies and sensitive skin should check the ingredients before using.

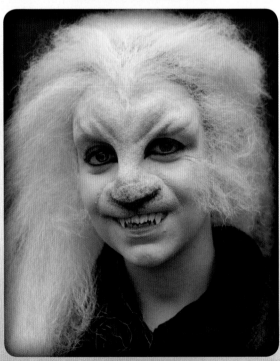

Tie the hair back. Apply Ben Nye's Nose and Scar Wax to the eyebrows with a cotton swab and sponge wedge for easy release when removing the appliance. Lay the eye-brow-nose appliance on the face.

If it doesn't lie flat, place a bit of the sponge inside the bridge of the nose. Brush ear with Derma Shield. Apply Pros-Aide with a cotton swab onto the ear. Then carefully fit the appliance onto the ear with the point facing back, not up. (Otherwise, it's an elf ear.) Tilt the head back, apply the brow appliance to the skin with a wedge sponge, and blow-dry it to cure it.

 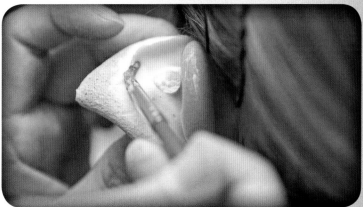

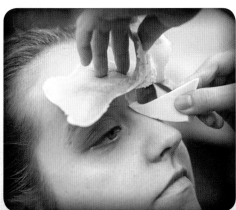 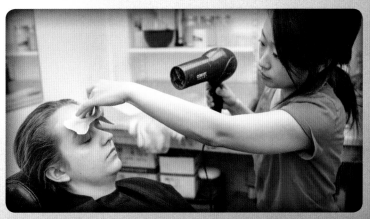

Use Telesis on a fine brush to glue down the edges of all the appliances.

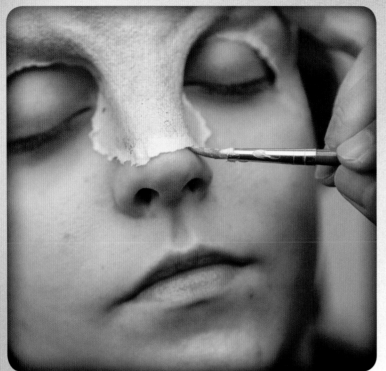 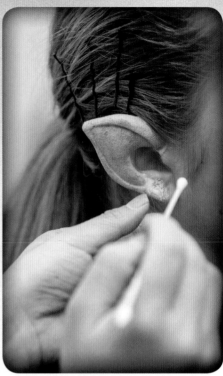

Create a "Bondo"-like substance made of Cabosil and Pros-Aide, and with a sponge wedge, blend glue along the edges and smooth out against the skin.

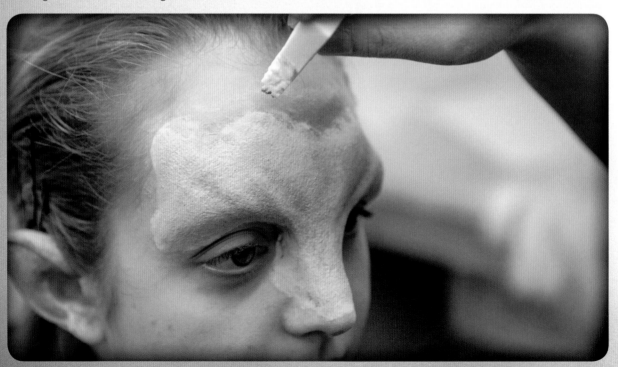

Once the facial appliance is glued down, pat it with translucent powder on a cotton pad to remove excess glue. Then mix a flesh-tone color to blend the skin and the appliances together.

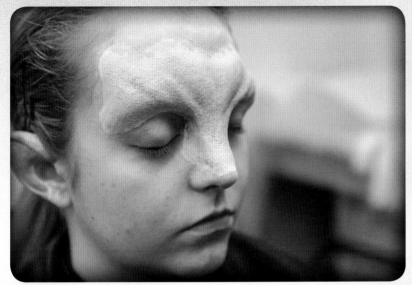

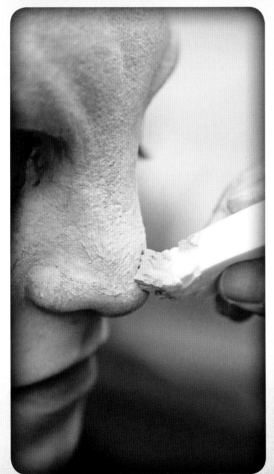

With a sponge and a small amount of warm water, blend the appliance flesh color into the skin. Then set it with Final Seal Matte Makeup Sealer.

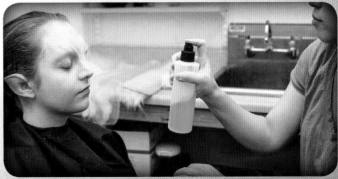

With a small paintbrush, spatter alcohol-activated red and brown paint colors (diluted with a bit of 99 percent alcohol) onto the skin and appliance to give it dimension.

Line the eyes with black eyeliner. Powder the skin beneath the eyes with translucent powder so that any excess eyeshadow powder can be easily wiped away.

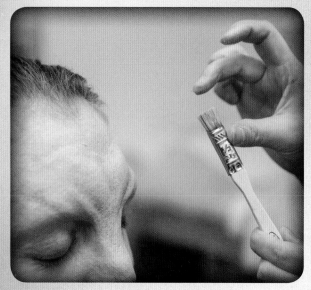

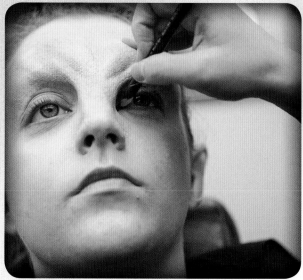

On the eyelids, and around the eyes, brush on regular beauty makeup eye shadow. Beneath the eyes, use white shadow for contrast. To create a set of wolfish eyes, brush dark gray and brown on the lids for depth and contour.

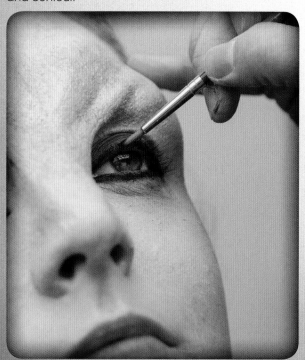

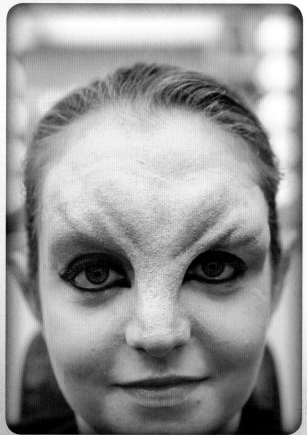

Use hairpins to attach hanks of long, flowing synthetic hair to your real hair. Use Telesis to glue down the strands to the forehead skin and to the sides of the face.

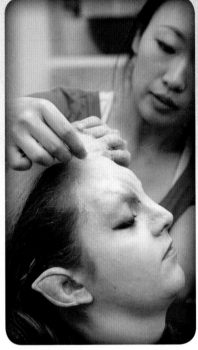
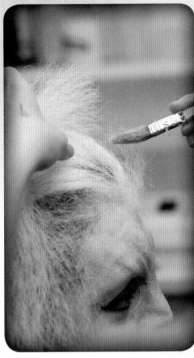
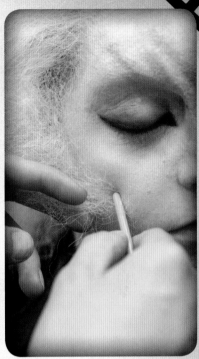

Brush bright red lip color onto the lips. Apply the ready-made nose appliance, following the same steps as described for the brow appliance, and add flesh colors to blend. Insert the ready-made teeth (tops and bottoms).

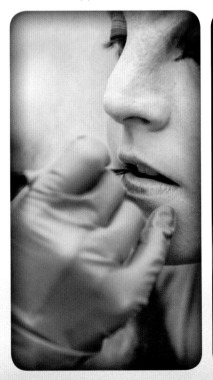
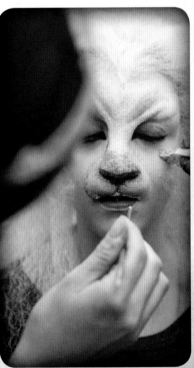
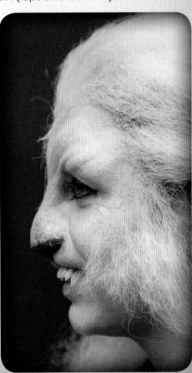

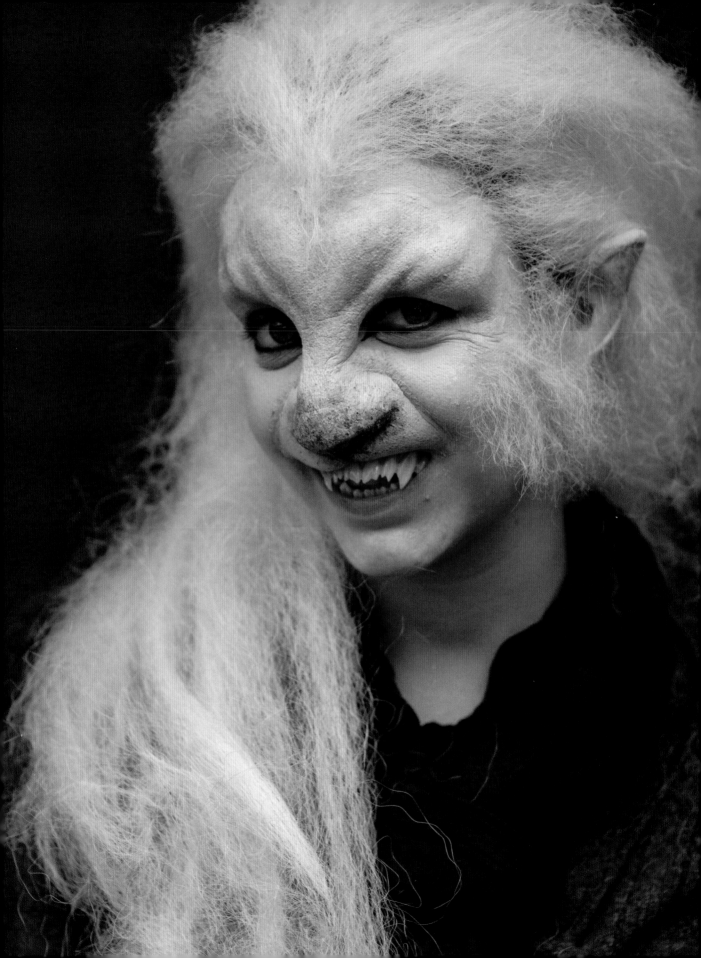

To remove the synthetic hair and appliances, use isopropyl myristate on a brush, sponge, or cotton pad, and gently pry the appliances and the hair from the skin. Use regular makeup remover for the remainder of the makeup. Place (but do not rub) a warm towel on the face to soothe and cleanse.

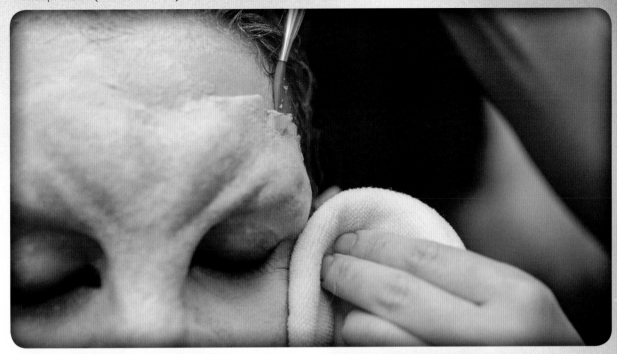

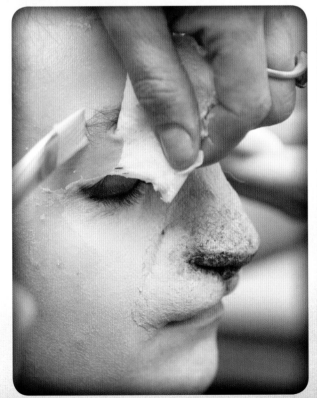

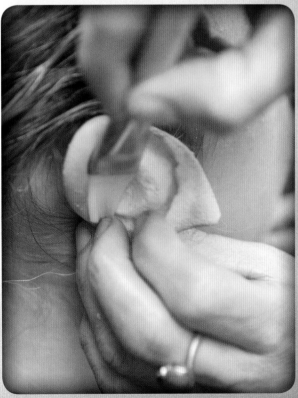

CHAPTER 9
TATTOOS

"Tattoos are like wearing your art on your sleeve, a great form of self-expression that immediately lets the world know something about you. Painting tattoos, instead of inking them, allows for a wide range of flexibility in the storytelling world. And learning about the different types and reasons for a tattoo is as interesting as creating the tattoo representation itself."

—Kerri McGuff

TATTOOS
with Kerri McGuff

By all accounts, the art of tattoo, or tatau, began 2,000 years ago in Samoa. In Samoan culture, and other Polynesian cultures as well, the tattoo was both a brand of pride and status. Males would cover their bodies, arms, and legs with tattoos—a process that would take months to accomplish and close to a year to heal.

Luckily, when film or television projects require characters with tattoos, the special-effects makeup artist is able to replicate the look in way less time, and pain-free!

Kerri McGuff of European Body Art (www.europeanbodyart.com) demonstrates the special-effects way to create authentic-looking tattoos, turning model Cesar Mazzo Nogueira's bare skin into an intricately decorated canvas.

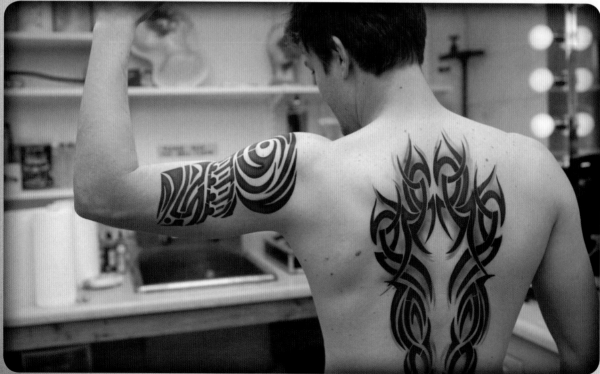

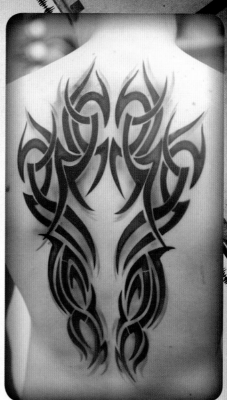

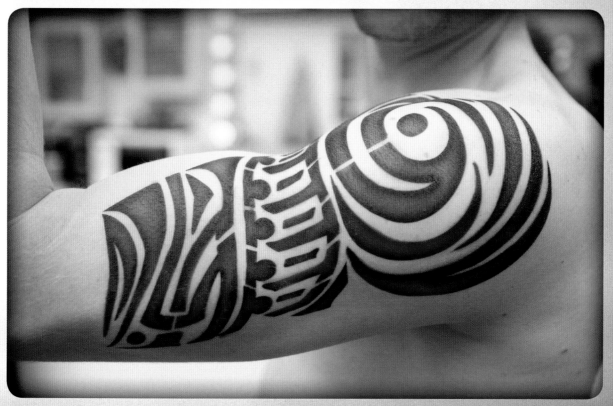

For most special-effects makeup artists, every great tattoo starts with a set of stencils, an airbrush, and an array of brightly colored paints.

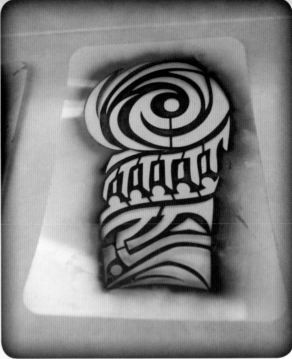

Kerri fits the chosen stencil to Cesar's bare arm.

EUROPEAN BODY ART™
WWW.EUROPEANBODYART.COM

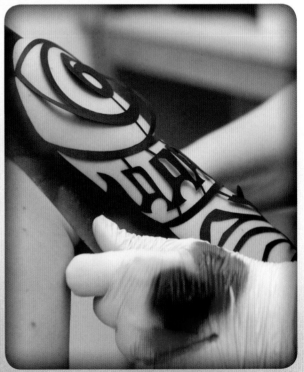

She holds the stencil in place as she airbrushes sections of the tattoo with red and black paints.

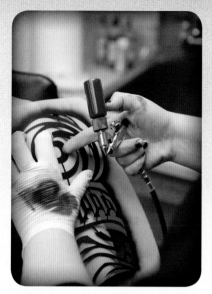
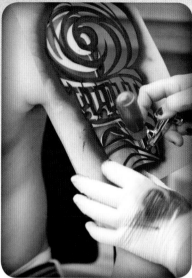
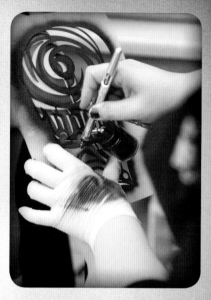

She fine-tunes the outlines of the stencil with a cotton swab. And tattoo number one is complete.

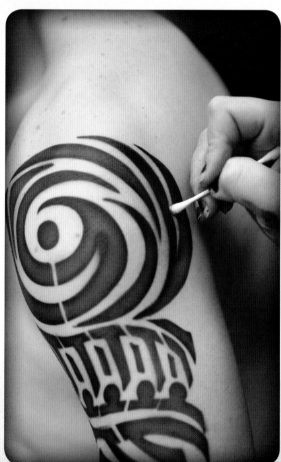
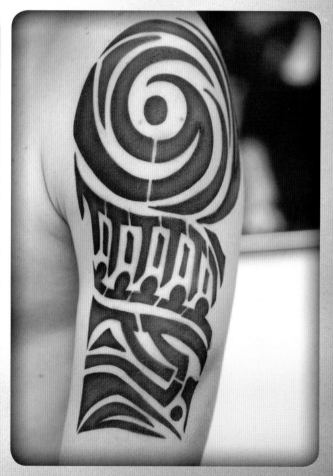

Now she selects a tattoo stencil for Cesar's back—a larger empty canvas that's just begging to be painted.

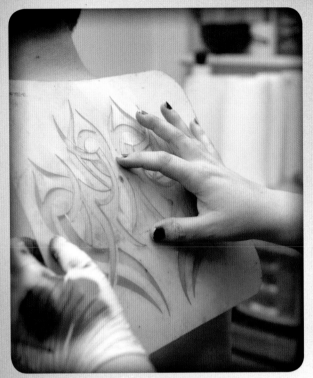
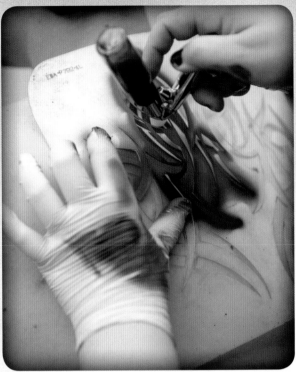

Kerri chooses blue family colors with a black outline for this tattoo design.

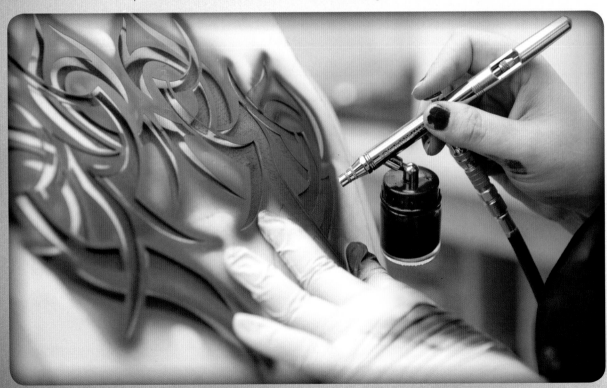

But Cesar's back still has plenty of bare canvas left. So, Kerri selects another stencil to airbrush as a complement to the one she's just completed, and then another stencil for symmetry. She airbrushes in different shades of blue to create depth. Now the back design is colorful, dimensional, and complete!

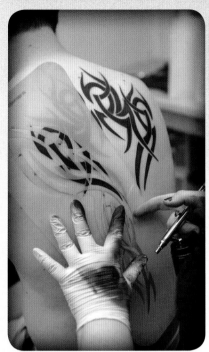

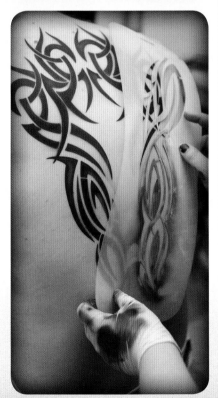

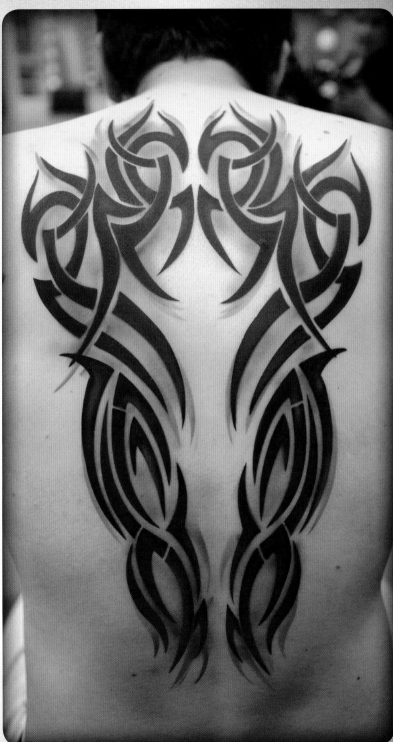

This time she uses yellow, green, red, and black.

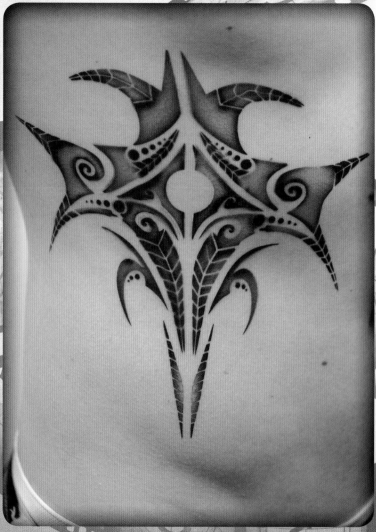

Cesar's body is now a live canvas and ready for camera.

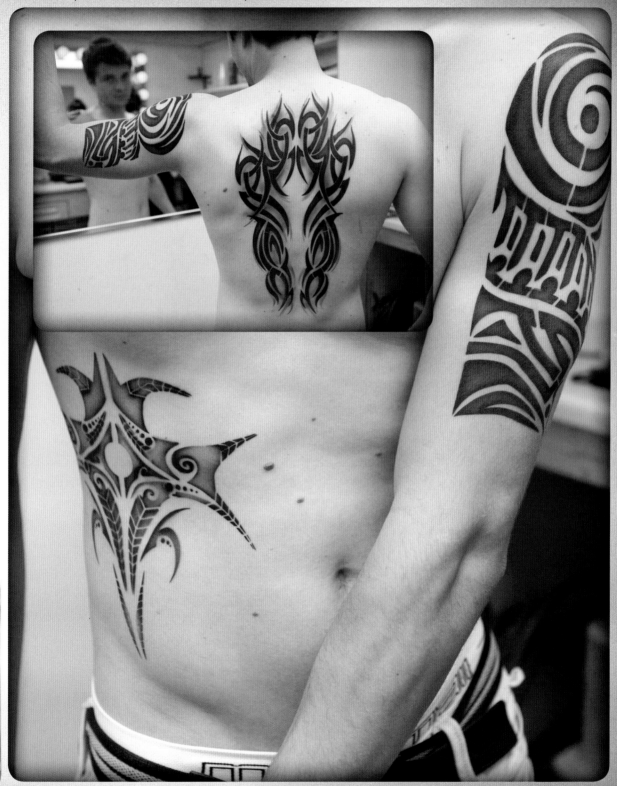

DO IT YOURSELF!
with Bruna Nogueira

Tattoos are one of the easiest and most fun effects to do on your own. Tattoos can be a costume by themselves if you put enough of them on. And with special-effects tattoos, there's no pain involved.

HERE'S WHAT YOU NEED:

Tattoo transfer sheets (available at any beauty supply or tattoo shop)

99 percent alcohol

Alcohol-activated paints

Sponge wedges

Powder puff

Water

Paper towels

Translucent powder

Powder brush

NOTE: People with allergies and sensitive skin should check the ingredients before using.

Every tattoo tells its own story. Different ethnic groups and cultures use tattoos as symbols. So when using tattoos to create an authentic character, it's important to do research to make sure that your Russian mobster isn't wearing a Brazilian tattoo.

Tattoo model James Wesley Hannah already has more than fifty tattoos, but he acquired his the hard way, with ink. The tattoos Bruna adds in this workshop will be a lot less painful!

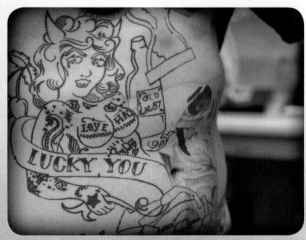

Cut out the outline of the tattoo and the white inserts between the designs, being careful not to separate the tendrils of the design.

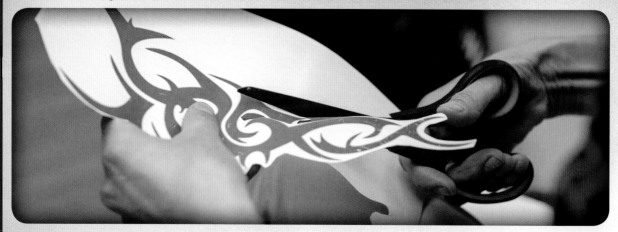

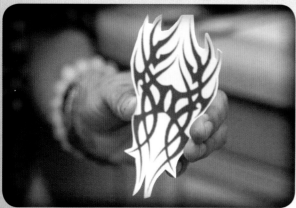

Peel the plastic off the trimmed tattoo design. Place the tattoo transfer facedown on the skin with the paper side up. Dampen a powder puff. Then pat the wet puff against the transfer.

The transfer should stick to the skin in place. Press a dry paper towel against the transfer on the skin.

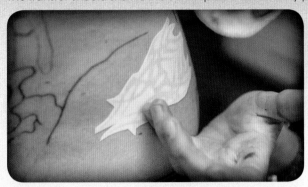 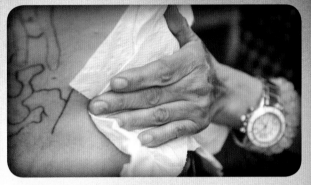

Peel away the white transfer paper, and remove any excess glue by brushing on translucent powder.

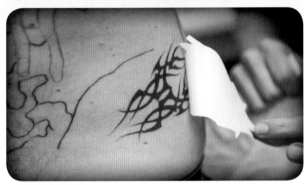 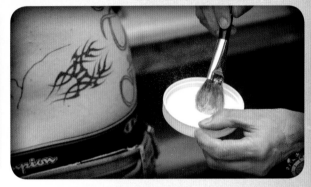

The tattoo transfer design looks just as authentic as the inked ones!

To add to a tattoo that already exists on the skin, add blood-red alcohol-activated paints. Dribble the blood beyond the rose outlines to create a "weeping rose" effect, which makes a nice addition to a Halloween costume. (Paint may be removed from the skin with alcohol; but if not, it can last for up to a month or two.)

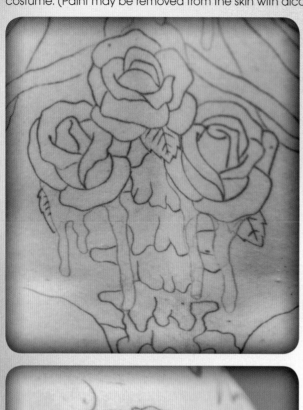

Sometimes when actors show up on set, they "forget" to mention their personal tattoos. At that point, the artist has to scramble to cover them up. Use a Pax Paint makeup base kit and a sponge wedge. Pat the skin rapidly, then let it dry.

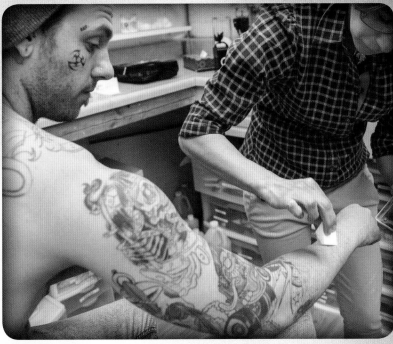

Like magic, James now has one tattooed arm, and one bare arm!

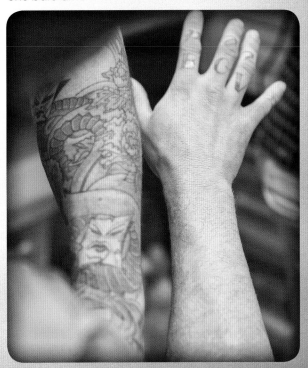

If the actor's role then requires a specific tattoo (not the one he or she came in with), the artist will airbrush over the Pax makeup base with a silicone base makeup to seal the cover-up and let it dry. (The airbrush seal is NOT necessary if no additional tattoos will be added to the skin.)

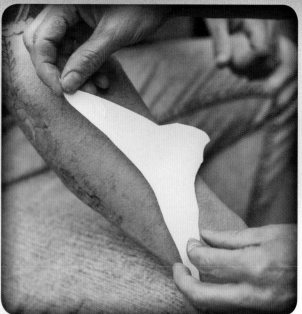

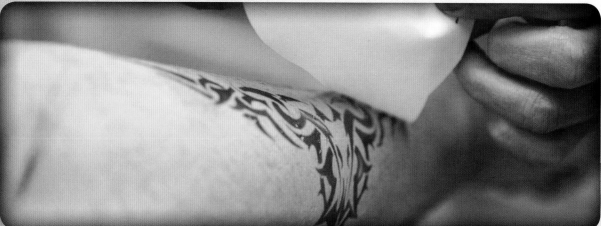

Then apply the transfer tattoo as before, and the new tattoo fits right in with the inked ones.

CHAPTER 10

RED CARPET AND FANTASY MAKEUP

"In the 1920s, when film was only black and white, the makeup was harsh and heavy, and the beauty standard was thin eyebrows and thin lips with lip colors in dark burgundy or black. In the 1950s, the makeup style was red lips and upswept hair. The 1980s was all about blue eye shadow, fuschia lips, sharp contours, and knife-slash applications of blush along the cheekbones. The modern-day emphasis is always to enhance the model's features—and focus on making the eyes wider, brighter, and bigger— unlike the days of old."

—Jackie Fan

RED CARPET MAKEUP
with Jackie Fan

How do the celebrities on the red carpet get that glowing, glamorous, yet natural look? Professional airbrush and beauty makeup, that's how. In fact, some celebrities never travel without their makeup artists so that they're always ready for their close-ups. When makeup is done just right to begin with, it diminishes the need for Photoshop later.

At the TEMPTU makeup studio (www.temptu.com) in Los Angeles, Jackie Fan, one of the TEMPTU professional beauty makeup artists, who also freelances for individuals, demonstrates on model Liza Goncharov how the professionals create that red-carpet look.

Jackie applies primer to condition, hydrate, and smooth out the skin. This way, when it's time to airbrush, any wrinkles or imperfections won't show through the foundation. Concealer goes under the eyes and around the nose.

Jackie selects the foundation color that best matches the model's skin. For olive skin, Jackie blends a base of yellow and white to match the skin tone. For darker skin, Jackie uses black and lightens it, adding more yellow and a little bit of red. Jackie airbrushes the foundation evenly over the face.

In the age of high definition, where every pore shows up on camera, airbrush is almost always the foundation method of choice. It achieves the most consistent continuation of a look, and it makes blending the makeup colors much easier.

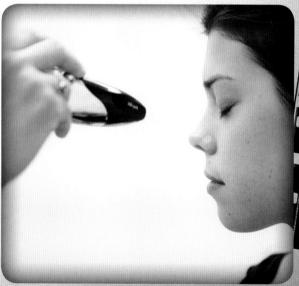

To create definition and depth for the eyes, Jackie adds dark shadow from the corners of the eye toward the middle.

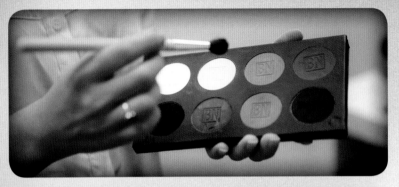

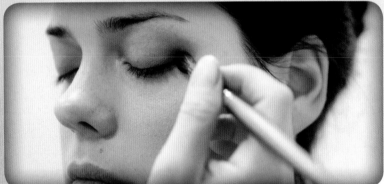

Contrast shadow under the brows brightens the eyes, making them look bigger and wider.

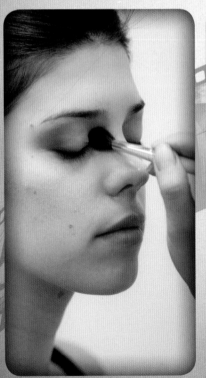

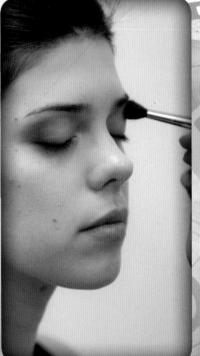

Jackie applies black mascara first and then artificial eyelashes. For a natural look, Jackie uses individual lashes. With a pair of tweezers and eyelash adhesive, Jackie meticulously applies each eyelash, one by one, to the model's own lash line. For Liza, Jackie puts the lashes in the middle to make her eyes look wider and larger. (To elongate the shape of an eye, Jackie will place lashes at the outside corners.)

Jackie then selects the best blush color and applies it to the "apples" of the cheeks and then to the cheekbones. Jackie uses a lip brush to paint on the lip color (matte orange/red), because it provides more precision. Beginning with the bottom lip, she starts at one corner, draws an outline, then fills in the lip. She then does the same for the top lip.

Jackie lets Liza blot the lip color before applying the next layer. She brushes on several layers to make sure that the color will stick and last through the evening.

For a bit of drama, Jackie adds a wing line of eyeliner. She starts at the outside corner of the upper lash, drawing a thin line toward the center. For Liza, Jackie chooses a waterproof aqua-colored liner. But black liner is always a good option. And Liza is now ready for her red-carpet appearance!

DO IT YOURSELF!
with Bruna Farias

You don't have to be a celebrity on the red carpet to look like one. There are a number of beauty makeup products available over the counter to make anyone look glamorous and professionally put together in under ten minutes! Here's how.

Today's model and makeup artist is Bruna Farias. Bruna uses a #4 base color foundation for her airbrush.

HERE'S WHAT YOU NEED:

Airbrush

Insert capsules of foundation colors

Makeup remover

Eyeshadow (Make Up For Ever)

Blush powder (Clinique)

Makeup brushes

Eyelash curler

Lip pencil (Smashbox)

Lip color (Julie Hewett)

NOTE: People with allergies and sensitive skin should check the ingredients before using.

Inexpensive airbrushes and the insert capsules are available at most beauty supply stores. Airbrush foundation is silicone based, and once applied, it lasts all day. It doesn't contain oil, so it doesn't break up—and yet it can be removed with ordinary makeup remover. Select the base foundation color closest to your skin tone. The range of base colors is #1 to #12. Most Caucasian skin tones require colors between #3 and #5. Browner skins usually use a #6 or #7. African American skin tones range from #9 to #12.

Brush on pale pink for eyelids and cheekbones in blush powder (by Make Up For Ever) and accentuate the cheekbones with a complementary blush powder (in Berry Pop) by Clinique.

Use a Smashbox lip pencil (Fair shade) to color in both lips, as a base. The lip pencil helps to control the lipstick and hold its color. Use a medium Sigma eye shadow brush to apply either one lip color or a blend of two, from Julie Hewett of Los Angeles—Camellia Balm in Rose or Peachie. (An eye shadow brush gives the lip color more volume and holds more product than a lip brush.)

FANTASY MAKEUP
with Jackie Fan

BEYOND BEAUTY: FANTASY MAKEUP

After a basic beauty look is applied, makeup artists love to create fantasy makeup looks. Jackie Fan is no exception. The best part about a fantasy makeup: There are no rules!

Jackie Fan was one of a team of artists who made up Lady Gaga for her Grammy performance in 2012 when Lady Gaga popularized the Skull Character look.

Here's how Jackie creates that fantasy look on model Rebecca Pilger.

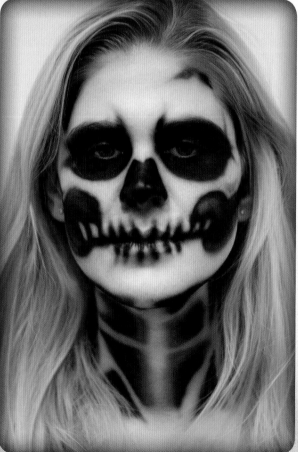

Jackie uses a dual-action air gun to white out the model's skin. (Or she could have used a silicone-based white foundation and applied it manually with sponges or brushes.) This waterproof foundation holds up under the hot lights and dance moves that cause a performer to sweat.

To create the skeleton lines, Jackie consults a photo for reference, but uses Rebecca's bone structure to create the best skull effect for her face.

Jackie paints the outlines of the skeleton bone shapes with a black bodyliner, starting with Rebecca's lips, then her nose, under and around her eyes . . .

. . . her cheeks . . .

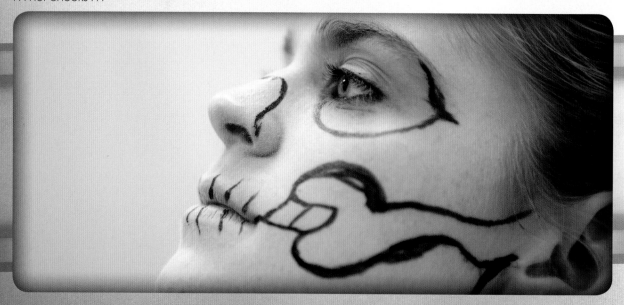

... and her neck.

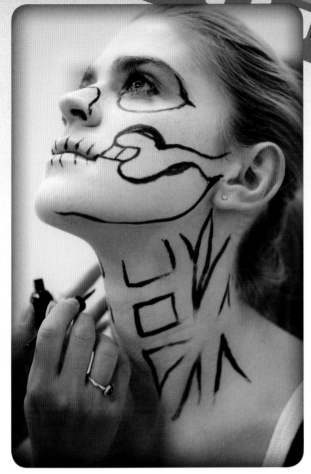

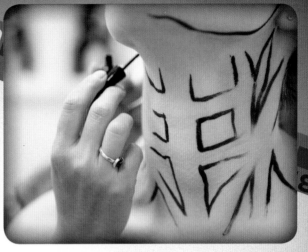

With a synthetic concealer brush, Jackie uses a deep black to fill in the eyelid and to line under Rebecca's eyes.

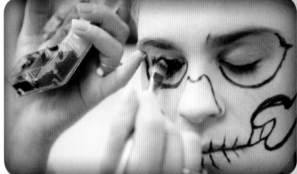

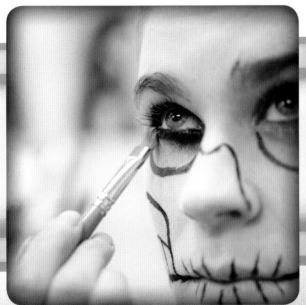

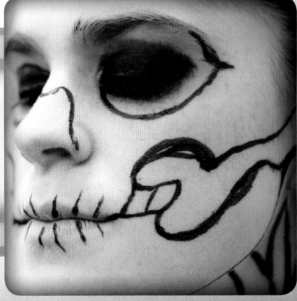

Jackie airbrushes in the shapes with black and then blacks out Rebecca's eyes.

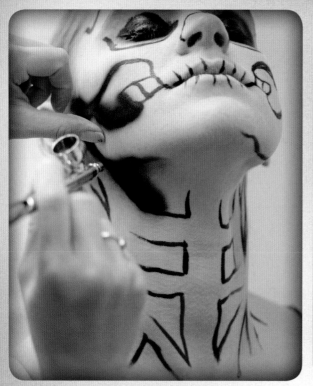

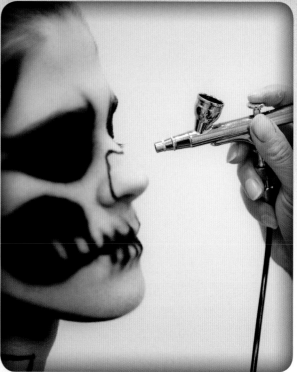

Then she fills in the shapes on her neck.

To complete the effect of a walking skeleton, Jackie airbrushes with black to hollow out Rebecca's facial edges and to fill in the black shadow.

It seems as though it would take a heavy-duty team of cleansers to remove this makeup effect, but in fact, Jackie uses coconut oil, baby oil, or 99 percent alcohol.

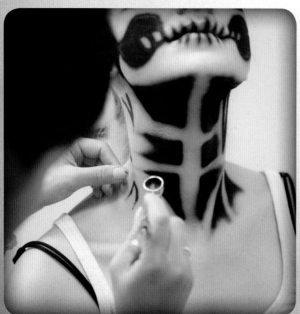

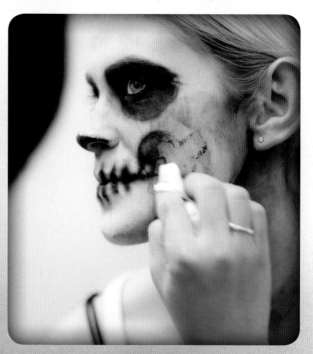

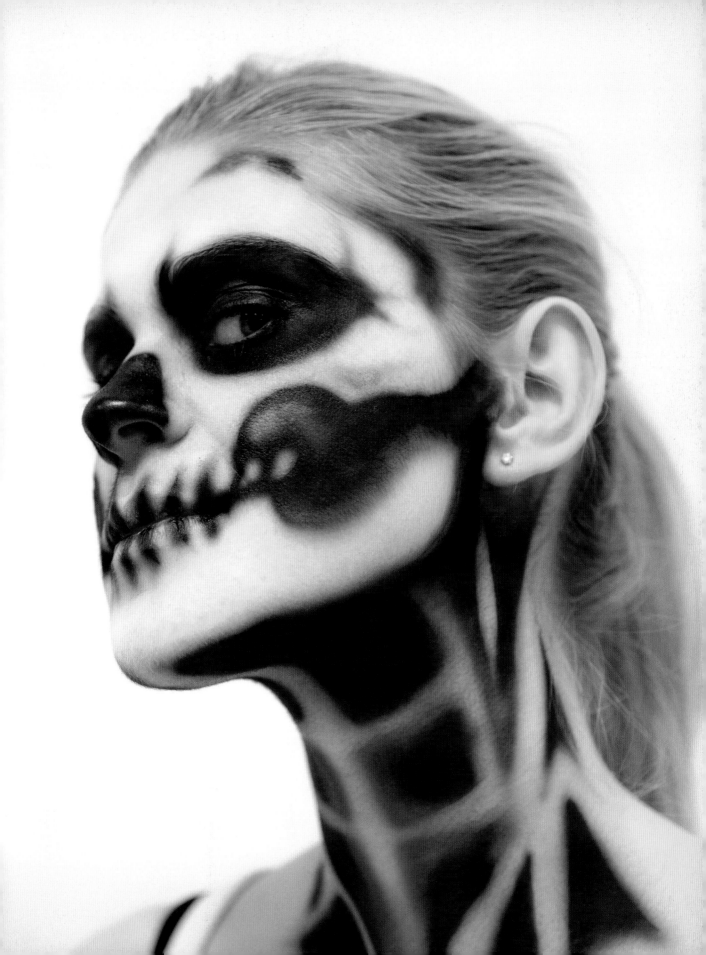

DO IT YOURSELF!

with Rebecca Pilger

CREATE A SUGAR SKULL LOOK

Model Rebecca Pilger makes herself up as a Sugar Skull.

HERE'S WHAT YOU NEED:

White base makeup
 powder and brush

Purple eyeshadow

Black eye pencil

Skin Illustrator alcohol-
 activated paints

99 percent alcohol

Fine paintbrushes

NOTE: People with
allergies and sensitive skin
should check
the ingredients
before using.

For the base, Rebecca brushes on white face powder. With black eye pencil, she outlines her eyes in black-line circles and fills them in with dark purple shadow.

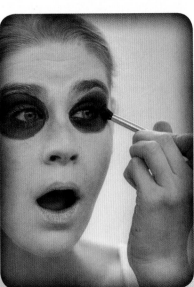

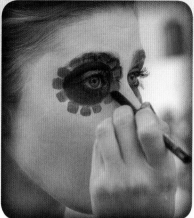

She frames the circles with squares of red paint then outlines the squares with black pencil liner.

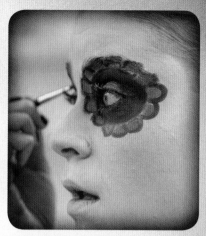

She paints her nose and below with black paint.

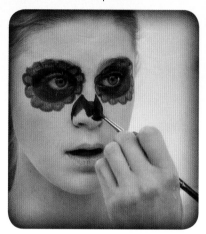

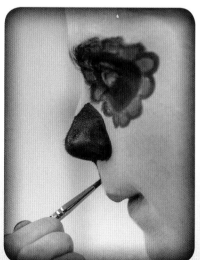

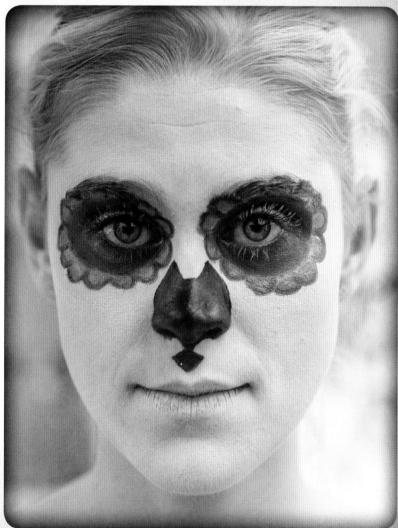

Then she adds a spiderweb-like design to her forehead . . .

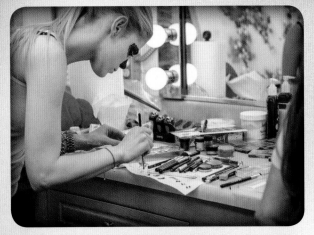
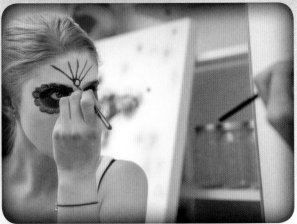

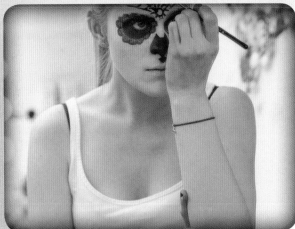
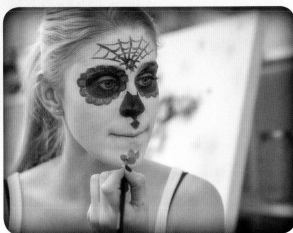

. . . a red flower to her chin . . .

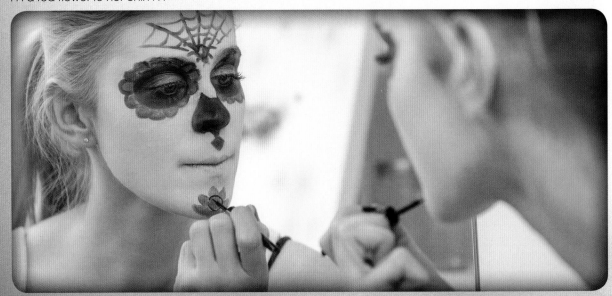

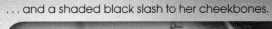

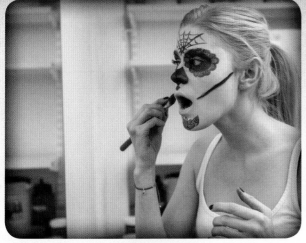

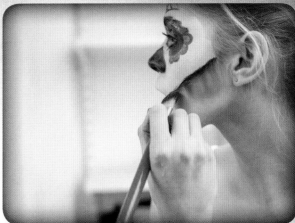

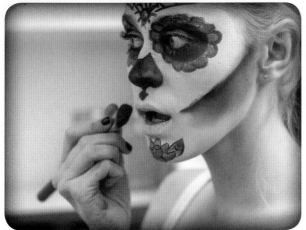

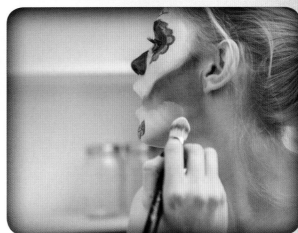

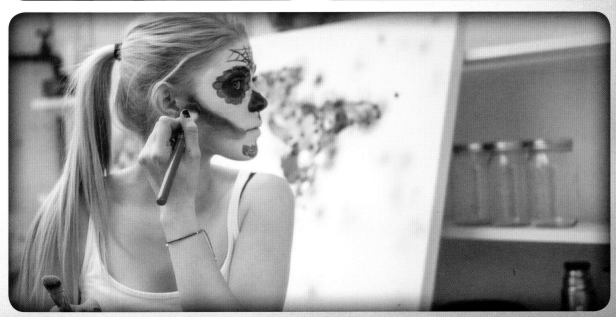

Rebecca adds black "stitch" marks outlining her mouth. Then she adds black paint inside her whitened lip.

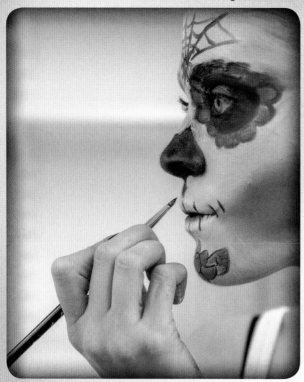 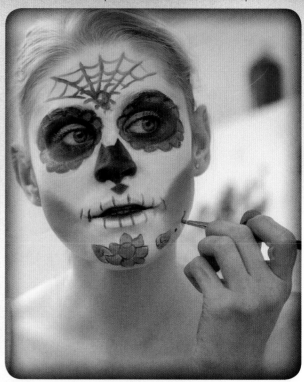

She adds curlicues, dots, and flourishes, in a symmetrical pattern, as the finishing touches.

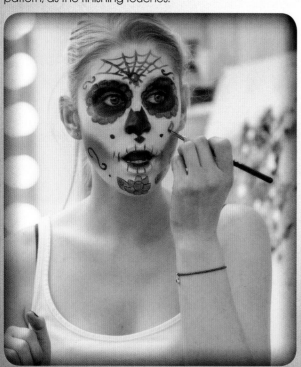 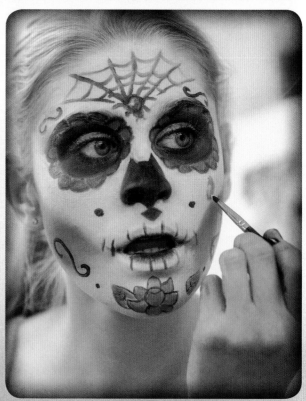

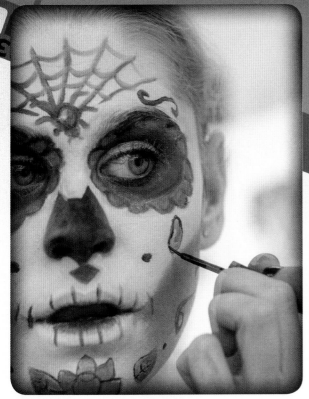
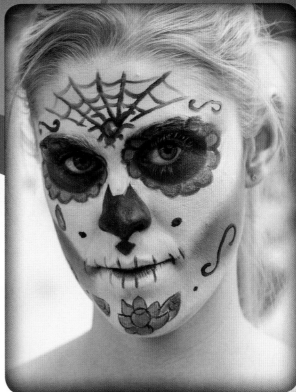
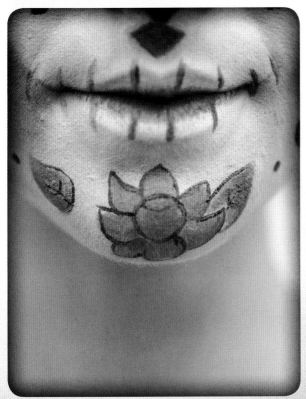

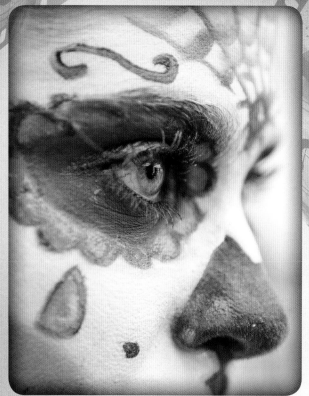
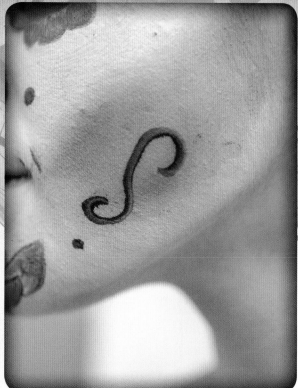
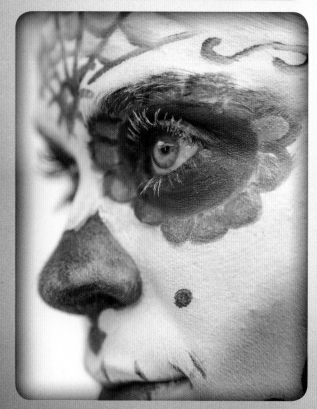
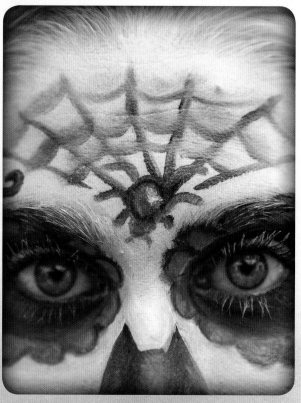

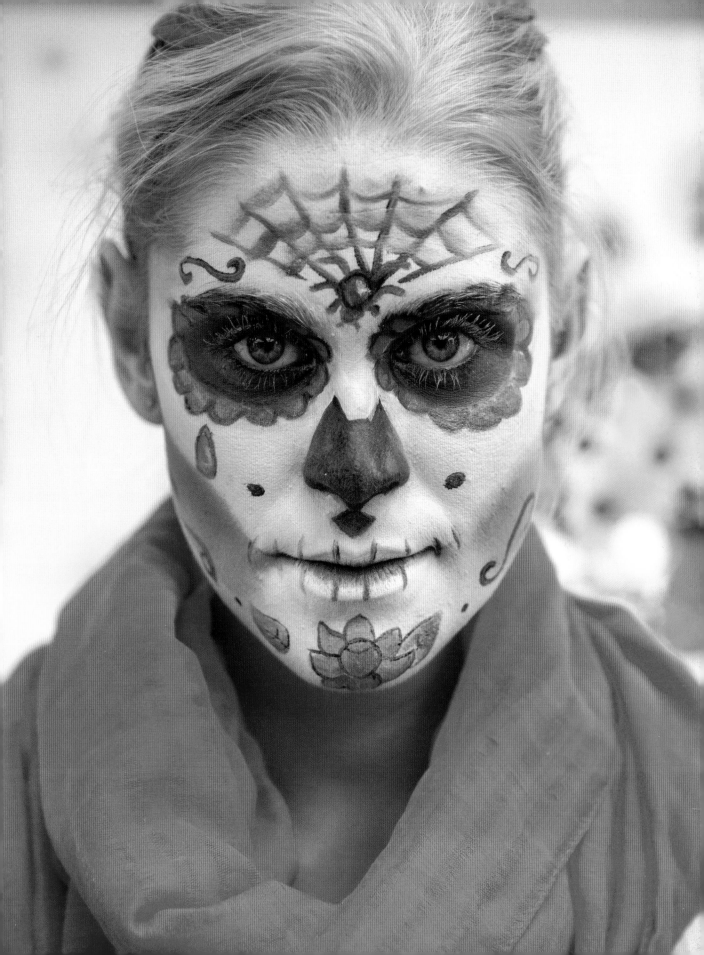

INDEX

ACKNOWLEDGMENTS

Bruna Nogueira, founder and owner of the Hollywood Makeup Lab Course Intensive (www.hollywoodmakeuplab.com), is internationally acclaimed for her extensive work on fashion shows and commercials. Bruna is one of the top makeup artists in the entertainment industry. Known for her work on *CSI: New York*, *Teen Wolf*, and *Hunger Games: Catching Fire*, Bruna is also the international consultant for Avon-Brazil's Beauty Awards.

Diane Namm is a filmmaker who writes and directs for film, television, stage, and the web (www.ladyofthecanyon.com). Best known for her international award-winning films *The Sacrifice and Finding Hope*, Diane is also the author of a wide range of books for children and young adults. As a director, Diane appreciates the challenges that makeup artists face as the unsung heroes of any successful production.

It takes a village to create a book like *Hollywood Makeup Lab*, and we couldn't have done it without the skill and cooperation of some very special artists: Mark Rappaport, Joel Harlow, Vincent Van Dyke, Edward E. French, Kim Ferry, John Black, Chris Nelson, Rod Maxwell, Bob Romero, Robert "Kato" De Stefan, Chris Escobosa, Kerri McGuff, Glen Griffin, Greg Solomon, Cleber de Oliveira, Cary Ayers, KC Mussman (Shiri Rae Burdette), Susan LaPrelle, Tony Carrillo, Steve Buscaino, Anderson Bueno, Jackie Fan, Drica Lobo, Yoshimi Tanaka, Jeff Cruts, Aida Caefer, James LaPrelle, Sandra Solomon, and the puppeteers at Creature Effects, Inc.: Jonah Zimmerberg-Helms, William Thornton, and Marika Soderlund-Robison, the costume designer who clothed Meagan Tandy in glamorous evil.

Our eternal thanks to the actresses, actors, and models who sat for hours while the special-effects makeup was applied and photographed and removed: Kate Flannery, Meagan Tandy, Julia G. Ruiz, Ricardo Vargas, Christopher (Topher) Morrison, Jamie Frazer, Vitor Nogueira, Cesar Mazzo Nogueira, Rebecca Pilger, Bill Myer, James Wesley Hannah, Gabriella Teixeira, Tab Haas-Winkleman, Manon Parisot, Bruna Farias, Liza Goncharov, Tina Sherer, Nesrin Ismail, and Gilbert Laberto.

We are most grateful to Leonard Engleman for the preface to *Hollywood Makeup Lab*; Joel Harlow for his Rogues Gallery photos, Rayce Bird for his digital design photos and step-by-step explanation of his process, Rod Maxwell for *The Wishing Well* photos, Edward E. French, Kim Ferry, and Kate Flannery for the photos from *The Office*; Edward E. French for his step-by-step explanation of the bald cap process; and Travis Smith-Evans for his tireless efforts and countless hours spent taking the incredible photos for the cover and throughout the rest of the book. —Bruna Nogueira and Diane Namm

I'd like to thank Nancy Hall of The Bookshop Ltd., my co-author Diane Namm, my wonderful son Vitor, my entire Nogueira family, and my friend Mark Rappaport and my second family at his Creature Effects workshop. I'd also like to thank all my dedicated and talented teachers, my friends, and all of my fantastic students from all over the world. —Bruna Nogueira